THE 35MM
PHOTOGRAPHER'S
HANDBOOK

Julian Calder John Garrett

A million pictures' worth of experience

A HERBERT MICHELMAN BOOK
CROWN PUBLISHERS, INC. NEW YORK

→3

John Garrett was a photographer in his native Australia before settling in England in 1966. He has worked on assignment for most of the world's top magazines including *Time, Paris Match, Stern,* and *The Sunday Times,* and has contributed photographs to several books including volumes in the Time-Life series, *Cities of the World.*

An experienced photographer who has covered every type of assignment from war to rock concerts and glamour calendars, Garrett is currently engaged on a long term project—documenting the formative years of his two young sons. Children and travel are Garrett's two main personal interests—both of which are subjects demanding a spontaneous attitude to photography, ideally suited to the 35mm SLR camera.

First published in USA 1979
Crown Publishers, Inc,
One Park Avenue, New York, NY 10016

Library of Congress Cataloging in Publication Data

Calder, Julian
 The 35 MM Photographer's Handbook

 Bibliography: p
 Includes index
 1. Miniature cameras. 2. Photo-graphy—Handbooks, manuals, etc. I. Garrett, John, joint author. II. Title.
 TR262.C26 770'.28 79-14094
 ISBN 0-517-53917-9
 ISBN 0-517-53918-7 pbk

Julian Calder's early inspiration came from the great 1950s photo stories in *Life* magazine. He acquired his photographic education at art college and as an assistant to several London photographers in the late 1960s. For him the still photograph has the essential quality of being tangible, involving the viewer in a way that the ephemeral images on the TV or movie screen cannot.

He is an inveterate traveller who obtains personal satisfaction from working on assignment for such leading magazines as *National Geographic, Sports Illustrated, Time, The Illustrated London News* and many other publications. Calder utilizes all the technical gadgetry available to realize the full potential of a picture—stretching the versatility of his camera system to its fullest to capture the kind of picture he wants.

Edited and designed by
Marshall Editions Ltd,
71 Eccleston Square,
London SW1 V1PJ

Editor: Graeme Ewens
Editorial Assistant: Lewis Esson

Art Director: Barry Moscrop
Design Assistants: Tony Williams,
 Paul Wilkinson

Artwork: Arka Graphics
Retouching and **Make-up**
 Roy Flooks

Reproduced by Gilchrist Bros. Ltd,
Leeds

Typeset by Art Repro, London

Printed and bound by Morrison &
Gibb Ltd, Edinburgh

CONTENTS

INTRODUCTION

The first million pictures were the hardest to take. But we have taken them, and the lessons we learned along the way are distilled in this book.

We learned lessons about equipment—not so much about brand-names, but about the right tool for the right job, which isn't necessarily an expensive photographic accessory. On a cold, cold day a warm anorak may contribute more to the sports picture of the year than a fancy lens.

We learned lessons about aesthetics—and then forgot them. Many a magical moment has been missed while the photographer sought the composition elements that are so dwelled upon in more pompous books.

And we learned lessons about technique—and found that the vital ones came from unremitting practice, like learning to ride a bicycle, and then the attention to detail that such confidence will afford. Once the ground rules and general disciplines become second nature, the photographer can explore and experiment.

Understand first that photography is fundamentally a simple process and modern cameras make it ever more simple. Once you are familiar with the routines and checklists that we suggest for both the humble and exotic 35mm cameras now available, you can concentrate on what really matters: looking and seeing.

We took every photograph in this book (not many other manuals show that courage on the part of the authors). But we felt that there was as much

8

to be learned from our failures as our successes. And as much to be learned from the frank admittance that the laboratory and fail-safe techniques like bracketing could give more people more confidence to take more pictures. And we do mean more pictures. For this book assumes that you wish to take photography seriously; that professional standards of work are what you are after; and that, like a professional, you will wish to take pictures every day.

This is why the book has a shape and size to suit the camera bag or a pocket in the car rather than the coffee table. It is meant to be of daily use to architects, teachers and salesmen and in a myriad other occupations where a picture can speak so much more persuasively than words. It should enhance the recollected pleasures of gardening, model-making, parenthood. Photography is a world of its own—and a visual access to every other world.

Most of the pictures in this book were taken on Nikon equipment—simply because we use it almost exclusively. Nikon makes one of the most comprehensive 35mm camera systems, but there are another dozen or so systems that are broadly similar. With the plethora of equipment now available there is a great temptation to become a gadget fanatic. Remember there is an unlimited range of photographs to be taken using one camera and one lens—and no two pictures are ever the same.

SLR Cameras

35mm cameras are compact and lightweight. The image is of high enough quality for most applications, while the 36 x 24mm format is a pleasing shape in which to compose, echoing the age-old golden section theory of design.

Through the reflex viewing system the photographer sees the exact image which will be exposed. He also benefits from through the lens (TTL) metering and has the ability to control both shutter and aperture without taking his eye from the viewfinder.

The 35mm SLR user has at his disposal the most comprehensive range of interchangeable lenses and accessories, which allow extraordinary versatility. The small size and weight of modern systems means that they are fast and easy to use. A fully equipped photographer has mobility and the capability of operating in any situation.

It is a fallacy that 35mm cameras are for amateurs while professionals use larger format cameras because bigger pictures reproduce better. Leading magazines, with the highest standards of origination and printing, have made nonsense of this belief. Available in 20 or 36 exposure rolls, 35mm film is also more economical than other formats.

There are basically two types of SLR camera body. The manual type is represented here by the standard Nikon F2 Photomic. This is a highly sophisticated piece of equipment with meter head, back, screens, viewers and motor drives all interchangeable. This facility allows the photographer to use the most fundamental piece of equipment—the camera body—in the way he chooses.

It is for this basic camera body design that the range and versatility of the system have been developed,

Nikon F2 Photomic

1 Film advance lever
2 Time exposure and lock
3 Shutter release button
4 ASA film speed setting
5 Shutter speed dial
6 Power check button
7 Meter window
8 Coupling lever release
9 Film rewind knob
10 Accessory shoe
11 Film rewind crank
12 Frame counter
13 Self-timer mechanism
14 Mirror lock-up lever
15 Depth of field preview button
16 Reflex mirror
17 Meter coupling lever
18 Lens mounting index
19 Lens release button
20 Flash sync terminal

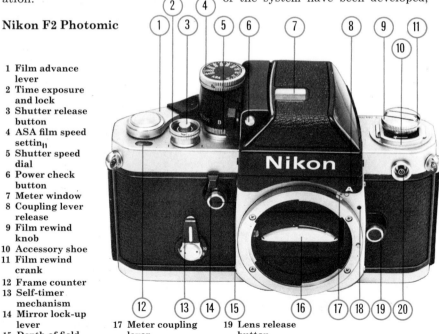

allowing the photographer to adapt his camera to any applications.

The new generation of SLR cameras, represented by the Olympus OM2 with wind-on, is totally automatic, with meter, shutter, aperture and film advance all electronically controlled. Other than the lenses, however, there are no interchangeable components. Battery powered cameras are cheaper to produce and more accurate than manual models and will undoubtedly capture most of the SLR market.

Unfortunately, while many cameras make photography more accessible to a wider public, some modern designs appeal more to the male jewelry market than to the serious photographer. Cameras are becoming smaller but as their use is related to the dexterity of the human hand, the limit of miniaturization may already have been reached.

New developments in the fields of battery technology, shutter design and electronic display and memory are leading to revolutionary design features in modern cameras.

Electronic cameras of the 1980s, designed for the general market, will feature much faster shutter speeds (up to 1/2000 sec); built-in auto winds; motor drives which can operate at more than 10 frames per second; complete LED (Light Emitting Diode) information displays in the viewfinder; automatic ASA setting by magnetic coded cassettes, and automatic film take-up.

While electronic cameras can provide acceptable, even perfect, pictures under most normal conditions, the creative photographer will often demand a manual override capability. To be in command of the medium a knowledge of the relationship between aperture and shutter is vital, even when using an electronic camera.

Olympus OM 2 with auto wind

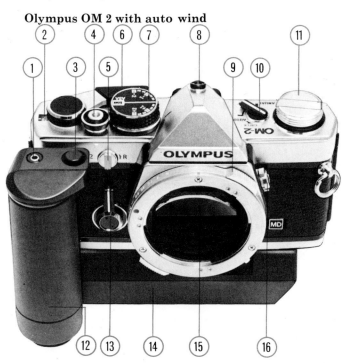

1 Remote control jacket socket
2 Frame counter
3 Auto shutter release
4 Shutter release button
5 Rewind release lever
6 Film advance lever (manual)
7 Exposure compensation/film speed dial
8 Accessory shoe socket
9 Shutter speed ring (manual)
10 Auto/manual meter selector lever
11 Rewind crank/camera back release
12 Auto wind unit
13 Self-timer lever
14 Battery pack
15 Reflex mirror
16 Flash sync terminal

Special purpose cameras

Although SLR camera systems fulfil most picture taking requirements, there are occasions when a different type of camera might be employed for specific purposes. While the studio cameraman might specify large format equipment, there is also a range of lightweight and sub-miniature 35mm cameras designed for particular assignments.

Widelux. A portable camera designed for landscapes and also useful for making portraits of large groups. During an exposure the 26mm lens moves within its mount, scribing an arc of 140°, and produces a sharp panoramic image occupying twice the width of a normal 35mm frame. It has a limited speed range (1/15, 1/60, 1/250). To prevent the hands intruding into the picture use a pistol grip.

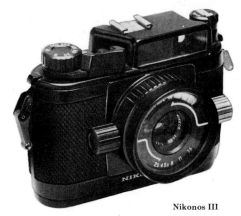

Nikonos III

Leica. The quietest full-size 35mm camera, due to the fact that it is a non-reflex design without the noise making mirror action common to SLRs. The design has remained virtually unchanged since its introduction in the 1920s. It is ruggedly constructed and extremely versatile. An extensive range of superior quality interchangeable lenses allow exposures to be made under any conditions, particularly when the light level is low. The M3 model illustrated is fitted with a detachable light meter.

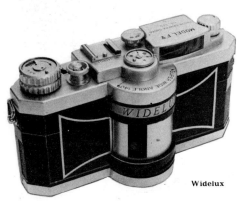

Widelux

Nikonos. A rugged, all purpose camera made by Nikon, which can be taken underwater to a depth of 50 metres. It can be fitted with any of four interchangeable lenses. Its unique construction features an inner body which is sealed into the outer casing. Being dust proof and virtually indestructible, it can be used in any environment from desert to mountains. It is the only 35mm camera which can be sterilized.

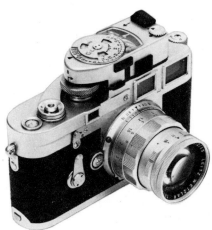

Leica M3

Minox. The smallest full frame camera presently available. The totally automatic aperture and shutter control is accurate, and the fixed lens can produce an image of high enough quality for press reproduction. Due to its pocket size and reliable mechanism it can be carried at all times and is suited to candid and spontaneous photography.

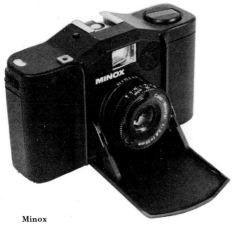

Minox

Olympus Trip. A compact camera suitable for use as a visual notebook. Its high quality 40mm lens is non-interchangeable. It has four pre-set focusing ranges and fully automatic exposure control, which is governed by the distinctive light meter mounted around the outside circumference of the lens.

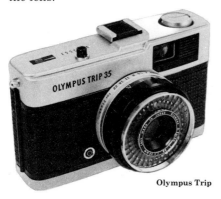

Olympus Trip

Hulcher. A portable high speed camera which can take between five and 65 exposures per second, the Hulcher is only built to order. Developed for scientific and industrial applications, it differs from movie cameras in that its shutter actually stops the film for each exposure. Although designed as an analysis camera to photograph such things as a bullet leaving a rifle, or a car hitting a wall, the Hulcher is used successfully by several news and sports photographers. The lens mounting accepts a range of Nikon lenses, and film is loaded in 100ft rolls.

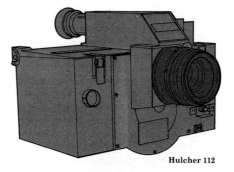

Hulcher 112

Instant picture cameras, such as the Polaroid SX 70, are useful for taking reference pictures or snapshots which are needed immediately. Professionals often use Polaroid backs on large format cameras to test exposure and lighting setups, but these are not available for 35mm cameras. In recent years Kodak have introduced a range of instant film cameras in competition with Polaroid.

13

Viewers and screens

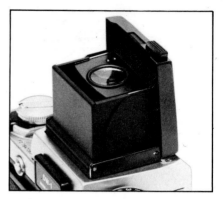

The pentaprism head through which the image is viewed is a feature of all SLR cameras. Its optically precise prism corrects the image which has been reversed by the lens.

For certain applications, where focusing is critical or difficult, photographers often prefer to use alternative viewers or ground glass focusing screens. The facility for changing these parts is only available on some sophisticated cameras.

On automatic cameras the electronic meter circuitry prevents the removal of the viewing heads. There are, however, certain adaptors to aid close focusing which can be attached to fixed head cameras; for wearers of spectacles prescription lenses can be fitted to the eyepiece.

In the highly specialized field of photomicrography, a range of viewing adaptors is available for use when the camera is attached to a microscope.

The pentaprism head **below left** corrects the reversed image from the mirror. With the head removed **right** the focusing screen is exposed.

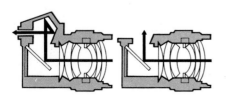

The waist level finder provides a direct view of the uncorrected image on the ground glass screen. It is possible to draw on the screen for composition reference. A four sided hood aids focusing by shielding the screen from unwanted light. It is useful for shooting from low down or from overhead **above left** when the camera cannot be brought to the eye.

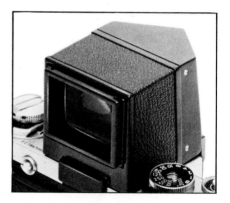

The action finder is a magnifying reflex viewer which enables the photographer to see the entire image with his eye some way from the lens. It is useful for shooting fast moving subjects such as sport or wildlife, when the action must be followed with both eyes. The large eyepiece makes it suitable for use when spectacles or goggles are worn.

14

As with viewing heads, focusing screens can be interchanged only on certain cameras. A comprehensive range is available for sophisticated manual cameras, while screens on certain electronic models can be replaced only by camera mechanics. The standard Nikon screen shows a split image in the centre of a plain screen, which is aligned when brought into focus. It is not suitable when a lens with a small aperture is fitted. Most types **below** are available with or without reference grids for framing.

The **focusing finder** magnifies the image on the screen and is used in scientific or close-up photography. Its 6X enlargement permits critical focusing of the whole image, while its complex optical construction allows adjustment to individual eyesight. As with all non-reflex viewers the uncorrected image on the screen is seen reversed, as in a mirror.

Type A. Matte/Fresnel with horizontal split spot. Used for fast focusing with wide aperture lenses. Reference circle is for centre-weighted meter.

Type B. Fresnel with clear matte central focusing spot. Used with ultra wide and super telephoto lenses, and those with small maximum aperture.

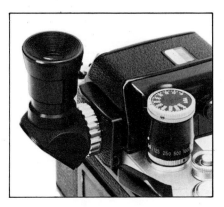

The **right angle finder** is not a replacement but an accessory to the pentaprism. By swivelling the eyepiece the image can be viewed from above or from the sides. It is mainly used with a copying stand, but it is also useful when the camera is in a tight corner. With the camera turned upright, pictures can be framed by looking straight down into the viewer.

Type E. As type B with reference grid for framing horizontals and verticals. Used in detail copying and architectural work with PC lens.

Type J. As type A with microprism centre focusing spot. Used for general purpose photography with lenses of f8 or brighter.

Type K. Features split image focusing spot surrounded by microprism within centre weight meter area. Unsuitable with lenses of less than f4, when centre goes black.

Type L. Identical to type A, except that the central split image focusing spot is diagonally aligned, enabling rapid focusing of images with vertical lines.

Lenses

The selection of a lens is one of the most vital creative decisions to be made by a photographer. The shorter the focal length the greater its angle of view; conversely, the longer the focal length the narrower the angle of view. The focal length of the lens also affects the relative image size of the subject.

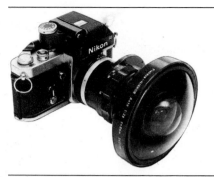

One of the most important characteristics of a lens is its effect on perspective. Wide angles exaggerate perspective, while long focus lenses diminish. Similarly, depth of field is much greater on wide angle lenses than telephotos. An understanding of these basic optical principles forms a large part of the creative base of any photographer.

When choosing a lens in which to frame a picture, be aware not only of the shape of the subject, but also of the other shapes created between the frame and subject. Do not look only at the subject, but look around the complete picture.

To become a 'natural' photographer one should continually be framing pictures in the mind's eye—whether or not the eye is behind a camera viewfinder.

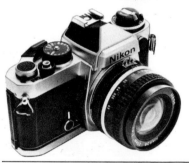

With experience a camera user will come to know instinctively which properties of which group of lenses will best enhance the picture. Many photographers use a particular lens so frequently that it becomes synonymous with their style.

In addition to general purpose lenses a variety of specialist types are produced. Zoom, macro, super fast and ultra-wide angle lenses are now available for all cameras, and as optical technology advances these are becoming more suited to general use. It is as necessary to become familiar with a new lens as with a new car; in the case of a lens, its balance in the hand, the position and operation of controls and the optical characteristics are the key factors.

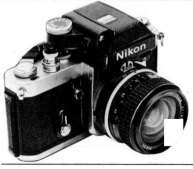

Fisheye 8mm f2.8
(Angle of view 180°)

Fisheyes were originally designed to photograph cloud cover for meteorologists. The wide angle of view and circular frame can contain a complete horizontal plane when photographing directly upwards or downwards. The extreme distortion limits their use and makes fisheyes unsuitable for general photography.

15mm f5.6 (Angle of view 110°)

An ultra-wide angle lens with little image distortion—it doesn't 'bend' the vertical or horizontal lines. It has enormous depth of field capability and doesn't really need to be focused unless used close up. A fine lens for interiors and sweeping landscapes. Because of its extreme exaggeration of perspective, spectacular pictures can be made.

20mm f4 (Angle of view 94°)

The most popular ultra-wide angle lens with many professional photographers, it is extremely versatile. Like the 15mm it is good for interiors and dynamic pictures, but comes into its own for landscapes when used with polarizing filters. Stylized compositions can be made which utilize exaggeration of perspective without appearing gimmicky.

24mm f2 (Angle of view 84°)

A versatile lens which is optically straightforward in construction and therefore good value for money. It provides just enough distortion without the image flying off the sides. The wide aperture makes it a good lens for using in crowds or tight areas. The photographer can stand back to get a group in frame, but still maintain close contact, which is important.

Lenses/2

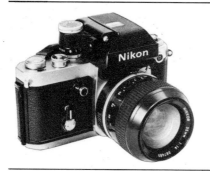

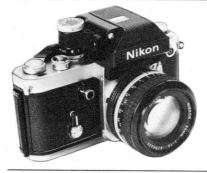

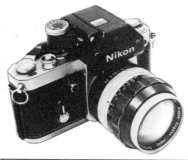

35mm f1.4 (Angle of view 62°)
Although a wide angle, this ought to be the 35mm photographer's standard lens. Its angle of view and minimal distortion allows more compositional possibilities than a normal lens. When shooting people, this emphasises the relationship between subject and environment. The ability to get 'inside' a picture creates an intimacy between photographer and subject.

**35-70 Zoom f3.5
(Angle of view 62°—34°)**
The advantage of zooms is that they give a choice of focal lengths, enabling variations of the same picture to be composed. When a subject is approaching the camera it is easy to hold focus and keep the subject full frame. This particular lens covers a useful range of the 'normal' lens family, and is good to use if only one camera is carried.

50mm f1.4 (Angle of view 46°)
50mm lenses are universally known as 'normal' as they correspond to the angle of view of the human eye. They usually have the largest aperture in any range. There are several choices of 50mm lens, so select the one with the largest aperture. They are used when a photographer wants no perspective distortion or when working in low light levels.

105mm f2.5 (Angle of view 23°)
This is one of the finest focal length lenses for 35mm cameras and a favourite of all professionals. Like the 24mm it is good value. Photographers consider it the portrait lens because, when fully framing a head, it photographs the face as the mind's eye sees it, with no distortion. It is sharp and fast with fine colour and tonal rendition.

There are many lenses of focal lengths in between the ones described here. This is not a catalogue of all available lenses, but an indication of the optical properties and the applications of a cross section of them.

It is usual to consider that lenses belong to specific families—such as wide angle or telephoto—and that these lenses are for certain designated subjects. However, this is not necessarily the case. Good portraits can be taken on ultra-wide angle lenses, and architecture can be shot on telephotos as long as the photographer is aware of the level of distortion and the effect on perspective.

There is an enormous amount of promotion by lens manufacturers, but be wary of those made by people other than the camera makers. Some ranges, such as Vivitar Series 1, are excellent but most cheap lenses do not offer the necessary quality.

The biggest problem with cheap lenses is that they do not stand up to extremes of temperature or any rough treatment. They may give reasonable results when new, because the elements are in the original settings, but they deteriorate rapidly. Exposure to high temperatures may cause elements to shift. With cheap lenses the photographer often feels that he is to blame for unsatisfactory pictures, whereas the fault may lie with the lens.

If the price of a new lens is beyond reach, secondhand lenses by a system manufacturer are excellent value, but they should be tested before purchase. If a used lens is out of adjustment it can often be re-set at reasonable cost.

When buying used lenses photograph a flat textured surface, such as a brick wall, at various apertures, and enlarge or project the picture as big as possible. Scrutinize the edges of the picture for fall-off or distortion. If the image appears sharp from edge to edge the lens is fine.

Lenses/3

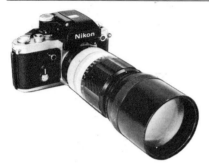

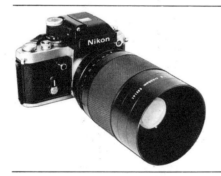

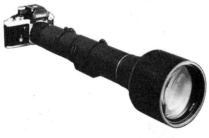

80-200mm f4.5
(Angle of view 30°—12°)

This is the most useful and versatile long focal length lens. It is extremely sharp and manageable, holding focus throughout the zoom. Good in the studio and outdoors, it allows the photographer to move in tight or pull back for a wide shot without moving. Some manufacturers offer macro attachments but none of these are as good as the macro lens.

300mm f4.5 (Angle of view 8°)

This lens is the first 'real' telephoto; it sees closer than the eye does. It compresses perspective with minimal depth of focus, providing exciting picture possibilities. Because of its light weight, it is the standard telephoto lens for press, sports and animal photography, allowing the photographer to stand away from the subject to record natural scenes.

500mm f8 mirror lens
(Angle of view 5°)

Mirror lenses are about half the size and weight of other long lenses. They are portable and usable with fast shutter speeds. The fixed aperture restricts depth of field control. New fast colour films have greatly increased their scope. Mirror lenses have one characteristic effect on out of focus highlights, which are made to look like doughnuts.

1200mm f11 (Angle of view 2°)

Visual and technical precision are vital with use of this lens. It sometimes requires two tripods (one on the camera body) for static pictures, but 'panning' is possible. The compression of perspective and shallow depth of field can give extraordinary and exciting results. These lenses enable pictures to be taken of subjects that are physically inaccessible.

20mm lens exaggerates distance between foreground and background

Standing in the same places, the people appear closer together when shot on 105mm

The 1000mm compresses perspective to dramatic effect

Lenses

21

Specialist lenses

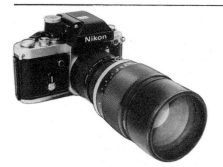

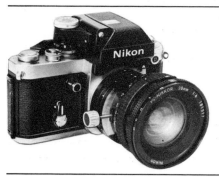

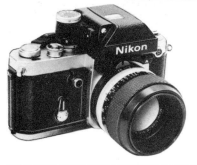

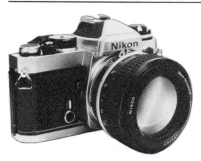

Tele converters are magnifying elements placed between the lens and the camera. They are useful for adapting an existing lens for telephoto use, but they cut out light and demand an increase of two f-stops. They can only be used on lenses of over 50mm, but provide an exact focal length in a range where no lens is manufactured. A 180mm, for example, can be converted to a 360mm lens.

Perspective correction lenses are for use in situations where the distortion of vertical or horizontal lines has to be corrected. Conversely they can be used to exaggerate such distortion for special effect. By offsetting the front of the lens they can also be used to simulate the effect of moving the camera, when there is no room to actually alter its position.

Macro lenses are offered by almost all lens manufacturers and can be purchased as standard with some cameras. The purpose of the macro is to allow a shot to be taken with the front of the lens as close as possible to the subject. These lenses are also exceptionally sharp. With the growth of interest in close-up photography macros are becoming increasingly popular.

Noct Nikkor is an ultra-fast (f 1.2) lens for use under low light conditions where there is extreme variation between light and dark areas of the picture. It allows correct exposure of the low lit areas at the widest aperture, and cuts down non-image forming light. This reduction in flare from naked light sources is achieved by the aspherical construction of the lens surface.

Specific technical applications require lenses which the general photographer may find hard to obtain. Among lenses designed for medical and technical purposes are the 200mm **Medical-Nikkor**, a close-focusing lens with built-in ring flash. The **Endoscope** fibre optic lens is an attachment which transmits light from inaccessible areas to the lens. It is used in medical work to photograph the inside of the body, and in engineering to analyse the interior of engines.

The 2000mm **catadioptric** (mirror) lens is the longest telephoto made. It is mainly used for astronomy or surveillance. It offers magnification 40 times that of a normal lens. **Image intensifiers** enable film to be shot in almost total darkness. A battery powered unit fits between an objective lens in front and the camera lens, and is only switched on in darkness.

The Novaflex is unique among high quality lenses in that it offers a follow focus capability, which is especially suited to such action subjects as sport or wildlife where the subject is in continual motion. The focus control is operated by a pistol grip, which is either squeezed or relaxed to retain focus as the subject moves towards, or away from, the camera.

Exposure

Photography is to do with light—the understanding of it and the correct photographic use of it. The application of the information provided by the meter is essential if the photographer is to gain control of the picture. Even if it is left to the camera to do all the 'thinking', the photographer must know the limitations of that thinking, and when and why to override it.

TTL metering

In most pictures the emphasis is on the centre of the frame, so the light meters in many SLR cameras are biased towards this area. Extra care should be taken with the use of centre-weighted TTL meters when the emphasis is on other parts of the picture.

Some meters, however, give an average overall reading. These are fine for evenly lit subjects, but can cause problems when there is a great difference in light levels. An average reading might be right by the meter, but wrong for the picture.

Meters have no taste and there are certain areas of photography where TTL metering should not be trusted. These include very bright subjects,

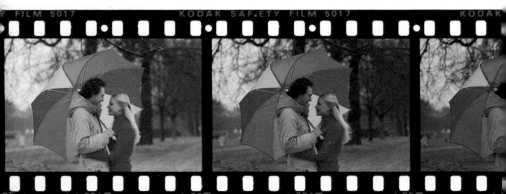

Bracketing

One of the professional photographer's trade secrets is bracketing—a process by which he makes certain that he gets the picture he wants. By exploring all the possibilities of exposure, pictures can be obtained which even the most experienced photographer might not have expected.

As a form of insurance it is also desirable to have as many near-perfect originals of an important picture as possible, so more than one frame should be shot at each exposure. There are four ways to bracket in the camera.

The first method **above** is to vary the f-stop from the one indicated by the meter. Under most light conditions a frame is taken at the metered aperture, then one at a half stop under, and another at a half stop over. It is perfectly reasonable to go as much as two stops either side of the indicated aperture, especially in low light levels when slow shutter speeds are being employed, or the photographer is unused to the light conditions. If the camera is electronic and the batteries are run down, some new models will make a mechanical exposure at 1/100 sec. In this case f-stop bracketing is the only way to alter exposure.

If aperture priority is critical to maintain depth of field, a second method can be used which involves altering the shutter speed in a similar way. At a fixed f-stop one frame is taken at the indicated shutter speed,

24

such as landscapes with snow or sand, and high-key studio shots; portraits of black people; backlit subjects of any kind; stage shows shot from the audience; document copying; and any shot in fog or mist.

The two ways to overcome the problems created by these subjects are the **grey card** method or use of the memory lock on the TTL meter. To use the second method, approach the subject until it fills the frame, set the meter and engage the memory lock. If it is not possible to get close, change to a longer lens and fill the frame that way. Set the meter and change back to the chosen lens. The exposure will be as calculated with the image filling the frame.

Grey card readings
Most scenes, when reduced to monotones, represent about 18 per cent grey. TTL meters and film speeds are calibrated for this average tone (reproduced on p.240). Other 18 per cent grey areas are grass, trees, tarmacadam, dull brickwork and neutral coloured clothing. For correct exposure in non-average conditions, measure something that represents this grey tone. When using wide angle lenses, determine the exposure off the ground, then recompose the picture using that exposure reading.

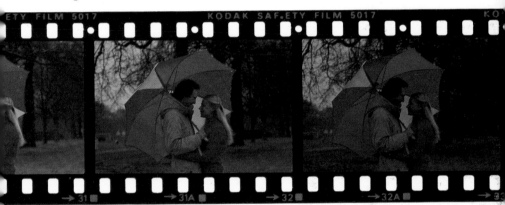

The centre frame was shot at the metered reading, others vary in stages of ½ stop. Final choice will depend on whether the umbrella colours or the skin tones are to be emphasised.

e.g. 1/125 sec; then one at 1/90 sec and another at 1/200 sec. (On modern cameras shutters work at speeds in between those shown on the dial.)

The third method is necessary for bracketing with electronic cameras set on automatic. The only way to affect the exposure is to alter the ASA setting. When using 200 ASA film, for example, one frame should be shot at the correct setting, then the dial should be changed to 150 ASA (½ stop over) then another shot at 300 ASA (½ stop under). The photographer must be familiar with the handling of his camera to employ this method suc-cessfully. It works well when using a motor drive or autowind.

A fourth method involves the use of neutral density filters, which cut down the light. These will not work when the camera is set on automatic. The method is to use two filters, an ND1 which cuts light by ½ stop, and ND2 which cuts the light by 1 stop. Shoot the first frame with the ND1, the next with no filter, and the third with the ND2. The basic reading is taken with the ND1 on the lens. With an uncontrollable light source this method allows the use of a particular shutter and aperture combination. In bright sunlight, for instance, use of ND filters is the only way to maintain a wide aperture.

Aperture/shutter

A camera is a box with a lens at one side and a film holder at the other. The camera contains a shutter, and the lens an iris. Light enters the camera through the lens and exposes the film when the shutter is opened.

The iris is a system of metal leaves which open and close. The space in the middle is the aperture, the size of which is measured in f-stops. The aperture governs the volume of light landing on the film, and the shutter controls the length of time that light is allowed to land on the film. If the shutter speed is doubled the amount of light is halved. This is also the effect if the aperture is decreased by one stop. Conversely a wider aperture or slower shutter lets more light through.

Aperture determines the depth of field — how sharp the picture is in front and behind the point on which the lens is focused. The smaller the aperture the greater the depth of field. With the lens wide open only the point of focus is sharp. A scale on the lens barrel indicates the extent of the area in focus at each aperture. The effects of aperture control are most visible on long lenses.

The shutter controls the effect of movement by the subject in the picture. It will either freeze the action or give the impression of movement. With modern cameras there is an infinitely variable range of shutter speeds.

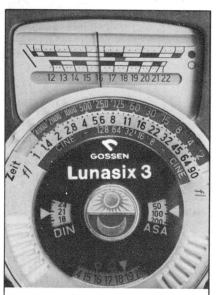

Correct exposure is obtained when the aperture and shutter speed are coupled in the right relationship, which is governed by the ASA film speed. The exposure meter needle moves with fluctuations of light and indicates a range of shutter/aperture combinations, any of which are technically correct.

With meter-coupled lenses which provide wide-open viewing the preview button enables the stopped-down image to be seen. Make it a habit to use the preview button to check sharpness. If more depth of field is wanted use a slower shutter speed and a tripod.

Remember it is the distance the subject moves across the film plane during exposure that determines the amount of 'blur'. For instance, if a man runs towards a fixed camera he can be held sharp at 1/60 sec, yet if he is running across the camera he will be blurred at that shutter speed.

When a camera is set on automatic the relationship between the aperture and shutter is maintained. Some cameras have aperture priority, some shutter priority, while others have both. Check the manual to identify a particular model.

If depth of field is required with a shutter priority camera, then a slow shutter speed is chosen. If the movement must be frozen on a camera with aperture priority, the lens should be opened wide.

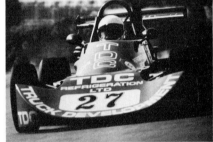

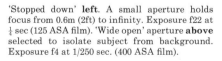

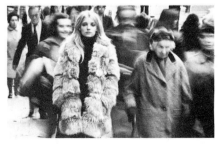

'Stopped down' **left**. A small aperture holds focus from 0.6m (2ft) to infinity. Exposure f22 at ¼ sec (125 ASA film). 'Wide open' aperture **above** selected to isolate subject from background. Exposure f4 at 1/250 sec. (400 ASA film).

Fast shutter **top right** freezes action. Exposed at 1/500 sec. at f8 (125 ASA film). Panning with action **centre** enables a slower shutter speed to be used. Exposure 1/30 sec. A slow shutter **right** isolates a static subject from a moving background. Exposure 1 sec.

27

Exposure

The white room was to be photographed as it appeared to the eye—which saw it evenly illuminated by daylight from the large windows. To the light meter, however, a different picture was apparent.

When exposing for the outside (1) the room was black. If the exposure had been made for the daylight in the room the windows would have flared out to large soft areas of white, and the long exposure would have registered movement of the people.

The problem, therefore, was to balance the light in the room to the outside level. The interior light sources could be controlled; the daylight could not. By late afternoon (2) the daylight level had dropped and the meter registered the same for the outside as for the 'pool' of light around each tungsten light source.

As both the window areas and the 'pools' of tungsten light appeared as part of the subject, spot readings were taken from the camera position. These represented highlights only.

The incident readings of the room were still far too low to match the daylight, so readings were taken from the dark areas to determine where, and how much, fill-in flash to use. Three flash heads were used, one to light the left side of the room, one from behind the camera as a foreground fill-in, and one on the wall

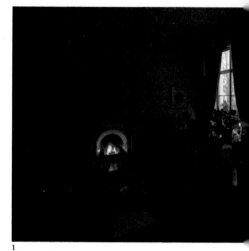

1

which was reflected in the mirror.

A tiny hand flash was used to boost the candlelight effect on the face of the girl at the piano. Another was placed under the plants in the far corner to stop them appearing solid. A silver reflector was used to kick some light back into the front of the piano, and a small piece of silver foil placed behind the whisky decanter.

Incident flash readings were taken and, by controlling the spread, power and position of the lights, an average

2

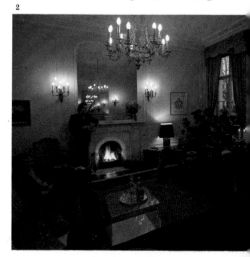

Incident light readings around the room. Unless indicated, exposures were 1/15 sec.

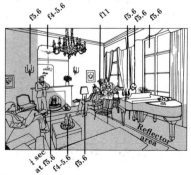

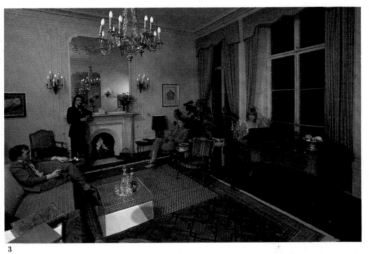

3

overall light reading was achieved.

The next picture (**3**) was shot at 1/60 sec with just the flash. The windows are black and the tungsten sources appear as just bulbs, with no effect of illumination. The flash alone is too cold—there is no atmosphere of warmth in the room.

The final picture (**4**) is really a multiple exposure. First the flash was recorded then, as the shutter speed was slow (1/4 sec), the daylight and tungsten were allowed to register. The

red quality of daylight film shot in tungsten light makes the final picture look warm and cosy with outside detail still visible.

To achieve this effect the readings were taken on a Gossen meter, with spot attachment, and a flash meter. Every light source was made to balance. The effect of the candle and firelight was increased by the use of a slow shutter speed. The final pictures were bracketed by adjusting the power of the main flash heads.

4

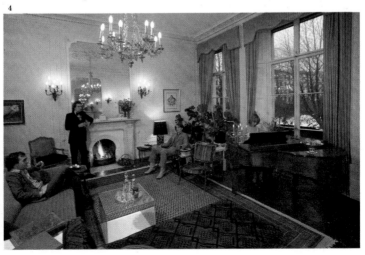

Exposure meters

Although TTL metering is sophisticated, the serious photographer cannot do without a good independent meter. He should know the level of light in every relevant area of the picture, which is often difficult and slow to deduce with built-in meters.

As with the built-in meter, the hand meter only provides basic information. The photographer then has to apply this to his own picture requirements.

There is no guarantee that any meter will give the exposure for the perfect picture, but with intelligent use of the TTL meter plus the hand meter, and bracketing, correct exposures will be achieved.

Mistakes should be studied. If a note is kept of exposure details, much can be learned from bad pictures.

Hand held meters can be used in two different ways to measure either reflected or incident light.

Reflected light readings are taken from the light which bounces off the subject in the direction of the lens. This method is little different from TTL metering, although the hand meter is more versatile.

Incident light readings are those where the meter is held in front of the subject but facing the light source, so measuring the amount of light which is falling on it. To take these readings, the meter must be fitted with a light diffuser, such as the Weston Invercone. Incident readings give a more accurate interpretation of the light falling on the subject without being affected by the brightness of the subject itself.

Once the film speed has been set, and an exposure value indicated on the scale, the complete range of relevant shutter/aperture combinations becomes evident.

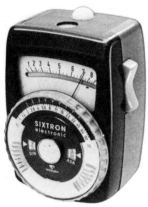

Gossen Sixtron

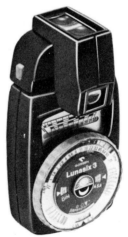

Lunasix

Weston Euro-master

Flash meters take readings off electronic flash units. They are capable of reading a sudden and brief surge of light. They work on an incident light principle with a diffuser. The **Gossen Sixtron** is ideal for the 35mm photographer because it is a remote meter which does not have to be plugged into the flash unit, and can be used with hand flash or large studio units.

The **Lunasix (Luna Pro)** is one of the most versatile meters produced. The basic unit is an accurate available light meter, capable of reading from extremely low light levels up to the brightest daylight. Reflected and incident readings can be taken. Attachments are available for spot metering, copy, microscope and enlarging work. A new model, the Profisix, has even more features.

The **Weston Euro-Master** is a selenium meter which is reliable and useful for most general purposes. As it is not powered by batteries it is good for use in extreme cold or high humidity, where any kind of battery is unreliable. It can read light at most levels, although it is less sensitive in low lit areas.

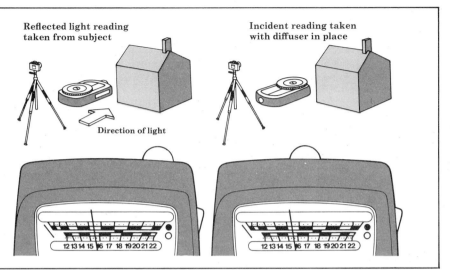

Reflected light reading taken from subject

Incident reading taken with diffuser in place

Direction of light

12 13 14 15 16 17 18 19 20 21 22

12 13 14 15 16 17 18 19 20 21 22

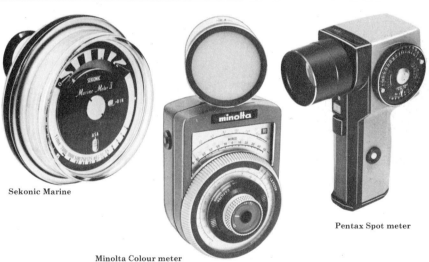

Sekonic Marine

Minolta Colour meter

Pentax Spot meter

The Sekonic Marine is designed for taking readings underwater at considerable depth, but it also makes a rugged meter for general use. Being completely sealed, the marine meter is ideal for extreme locations, such as deserts and rain forests. For underwater use it makes an excellent partner for the Nikonos camera.

Colour temperature meters measure the 'colour' of light in degrees Kelvin, and will indicate the type of filtration required to achieve correct colour balance. The **Minolta** will measure from light levels as low as 3ft/candles through to

midday sky. Colour temperature meters are mainly used when shooting with mixed light sources, and reversal film stocks.

Spot meters have a reflex viewing system with a spot in the middle of the screen which takes a one degree measurement, and are used for precision work. Readings can be taken of all areas of the picture from a considerable distance, providing the photographer with sufficient information from which to expose correctly for any part of the picture. They are ideal for shooting backlit subjects, sport and stage performers.

31

Film/colour

There are many types of reversal and negative films on the market, although some films are only available in certain parts of the world.

Daylight reversal (transparency) film is colour balanced for noon/daylight, electronic flash and blue flashbulbs. Other films are balanced for incandescent (tungsten) lamps of various types. Filters may be used to balance the colour of light for the film.

There are films of various speeds. The faster ones are inevitably coarser in grain and less sharp. Processing methods vary. Kodak Ektachrome films use the E6 system and other manufacturers are adopting this method. All E6 films are best processed soon after exposure and should be fresh.

Kodachrome films use a different processing system (K14) which the user cannot employ. These films are very stable and an excellent choice for long trips. Although classified as amateur products they are used by many professionals, when delay in processing is acceptable. Some films are classified as being best for long or short exposures. Fastidious photographers sometimes choose films by batches, since each batch of film can vary slightly despite manufacturers' attempts to ensure uniformity. Colour negative films are universal in balance, being used in all lighting and corrected at the printing stage. Most types are 80/150 ASA or 400 ASA and use the Kodak C41 processing system or an equivalent. The trend is for makes using the older C22 system to fall into line.

Colour reversal film

 Kodachrome 25. Daylight. Sharpest and least grainy ordinary slide film available. Stable but slow. Colours less saturated than Ektachromes. Good exposure latitude.

 Ektachrome 50. Artificial light version of ER64. Excellent film for still life, as long exposures create minimal reciprocity failure. E6 process. Develop soon after use.

 Kodachrome 64. Daylight. Slightly higher contrast than Kodachrome 25 but virtually the same sharpness and grain. Good all round film, except for skin tones or contrasty light.

 Ektachrome 160. Balanced for artificial light. Good choice for general interior work with tungsten light. E6 process. Can be pushed $1\frac{1}{2}$ stops. Develop soon after exposure.

 Ektachrome 64. Daylight. More saturated colours than Kodachrome. E6 process. Professional and amateur types. Good grain/sharpness. Develop soon after use.

Agfacolor CT18. 50 ASA. Known in USA as Agfachrome. General purpose film with warm tonal rendition. Daylight. More grain and less sharp than Ektachromes.

 Ektachrome 200. Daylight. High speed. Good for general use. Clean separation of subtle hues. E6 process. Professional and amateur versions. Develop soon after exposure.

 Agfacolor CT21. As CT18, but faster speed (100 ASA) and inferior quality. Contrast and grain give 'old fashioned' rendering. Also known as Agfachrome in America.

 Ektachrome 400. Good quality for such a fast film. Used in difficult lighting. Can be pushed two stops. Coarser grain than other E6 films, but more versatile.

 Agfachrome 50S. Professional version of CT18 with better neutrals and higher saturation. Suitable for short exposures. Individual batches have their own speed ratings.

Agfachrome 50L. As 50S, but balanced for tungsten light. Reciprocity characteristics adjusted for long exposures. Batches have individual speed ratings.

Sakurachrome R100. Balanced for daylight. General purpose amateur film. E4 process. (Will probably soon be replaced by an E6 version).

Ektachrome Infra-red. Special film sensitive to IR and visible spectrum. With strong yellow filter rated at 100 ASA. Alters colour. Critical exposure and focus.

Colour negative film _____

Agfa CNS2. 80 ASA. Amateur film. Improved version of previous CNS film. Grain and sharpness are not as fine as Kodacolor II, but it can be easier to process and print.

Agfacolor 80S. 80 ASA. Professional film, improved version of previous type. Good reciprocity characteristics. Grain and sharpness not as good as C41, but easy to print.

Kodacolor II. 100 ASA. Fine grain and sharp. Excellent general purpose amateur film, used by professionals for some subjects. Colours fairly saturated. C41 process.

Vericolor II. Type S. 100 ASA. Professional version of Kodacolor II giving less saturation; better pastel colours and skin tones. Best results with short exposures.

Fujicolor FII. 100 ASA. Basically similar to Kodacolor II though not absolutely identical. C41 processing.

Sakuracolor 11. 100 ASA. Similar to early versions of Kodacolor and Fujicolor II. C41 process.

3M Color slide. 100 ASA. Daylight. General purpose amateur film. Resembles early E4 Ektachrome and can be processed at home. Grain and sharpness inferior to E6 films.

Fujichrome 100. Daylight. General purpose amateur film. New version uses E6 process. Resembles E64 though not identical. Develop soon after exposure.

Kodak Photomicrography 2483. Special professional film for microscope slides. Daylight 16 ASA. Sharper than Kodachrome. High contrast, and saturation.

3M 100. Similar to Kodacolor II, Fujicolor II, and Sakuracolor II. C41 process.

Agfacolor CNS 400. Finer grain and sharper definition than other 400 ASA films. Can be used in high contrast light. Immense latitude to overexposure. Uses C41 process.

Kodacolor 400. Excellent grain and sharpness for so fast a film. Immense latitude. High contrast. Good for dull days, less good in sunshine. Useful with fluorescent light.

Fujicolor 400. Closely resembles Kodacolor 400. C41 process. Best of its type for push processing.

Sakuracolor 400. Similar characteristics to Kodacolor 400 and Fujicolor 400. C41 process.

3M 400. Similar to Kodacolor 400 in all respects. Any differences swamped by printing variations.

Film

Colour negative film is not normally used for reproduction work, as origination houses prefer to use transparencies. However, it is useful with mixed light sources as the results can be corrected in printing. If it is discovered after shooting that the light meter is broken E6 type colour reversal film can be processed as negative, allowing more scope for correction.

Saturation is a term used to describe density and strength of colour. With many films slight underexposure will increase saturation. Most professionals overrate transparency film. Kodachrome 25, for example, can be shot at 32 ASA; 64 ASA film can be shot at 80 ASA. The slightly under exposed transparency ensures saturated colour. This does not apply to negative film.

The range and availability of colour films change rapidly. There are many more names and labels than manufacturers, and the make used for a private label may be altered without the customers being informed. Any film made in Italy is a 3M product. Some films which are process paid in one country may not be so in other countries. Check with the retailer.

In theory a long exposure made in daylight should provide a picture equivalent to one made at a shorter exposure in bright light. In fact there is an area at both ends of the exposure range where film emulsions behave inconsistently.

In extremely long exposures under dim light, or extremely short ones under bright light, films can appear underexposed, while on colour films the balance of one of the three emulsions might be altered.

The effect is known as reciprocity failure, because the reciprocal relationship between exposure and light intensity does not apply.

When choosing a film stock it is necessary to select the right film for the intended picture.

Fast film (400 ASA, 27 DIN)
News and reportage photographers choose fast film for its wide 'latitude' —the ability to cope with many different light conditions. When shot at its normal rated speed it has good grain structure. It can be pushed three f-stops or more and can be processed in many types of developer, depending on the negative quality required.

Medium film (125 ASA, 22 DIN)
This range of films has a fair amount of latitude and can be pushed if required. At its normal speed rating it is best used when the light level is bright—in summer sunshine, or under studio lighting where it is used for fashion shots. Its slower speed allows the photographer to vary the f-stops to a greater degree than with fast film.

Slow film (50-25 ASA, 18-15 DIN)
These films have extremely fine grain but must be developed accurately to obtain optimum quality. Good definition is achieved either when shot in bright light or when long exposures can be made. Its ability to record a wide range of tones is useful with such subjects as architecture.

Kodak Panatomic X. 32 ASA. Extremely fine grain and sharp. Tends to be low in contrast for a film of this speed. Suitable for scientific recordings.

Kodak Plus X. 125 ASA. Good grain and definition. A reasonable general purpose film with no unusual characteristics.

Kodak Tri X. 400 ASA. Grain and definition good for so fast a film. One of the two best films in terms of grain/speed/sharpness ratios. Suitable for push-processing.

Ilford Pan F. 50 ASA. Extremely fine grain, high sharpness, and high contrast. An excellent choice of slow film for general photography.

Agfapan 100. Professional film. Almost as sharp as Agfapan 25 despite speed increase, but coarser grain.

Ilford FP 4. 125 ASA. Considered by many to be the best medium speed monochrome film for general photography.

Agfa Isopan. 125 ASA. Medium speed film for general amateur work. Acceptable quality but not the finest grain film in this group.

Ilford HP 5. 400 ASA. Similar to Tri X although not identical. Suitable for push-processing. One of the two best films in this group.

Agfapan 400. Professional film. Reasonable sharpness, considering speed but comparatively coarse grain.

Agfapan 25. Professional film. Fine grain and good definition but slower than some comparable types without excessive contrast.

Fuji Neopan 400. First of a new generation of Japanese films comparable in quality to the brand leaders. Grain/speed/sharpness ratio is almost as good as Tri X and HP5.

Kodak Recording Film 2475. 1000 ASA but generally expose at 1600 ASA. Made for surveillance work in dim light. Increased sensitivity to red. Grain comparatively coarse.

Agfaortho 25. Professional film. The only orthochromatic 35mm film generally available. Much sharper than Agfapan 25. Extremely high contrast. Good for document copying.

Kodak High Speed Infrared Film. For pictorial work use a red filter and rate at 50 ASA. Set lens by IR index. Read instructions! Coarse grain and high contrast.

Agfa Dia-Direct. 32 ASA. The only monochrome slide film. Gives excellent results with pleasant warm-black colour. Expose carefully. Requires special processing.

Film

Only push (uprate the speed) when it would be impossible to make the exposure without doing so.

Rate film slower than indicated in tungsten or low available light.

Expose for shadow details—never starve a negative film of light. Even when film is pushed, shadow detail will not improve. A flat light on a subject will enable detail to be extracted from pushed film.

Even under low light levels, an image will usually register on b/w film. If a scene is visible it can be photographed.

Orthochromatic films are blind to red and yellow. They are used for copying when no mid tones are required.

Films for general use are panchromatic—sensitive to all colours.

To see how colour tones convert to monochrome adjust the controls of a colour TV set to black and white.

ASA/DIN equivalents

ASA 16 13 DIN	**ASA 100 21 DIN**
ASA 25 15 DIN	**ASA 160 23 DIN**
ASA 50 18 DIN	**ASA 200 24 DIN**
ASA 64 19 DIN	**ASA 400 27 DIN**

Use of film

This static, brightly lit subject was shot on Kodachrome 25 for sharpness and fine grain. A polarizing filter was used to emphasise contrast.

Action shots in dim light require fast film and shutter speeds. Ektachrome 160 (tungsten) film had to be pushed one stop, resulting in increased grain.

There are two approaches to shooting black and white pictures. Either shoot a perfect negative, from which to obtain a great print, or just shoot to get the picture. Both attitudes indicate the importance of choosing the correct film.

Pan F was used **above** with plenty of controlled light; while the second method **below** relied on the latitude of FP5 fast film. In both cases the camera exposure is the first part of a process which includes development and print stages.

Film/handling

All film materials deteriorate with time—colour film stocks, especially, are affected by temperature and humidity. If changes in climatic conditions occur the speed and colour balance is likely to alter.

There are two types of colour film, those for professional and those for general usage. Professional emulsions are designed to meet the demands of serious photography, which they do only if stored properly.

Before exposure they should be kept in a refrigerator at, or below, 13°C. If intended for extremely critical colour reproduction film should be kept in a freezer at even lower temperatures, around −20°C. Before use the film must return to room temperature—slowly to avoid condensation inside the cassette. Films should be processed as soon after use as possible.

Amateur films which share the same brand name, emulsion and film speeds, are designed for less critical applications. It is assumed that they will be stored at room temperature, and the length of time between purchase and process will be longer than with professional films.

When travelling in hot countries the more stable amateur film is preferable. If chosen for professional use and kept under the same controlled conditions, the consistency of amateur film batches can still be maintained.

To protect film from humidity, sealed foil and air tight cans are used for packaging. Under humid conditions it is important that exposed film is processed as quickly as possible.

On location exposed film should be kept separate from unexposed rolls but protection is just as vital. Once the packs are opened they must then also be protected from light. Never open a film pack until it is to be loaded.

Insulated bags are available for the carriage of film, and picnic type freezer sachets can be used to maintain low temperatures. If shooting in arctic conditions these bags can be used to keep the film comparatively warm. Exceptionally cold film is likely to crack or snap. It can also cause cuts to the fingers when being handled.

Other dangers from which films must be protected are chemicals and radiation. X-ray scanners used in airport security present the most likely dangers to unprocessed film. Lead lined bags are available which offer protection, but it is worthwhile arranging for film to by-pass these X-ray devices. Carry them on your person and do not let them out of sight.

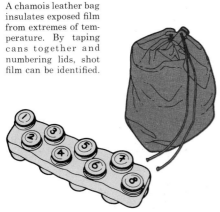

A chamois leather bag insulates exposed film from extremes of temperature. By taping cans together and numbering lids, shot film can be identified.

Use of a bulk loader enables photographers to save on the cost of film. Available in 30.5m (100ft) lengths, the film is wound onto used cassettes. Bulk loaders are essential for the special backs used with motor drive units.

Film

39

Times of day

The quality of daylight varies tremendously in different parts of the world and at different times of the year, depending on the angle of the sun in the sky. Just before the sun rises and immediately after it sets, a phenomenom known as 'green flash' often occurs, which registers on film as an unusual green tint.

Dawn has wonderful photographic properties. The light is clean, clear and cold. Many car advertising pictures are shot at this time as the modelling effect of the light is so good.

It is shadowless with little difference between the highlights and the shadows. It is well worth getting up for this time of day as many of the best pictures are taken then—when most people are still in bed.

Sunrise produces a warm, romantic light containing more red than blue tones. The sun's rays are sharper than at sunset. There is high definition on directly lit subjects but as the sun rises in the sky the quality of light changes quickly, leaving very little time to shoot.

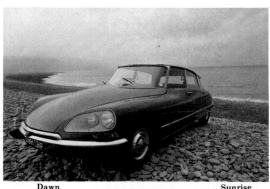

Dawn

Sunrise

Morning

Midday

Morning. The fine light which lasts until about ten o'clock is used by most professional photographers when shooting fashion or travel assignments on location. The sun climbing in a blue sky provides a clean almost colourless light. Visibility is good and shadows are clearly defined although not yet totally black.

Midday is not the best time for general photography as the sun is too directly overhead. There is a tremendous difference in exposure between shadows and highlight areas. It is usually too hazy for landscape shots, although in the winter or after rain this is not always so. In portraiture, eye sockets tend to fill in with hard shadows. This hard light with its black shadow areas can be used to advantage with a polarizing filter.

Afternoon. As the sun gets lower in the sky, modelling comes back into the landscape and the warm quality of the light is good for skin tones. This diffused light is best for backlighting. Water sparkles and the long shadows are blue.

Sunsets can never be chased, so a knowledge of where the sun is going to drop is vital. Good sunset pictures are very satisfying for any kind of photographer. Meter readings should be taken from one side of the sun and exposures should be bracketed.

Dusk. After sunset the glow which remains provides a similar light to pre-dawn, but it is softer and full of colour. As the light level decreases, longer exposures are necessary. The indirect light softens hard surfaces.

Sunset

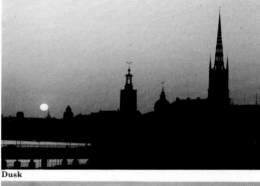

Afternoon

Dusk

Daylight

God's light is best: daylight is a raw material of photography. It has an infinite range of effects of which the serious photographer must be aware. One of the old laws of photography stated that the sun should always be on the photographer's back. This no longer applies. With modern lenses pictures can be taken wherever the sun is. Light from a window enables good interior shots to be taken if the subject is positioned with care.

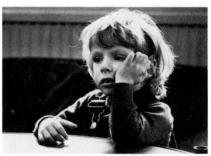

Shade is flattering to people because it is diffused, shadowless and flat. At midday, when direct light is too harsh, it can be used effectively. Be careful with colour film as this light has a blue or greenish cast.

In the morning or afternoon, a halo effect can be achieved by placing the subject between sun and camera. If indoors, the window should be above and behind. Depending on the strength of rim light required, a reflector may be used to fill the subject with light. The background can be dark or it can be allowed to flare out completely. This is a flattering light.

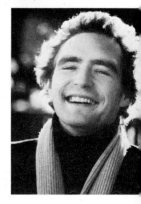

For dramatic silhouette effects, expose for the highlights, allowing the subject to become just a shape.

Light is immovable. It is important that the position of the subject, and the angle of the camera to it, is altered in relation to the light source. Give liberal exposure with negative film in this light. Never overexpose reversal film.

With backlighting there is little detail other than in the subject. For portraits, readings must be taken off the subject's nose. A good way to obtain a white background is with net, white nylon curtains, tracing paper or a sheet, which diffuse the light.

Weather

Bad weather has as dramatic an effect on the quality of light as the changing angle of the sun. Don't be afraid of the wet or cold—prepare the camera properly and shoot in conditions from which most people shelter.

Snow scenes like this Scottish landscape **above** have a blue cast which could be corrected with 81 series filters. As snow reflects light be careful with exposure.

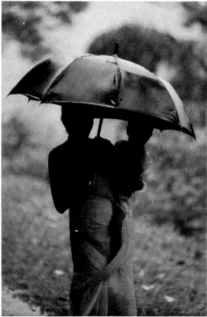

Rain makes surfaces glossy and highlights sparkle. This shot **above** was taken in Sri Lanka during the monsoon season.

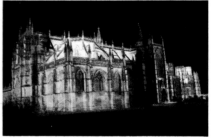

After sunset, daylight or tungsten film can be used on artificially lit subjects. Tungsten film used **above** gave correct colour of this floodlit Portuguese cathedral.

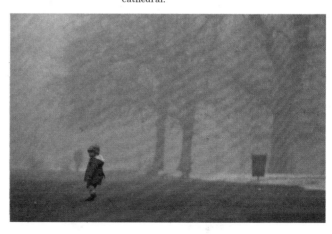

Fog gives muted colours, allowing key images to be picked out from the background, as in this London park scene **right**. Exposures should be bracketed.

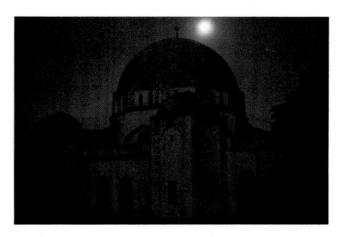

One of the eerie effects of shooting by moonlight is reciprocity failure caused by long exposures **left**—here it produces a purple cast on a Zanzibar mosque. On exposures over 10 secs, movement of the moon will also be registered.

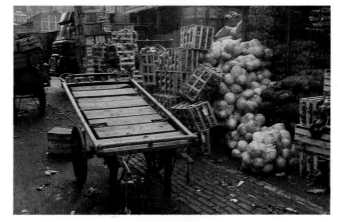

After rain the clearing sky provides a clean, soft light as if the air has been washed, as in this shot **right** of London's old Covent Garden market.

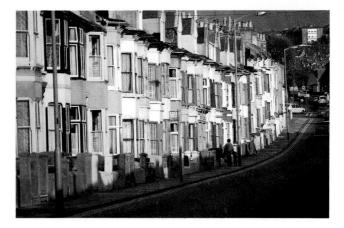

Gaps in storm clouds let through bursts of clean light with strong modelling effect, which is often observed in coastal areas. This street scene **left** is in Brighton, England.

Filters, b/w

The use of filters can be divided into three categories; black and white filtration; colour compensation filtration, and special effects.

Each involves different principles. Most amateurs consider filtration to be a total mystery which they cannot hope to understand. In fact, the use of filters is quite simple once the basic knowledge is gained of how they work.

In black and white photography there is just one basic principle to be understood. Filters lighten their own colour (and those in that area of the spectrum) and darken the complementary (opposite) colour.

A yellow filter, for example, will hold the tone in a blue sky, while giving separation from the clouds. An orange filter will darken the sky, and red will have a spectacular effect on the blue, turning it almost black in contrast to bright white clouds. Any element of red in the picture would lighten with each filter. Care should be taken with exposure when filters

are used with black and white because they increase the contrast in the negative. Remember to expose for the shadows (especially in landscapes) otherwise the picture will include only highlight detail, with none in the shadows.

Professionals often use filters on black and white film to increase the tonal separation for press reproduction. If a photograph was to be taken of an orange car against a background of blue sea the tone of the car and the sea would appear too similar for the car to stand out sufficiently. With the use of a yellow filter the car can be lightened and the sea darkened without any loss of detail.

In black and white portraiture an orange filter is useful for improving spotty skin by lightening the tone of the spots. Smooth white skin tones are achieved with red filters. Polarizing filters are used to control reflections and also as neutral density filters in b/w photography.

Filters for use with black and white films in daylight

Subject	Effect	Filter
Blue sky	Natural	No 8 Yellow
	Darkened	No 15 Orange
	Dark	No 25 Red
	Almost black	No 29 Deep Red
	Day for night	No 25 Red plus Polarizing
Seascape with blue sky	Natural	No 8 Yellow
	Dark water	No 15 Orange
Sunsets	Natural	No 8 Yellow or None.
	Increased contrast	No 15 Orange or No 25 Red
Distant landscapes	Natural	No 8 Yellow
	Haze reduction	No 15 Orange
	Greater reduction of haze	No 25 Red or No 29 Deep Red
Prominent Foliage	Natural	No 8 Yellow or No 11 Yellow-Green
	Light	No 58 Green
Outdoor portraiture Sky background	Natural	No 11 Yellow-Green No 8 Yellow or Polarizing
Flowers and foliage	Natural	No 8 Yellow or No 11 Yellow-Green
Red and orange colours	Lighten for greater detail	No 25 Red
Dark blue and purple colours	Lighten for greater detail	None or No 47 Blue
Plant foliage	Lighten for greater detail	No 58 Green
Stone, Wood, Sand, Snow etc, in sunlight, blue sky	Natural	No 8 Yellow
	Increased texture	No 15 Orange or No 25 Red

A 15 Orange filter gives increased contrast, separating areas of similar tone in the sky and the water. It is more effective than the yellow types sold to non-professionals as 'cloud filters'.

A 25 Red can be used in portraiture to make skin tones smooth and white. Backgrounds are also darkened, giving prominence to the subject.

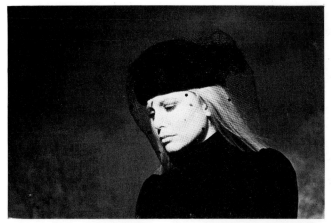

The most dramatic filter for b/w use is the 29 Red which turns the sky almost black, while the clouds remain white. As the blue is filtered out, the effect of haze is also reduced.

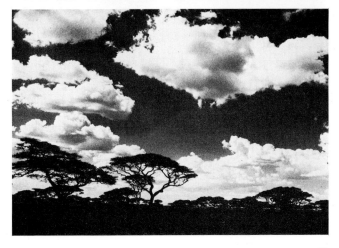

Filters/colour

Magenta
Absorbs Green

Green
Absorbs Blue & Red

Cyan
Absorbs Red

Red
Absorbs Blue & Green

Yellow
Absorbs Blue

Blue
Absorbs Red & Green.

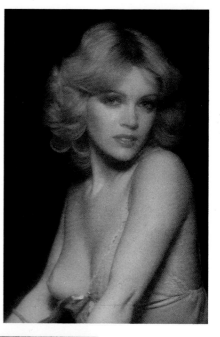

By using an 81EF **above** the skin tones are warmed. A Softar filter softens the overall effect. To cut out unpleasant green cast from the trees **left** a 10 Magenta was used. Two uses of polarizing filters are illustrated below. Reflections are cut out **left** with the effect of seeing through the water. Used on sky **right** clouds are whitened and blue made darker.

Colour compensating filters are used to change the colour temperature of the light falling on the subject. Their use is limited to colour reversal film.

Compensating filters increase their own colour in the picture by filtering out the complementary colours. When shooting a portrait under the green leaves of a tree, skin tones will take on an unpleasant green cast. By using a 10 Magenta (the complementary colour to green) the skin tone will be brought back to normal without upsetting the greens of the background.

When shooting colour portraits, beauty, glamour or nude shots, where skin tones are important, they can be enhanced by use of the 81 series filters. These add warmth to skin tones, giving a richer, suntanned appearance. Care should be taken when shooting on Agfa film stock which is more brown in tone then the E6 process Ektachrome films. The 81 series are useful on dull overcast days as they increase the saturation of all colours in the shot.

The 1A, and 2A filters are also useful 'cosmetic' filters—like the 81 they warm and intensify colours but with a pink hue, rather than the brownish tint of the 81 series.

Other filters correct the colour temperature of light to match the film being used. An 80B is used to balance daylight film for tungsten illumination, and 85B enables tungsten film to be used in daylight.

The polarizing filters are essential for the serious colour photographer. They are used to hold saturation in directly lit subjects; for controlling reflective surfaces such as metal, glass and water; and for penetrating the reflections on transparent materials. These filters act in the same way as Polaroid sun glasses—which can also be used over the lens if there is no filter available.

Polarizing filters are most often used to bring out the blue sky and cloud effects—which the red filters do on b/w film. They are adjustable. When there is a chance of obtaining a good shot, take several frames, each with a different degree of polarization. They are not effective on backlit subjects, sunsets or sunrises. Polarizers hold highlight detail and reproduce saturated 'hard edge' colours on the beach, in sunny snow scenes or anywhere there is an enormous amount of light bouncing around. When used with Kodachrome 25 and exposures are made for the highlights the shadows will drop out to black, making a simple graphic effect.

UV (Ultra Violet) and L39 filters, much used in the past, have virtually no effect on modern coated lenses.

Filtration for fluorescent and mixed light sources is discussed on p51.

Film type	Type of fluorescent lamp (written on tube)*					
	Daylight	White	Warm white	Warm white Deluxe	Cool white	Cool white Deluxe
Daylight	40M + 30Y +1 stop	20C + 30M +1 stop	40C + 40M +1⅓ stop	60C + 30M +1⅔ stop	30M +⅔ stop	30C + 20M +1 stop
Tungsten and Type L	85B + 30M +10Y +1⅔ stop	40M + 40Y +1 stop	30M + 20Y +1 stop	10Y +⅓ stop	50M + 60Y +1⅓ stop	10M + 30Y +⅔ stop
Type A	85 +30M +10Y +1⅔ stop	40M + 30Y +1 stop	30M + 10Y +1 stop	None	50M + 50Y +1½ stop	10M + 20Y +⅔ stop
*** Beware—colour balance alters with age**						

Hand flash

An effect of light is often what stimulates a photographer to take a picture. So often the effect is lost because of the lighting introduced. The first question a photographer should ask himself is whether it is necessary to introduce a new light source or whether a tripod and long exposure would be better to retain the mood of the picture.

Many photographers automatically turn to flash because the subject is too dark to shoot with a hand held camera. An excellent method of coping with a scene which is beautifully lit, but at too low a level, is to replace the light bulbs with ones of a higher wattage. This retains the quality of the existing light while providing a usable meter reading.

Often additional light really is necessary, and it is those occasions which make a portable flash unit an essential piece of equipment. There are four basic types; the two alkaline battery unit; the sophisticated four battery type; the all-in-one nickel cadmium unit; and the separate power pack and head. A common and frustrating fault with the big units is that there is no indication of how much power is left in the pack.

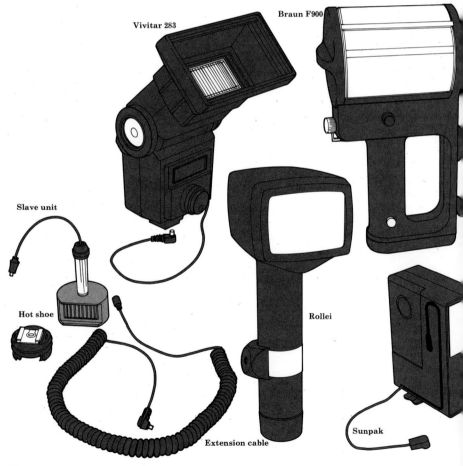

Vivitar 283

Braun F900

Slave unit

Hot shoe

Rollei

Extension cable

Sunpak

Mixed light sources

Shooting colour film under mixed light sources is a nightmare for any photographer. Colour temperature meters are useful under such conditions, but they are expensive.

When faced with daylight, tungsten and fluorescent light in the same shot, be methodical. Use a hand meter to find out which is the dominant light source. Turn out the artificial light and meter the daylight. Then turn on the tungsten and measure it, and do the same with the fluorescent. If the daylight is the dominant light source, choose daylight film. (Any tungsten light will only warm the colour. New E6 films cope well with this combination.)

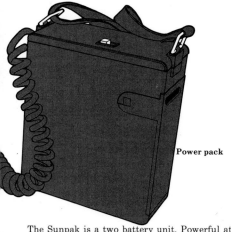

Power pack

The Sunpak is a two battery unit. Powerful at close range, but falls off rapidly. Often used as a second 'fill' light. It is cheap, reliable and useful. Vivitar 283 is a four battery flash. An automatic sensor calculates correct amount of light. Head tilts for bounced flash, and includes filters. Although slow to charge, it is a good piece of equipment. The Rollei is a nickel cadmium unit with automatic facility. It has a fast recycle time providing four shots per second on automatic. Good for press work with a motor drive. Braun F900 is rechargeable lead, or nickel cadmium battery pack with separate head. Powerful all purpose unit with computer eye. Flashes at speeds up to 1/20,000 second. Supplies hundreds, even thousands of flashes, on one charge.

Ignore the fluorescent light if its influence is slight—the warmth of the tungsten light will help to balance it. If the fluorescent is substantial, balance it out with a 10M filter on the camera.

If the tungsten light is the dominant source choose tungsten film. The daylight will then introduce a blue cast and the fluorescent a green cast, depending on how much of each is present. (Calculate this from meter readings.) Colour is usually considered to be better warm than cold. It can be warmed up with a 10M and 81B filter.

If fluorescent is the dominant light source consult the table on p49. Fluorescent makes a good black and white light but it can produce disastrous colour balance if the photographer is not aware of the type of tube he is shooting under—each produce a different colour balance.

When shooting a foreground figure in a large fluorescent lit room a 30M filter placed on the camera will correct the light. Although the room will now be correctly colour balanced the foreground will be magenta. To overcome this take an exposure reading of the room, e.g. 1/8 sec at f8 (64 ASA) and then light the foreground figure with the flash filtered with a 30 Green and balanced at f8. This brings the figure back to normal while the room remains corrected.

Fluorescent lights are most often encountered in factories, or other buildings with high ceilings, where identification may be difficult. To find out what tubes are fitted to the lights, ask the janitor or the person who orders the replacements. Large sheets of fluorescent correcting gelatine, which are made for the movie industry, can be stuck over the tubes, balancing the light to daylight. If the balance is too difficult to correct use colour negative film, which can be corrected at the print stage.

Lighting

Hand flash/2

Use of a single hand flash against a plain background. For most pictures the Vivitar 283 flash was diffused with a double layer of tissue paper. It is important that this does not obscure the photoelectric eye. The 'eye' can be over or under exposed by changing the ASA dial on the flash. The level of flash is automatically calculated from the surface which the light hits. Correct exposure is achieved when the distance from the flash to the subject is the same as the distance from camera to subject.

Flash mounted on camera hot shoe **above** with no diffuser gives hard light. Shadows are dark, nose is burnt out. With colour film the eyes go red. This is a typically boring 'mug shot'.

Flash mounted on camera, shot from an angle to subject **top right**. Light is too hard, with too many shadows and no atmosphere. A common type of fault.

To lose the hard shadows a long exposure is made **right** with camera on tripod ($\frac{1}{4}$ sec exposure plus flash). No hard shadows. Room atmosphere maintained.

'Painting with light' involves leaving the shutter open and firing flashes on every area which requires lighting. Particularly used on interiors shot to preserve atmosphere. Cathedrals and tombs, with no illumination in the corners, are the most obvious types of location to 'paint'. In total darkness leave the shutter open but if there is some light cover the lens between flashes. For bright areas give two flashes; for shadows, one flash on half power.

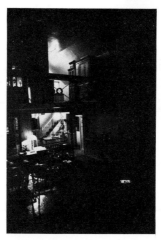

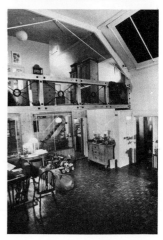

Flash at arm's length above camera on extension cable. More modelling, less contrast makes this a more flattering light. No 'red eye' with colour.

Flash at 45° from camera, held about 1ft above height of model. Use another lamp to test positioning of flash. Nose shadow should join with cheek shadow.

Flash at 90° to the model about 1ft in front. Face height. Be careful not to fill in the eye shadow. Again, check with another light source.

Flash held 1 or 2ft above model, aimed directly at her face. Subject should look upwards to achieve flattering chin line.

Flash aimed from the feet of the photographer. Not a flattering light, but gives a spooky effect.

Bounced off a side wall. A soft flattering light. Electric eye picks up off subject. Over expose one stop to give shadow detail with b/w film.

Top bounce is soft light but not considered suitable for women. Overexpose one stop otherwise bags under eyes become prominent.

Flash behind the head against a dark background such as a curtain. Overexpose three stops. Use reflector to fill face.

Silhouette. Flash is directly behind the model, aimed at wall. Level of exposure governs whiteness of wall. Overexpose at least one stop.

Lighting

Lighting

There are two types of artificial light available to the photographer: tungsten and electronic flash. Tungsten lamps, which remain on all the time, allow you to see what effects are being created. When shooting colour film, artificial (type B) stock must be used. Quartz bulbs are in the same colour temperature range as tungsten bulbs, although they are much brighter. Even so, many lamps are needed to simulate the effect of flash. Quartz lamps are good to use when many different sources of illumination are needed as they give localized, controllable light.

Electronic flash runs off domestic power or generators and provides a light balanced to within the range of daylight (3200–3600° Kelvin). In its naked state it is hard, clear and intense. Professional photographers have perfected the use of high wattage flash to gain maximum picture quality in order to satisfy the requirements of the advertising and fashion industries. Most studio photographers use large format, or sheet film, cameras, but the principles of lighting apply whatever camera is used. The larger the area of a light source the better the quality of the light, so it is either bounced back off an umbrella or flat reflector, or put through a diffuser. Well diffused light comes closest to the 'north light' preferred by painters.

a b

1. (a) Single direct light source picks out the features of the face. Keep the light higher than the head and don't let the eye sockets fill in. Emphasises the eyes and moulding of the face. A good light for men. (b) Same set-up but the light is reflected off black, softening the features but retaining the roundness of the face. The eyes are still strong. A good general portrait light.

2. The same lighting set-up for both pictures. Having created a lighting set-up, walk round to see the effect of light from other angles. This set-up is based on old Hollywood b/w film lighting. Their film stock was so slow they had to light everywhere. The spot on the back of the model holds him off the background. Study old Hollywood film stills for their use of lighting.

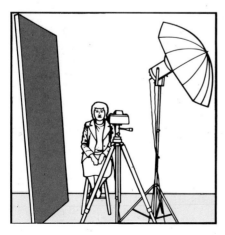

Complicated set-up good for full length fashion shots. Textures stand out. Used for "off-the-peg" suits. Angle of camera to model determines how much light is on the model.

Spot light gives theatrical mood, emphasising the cheek bones and narrowing the face. Good for men or women. Flattering for a rounded or fat face. Use with care. It is too harsh for bad skin.

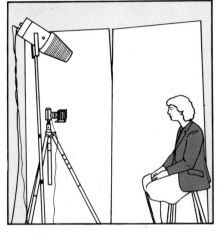

Soft lighting for still life of rounded objects and flattering light for nudes. Often used by baby food manufacturers for mother and child pictures on pack shots.

A beauty light. Black reflectors, as close as possible to model's face, hollow the cheeks. The model looks up a little so the whole plane of the face is evenly lit. Good with soft focus filter.

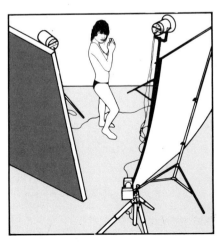

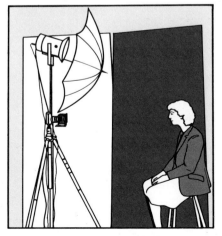

Lighting

Lighting

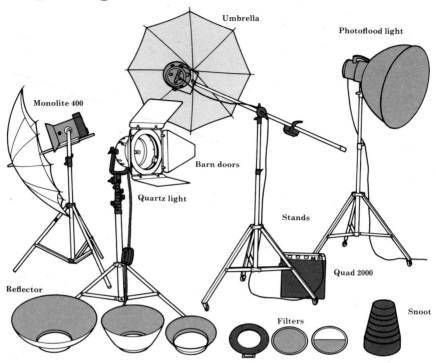

Umbrella

Photoflood light

Monolite 400

Barn doors

Quartz light

Stands

Reflector

Quad 2000

Filters

Snoot

Bowen's equipment is used here to illustrate the range of flash equipment available. The **Monolite 400** head is self contained. All the power selection, sync, slave and model light controls are in the head which plugs straight into the mains supply. It has enough power for general 35mm photography, but it is much better to use two heads wherever possible. The **Quad 2000** pack. Up to four heads can be run off one pack. All the controls, except the model lamp, are on the pack. Various types of heads can be run off the pack. Several packs can be linked together to power one light. Not illustrated are the special studio lights—the striplight, fish fryer, and swimming pool. These need a lot of power and are generally used with large format studio cameras. **Umbrellas** are used to soften and spread the light. The gold one gives the light a warming cast which is ideal for skin tones (equivalent to an 81B filter). The **snoots, barn doors** and **reflectors** are used to control the spread of the light. Dichroic filters are used on quartz lights to correct to daylight, and skrims to soften the light. Make sure the **stands** are strong. The pack should be kept off wet surfaces and concrete. If in doubt cover the base of the pack in rubber or stand it in a plastic bowl. What can be done with the flash light can be done with either quartz or tungsten. The only difference in the resulting photograph is that the speed of flash light makes the picture sharper. **Quartz** lights are mainly used in the film industry. The portable kits on the market are useful as secondary lights, in conjunction with flash, for industrial and location photography. **Photoflood** tungsten lights are still favoured by many photographers who consider the softness to be ideal for portraiture.

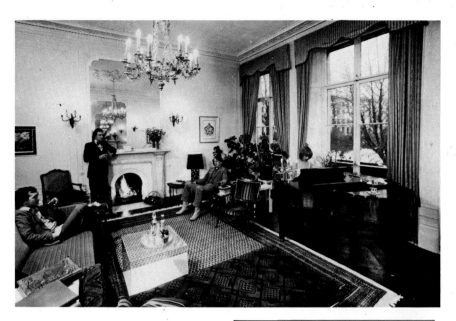

When using electronic flash as a 'fill' light on a room shot such as this be careful not to overfill. If the reading of the naturally lit room is f8 at a given shutter speed, build up the fill flash to get a reading of f5.6 (one stop less). If the flash is set at the same level as the main light source the shot will be overlit.

As the ceiling appeared in the picture it could not be lit. Bouncing light off it would produce uneven patches.

The spread of the lights is indicated by the lines in the diagram. The top light (1) could be strong. It gave good moulding to the furniture and was masked off the camera with a French flag. The light behind the camera (2) was also direct but diffused with tracing paper. It is used to balance the daylight. Another light (3) was illuminating the back wall, which only appeared as a reflection in the mirror. Without this the mirror appeared as a dark square and the picture lacked depth. A tiny hand flash (4) was taped to the piano to boost the candlelight

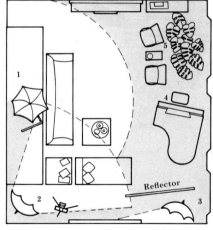

effect. Several layers of tracing paper were used to keep the power down. Another baby flash (5) was pointed directly under the leaves to give them life. Both the hand flashes were fired by slaves.

The silver foil reflector was used to pick up light from (1) and kick it back into the shadow under the piano to bring out the floor texture.

Lighting

57

Backgrounds

Good photography requires the rigorous searching out not only of the beautiful but also of the ugly. What separates the good photographer from the snap-shooter is the ability to eliminate ugliness from pictures. Be aware of such things as lampposts which appear to grow out of the heads of models, and change position to avoid them. Get into the habit of using the preview button: what is unnoticeable when the lens is wide open may appear terribly distracting when the lens is stopped down. Once the ugliness is removed from backgrounds the beautiful will become apparent.

On location

When shooting portraits outdoors a wide open aperture keeps the background out of focus. This is especially effective on long lenses where the depth of field is naturally limited. Mirror lenses produce their own distinctive doughnut shapes on out of focus backgrounds. On location choose plain, simple textures which enhance the subject. Sand, water, pebbles and brick walls make good neutral backgrounds.

The sky can be used as a good background for some shots, but be careful with the exposure readings at close range, otherwise the pictures will be underexposed. A white sheet hung on a clothes line makes a fine background when backlit. A white reflector should then be used to fill in the subject. In shooting colour portraits a gold fill gives more pleasant skin tones.

Interiors

To obtain a large continuous background area with no floor edge, professionals use Colorama paper. This comes in large rolls, 1.3m (4′ 6″) to 3.6m (12′) wide by 12, 25 or 50 metres in

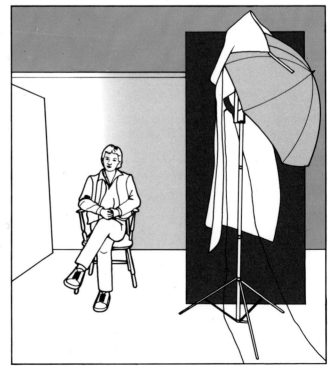

To obtain the half and half effect a single light source is used. The light is well diffused. It lights the right side of the face but is masked from the right side background by a screen.

On the left side a white reflector bounces light onto the background but not onto the left side of the face. By experimenting with the angles of screen and reflector and framing the subject tightly the degree of contrast can be altered.

length, and is available in an enormous range of colours.

Black velvet absorbs light and is excellent for obtaining solid backgrounds when front lighting still life or people, especially for stroboscopic multiple image pictures. The velvet should be of good quality and thick. A transparency light box makes a good 'white out' and backlit background for small still life subjects. Place reflectors all around the camera for a beautiful rounded light.

Pressure pack (aerosol) paint spray can be used to take the flatness out of plain coloured backgrounds. Combinations of colour applied in short bursts blend together.

Projecting slides onto a screen or paper background and then lighting the foreground subject can be effective.

Plastic laminate makes a good continuous background for still life, as it

can be bent into a curve and can be wiped dry. This is especially useful when shooting liquids or food which could spill and demand a new set up each time the paper got wet. Large rolls of white plastic are available for this type of use. Opaque acrylic makes a fine background material for obtaining a flat, bottom light.

Photographers often make large out-of-focus prints of scenes, in front of which they pose their models. This can give the effect of an outdoor location in the studio. Projection screens can be used effectively as portrait backgrounds, as can large white and black blinds, which are also easy to store.

Collect beautiful things, such as pieces of wood, marble or glass to use when the right subject appears. These can add an extra dimension to still life shots.

Studio background **right** is spray painted paper. It is possible to have either an overall white background or a dark background with the same set-up **below**. A heavily diffused single light above the subject gives an overall white. By taking the background farther back the subject sits in a pool of light against black. Plenty of light is bounced into the shadows.

Tripods

The ideal tripod would be so heavy as to be immovable. As a tripod is an essential part of a photographer's kit, any type is something of a compromise. Although they must be portable the lightest tripods are too flimsy to be of use. Extended legs should not flex under pressure, nor should leg locks be able to slip. If the head wobbles when a camera is mounted the tripod is useless. It should be tested for any movement with the longest and heaviest lens available.

Even if it is possible to hand hold a camera, a tripod allows for extra precision in composition, and enables the photographer to leave the camera in position while he moves around.

Tripods are indispensable when shooting with long focal length lenses. As the shutter speed gets slower or the focal length of the lens increases, a tripod becomes more necessary.

As a rough guide, use a tripod when shooting with a 500mm lens at less than 1/500 second; or with a 200mm lens at less than 1/200 second.

The best tripods have a central

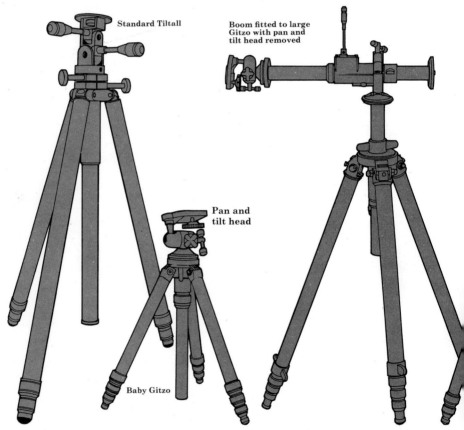

Standard Tiltall

Boom fitted to large Gitzo with pan and tilt head removed

Pan and tilt head

Baby Gitzo

Standard size tripods such as the Tiltall, Gitzo or Linhof are for studio or location use, although they are too heavy to be carried around all day by one person with a bag full of equipment. Extendible to a height of 2·1m (7ft) with a pan and tilt head, they can also be fitted with a boom. With the centre column reversed, the camera can be held close to the ground.

The Baby Gitzo is an outstanding portable tripod which can be extended to eye level. With

column which is adjustable for height and reversible. They also feature heads with pan and tilt movement. The bottoms of the legs are fitted with rubber caps for general use, which can be detached to expose spikes for sticking into soft ground. For surfaces such as sand, 'snow shoe' adaptors can be fitted to the feet.

The most important tripod for the 35mm photographer is one that can be packed into a suitcase. It should be strong as well as compact with both low angle and eye level capability.

Spirit levels are used when the picture has to be perfectly square, e.g. shooting architecture, paintings or documents. They are useful in close-up work when it is hard to square up a picture, and to get horizons flat when framing in a wide angle lens. Some tripods have built-in spirit levels and others are available which fit into the camera hot shoe.

Central column reversed for low level shooting

Gitzo monopod

Leitz table top tripod

The Leitz table top unit is a miniature tripod, with ball and socket head, small enough to be used almost anywhere. It is extremely solid, sometimes more so than a heavier stand. Some other makes are less sturdy. When folded, table top tripods are less than 0.3m (1ft) in length.

the ball and socket head removed it fits easily into a suitcase, or it can be carried between the handles of a camera case.

Monopods are used in confined spaces, where tripod legs would get in people's way.

When shooting without a tripod, a table top stand can be used to steady the camera against any available surface. If there is no wall or table at hand the camera can be braced against the photographer's chest.

Tripods

Tripods/clamps

There are many occasions when a photographer needs to be mobile and can only carry a small tripod, but by also carrying a clamp or rest of some kind, he can ensure that he maintains a rigid camera at all times.

Even when a camera is mounted on a tripod or a clamp and slow shutter speeds are being employed, it is advisable to lock the mirror up because the mirror return action can cause the camera to shake.

When more than one camera is used to take shots of the same subject, clamps enable one tripod to hold several bodies. Use this method **right** for a non-repeatable shot, or if the action is moving towards the camera.

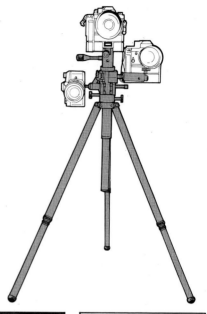

Bean bags provide a solid base for a camera **below** and are useful for low level shooting, or when a ledge such as a car window sill is being used as a rest. On occasion a soft camera bag can be used to the same effect.

Monopods are suited to location work when a tripod would prove too bulky or slow to use. By bracing it aginst his body **below** the photographer becomes a part of the stand, his two legs and the monopod making an effective tripod. When kneeling or sitting the knee provides additional support. Slipping the right arm through the neck strap provides extra rigidity.

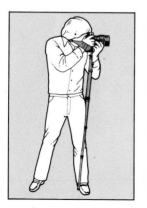
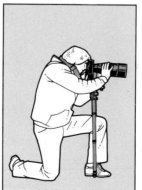
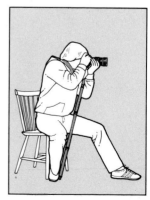

Clamps can be used to place cameras in inaccessible corners. If fixed to solid objects they are sometimes even preferable to a tripod. With a small ball and socket camera mount, most types of lighting or woodwork clamps can be adapted to hold a camera. The tripod screw thread on most cameras is $\frac{1}{4}''$ Whitworth.

Clamps can be attached to most objects and, by using glazier's vacuum suckers, they can even be mounted onto plate glass windows. They must be strong, however. Be wary of anything with plastic tightening screws.

Use of clamps allows a photographer to get shots which would otherwise be impossible. Attached to an expanding pole, for example, a camera can be placed high up in the corner of a room. If the presence of the photographer is likely to be disruptive, cameras can be positioned prior to shooting and operated by cable release or electronic remote controls.

With remote releases, auto winds and automatic exposure control, clamps open up new opportunities for picture taking. Such methods do, however, require an exact knowledge of the desired shot.

Spring grip clamp fixed to a plank of wood

Stanley strap clamp fixed to a tree trunk.

A C-Clamp attached to the top of a ladder

Another C-clamp screwed to a tripod leg

A lighting boom with camera mounting attachment **below** can be used to set up shots from positions which the photographer cannot reach. It makes a useful arrangement for shooting out of windows or from the corners of high-ceilinged rooms.

By maintaining tension on a piece of string, wrapped under the feet and around the top of the lens, camera shake can be minimized.

When using a tripod in high wind the same principle can be employed. Two camera straps joined together make a foot hold on which to exert downward pressure. A bag of stones hung from the tripod head also helps stability.

Tripods

63

Cases/1

Selecting just one bag that will suit the requirements of a photographer has always been a problem. There are basically three types, each with its own application. All have to protect expensive equipment, so it is a false economy to skimp on the price.

When packing get into the habit of knowing exactly where each piece of equipment is—it will probably be needed in a hurry. Never pack the bag too full—carrying a heavy load all day will absorb most of a photographer's energy. Quite a lot of equipment can be distributed about the person. A bag should have a grab handle as well as a shoulder strap, which should be non-slip. Never leave any camera case in the sun—it will heat up like an oven doing neither the film nor the camera any good.

Soft bags, such as the canvas fishing type **above**, are the most useful for working out of on the move. They hold a lot of gear and the top opening fold-over flaps allow easy access to the equipment. The top and bottom should be waterproof. Carried over the shoulder, soft bags leave the hands free. They are good to use in crowds because they mould around the photographer and don't hurt people, furniture or paintwork, and they are easy to run with. Although they are soft they do protect equipment when packed carefully. Corners should be packed with lens cases and partitions can be reinforced with Karrimat (camper's foam sleeping roll).

The traditional photographer's case is the leather 'box' type **below**. They come in many sizes and offer good protection. Most are fitted with built-in partitions which can be tailored to individual systems. Airlines classify them as hand baggage. The insulating properties of leather make these bags good for travelling although, in extremely cold weather, leather will freeze and stick to cold surfaces. They carry a fair amount and are useful as a stand-by carrying case when travelling with lights or extra equipment.

Optimum dimensions for hand baggage under aircraft seats is (229mm) (9″) x (610mm) (24″). Some have more room, others less, depending on aircraft.

Metal cases provide the best protection for transporting equipment in all weathers, although they are slower to work out of than shoulder bags. The best types are made by Rox, Halliburton and Samcine. The silver finish reflects the sun, while black ones absorb heat. Most are fitted with built-in locks. Their solid construction allows them to be used to stand or sit on — a useful aid on some assignments.

Cases can either be fitted with partitions that are held in place by Velcro, or solid foam that is cut into a shape matching each item. An alternative to using a hot knife is to freeze the foam in a freezer before cutting. Cheaper cases use open cell foam, which is softer and does not offer as much protection as closed cell.

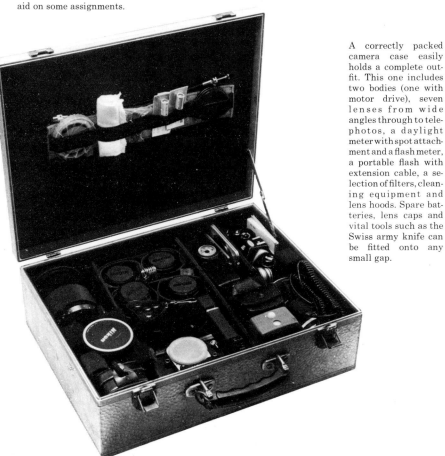

A correctly packed camera case easily holds a complete outfit. This one includes two bodies (one with motor drive), seven lenses from wide angles through to telephotos, a daylight meter with spot attachment and a flash meter, a portable flash with extension cable, a selection of filters, cleaning equipment and lens hoods. Spare batteries, lens caps and vital tools such as the Swiss army knife can be fitted onto any small gap.

Accessories

Cases/2

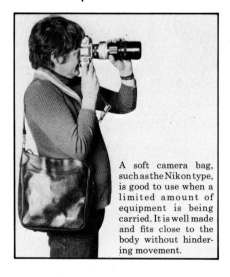

A soft camera bag, such as the Nikon type, is good to use when a limited amount of equipment is being carried. It is well made and fits close to the body without hindering movement.

Ever ready cases are more popular with amateurs than professionals. Available in soft or hard versions, they do provide protection, especially if no other type of case or camera bag is used. They are useful in dusty conditions, but the size precludes their use with telephoto lenses.

The inflatable air bags give good protection to the contents and come in a variety of sizes, including individual lens bags. When deflated they fold up to pocket size. Inflatable bags are especially useful to protect the contents during rough car rides or when sailing.

For the carriage and protection of lenses a variety of cases are made. The transparent plastic types are actually display cases in which some lenses are sold. They can be used to keep lenses in the studio or safe, but are not suited to other uses. The hard leather tubes are the best lens cases to

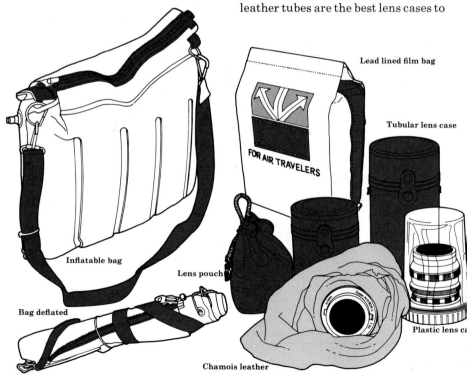

Lead lined film bag

FOR AIR TRAVELERS

Tubular lens case

Inflatable bag

Lens pouch

Bag deflated

Plastic lens ca

Chamois leather

use with a soft camera bag. They can be used to carry a selection of filters which are screwed together into a tube. Chamois leather can either be made into a pouch or used loose. It is the ideal material as it insulates and can be used to clean lenses. It is also washable. Some type of lens pouch is vital to keep metal from rubbing against metal. The felt lining on cheap pouches tends to come off easily and can clog the camera. Buy the best.

Lead lined travellers' bags offer some protection from X-rays but security crews often turn up the power of the machines until they can see what it is inside. This obviously defeats the purpose. It is best to carry film on the person.

The Kodak insulating bag is primarily for carrying film but it is also useful for storing cameras in hot cars or on the beach. Use freezer sachets to maintain low temperature.

Fishing pouches can be used to carry small items, such as sync units, slaves or filters. They are usually much cheaper than equivalent photographic pouches.

When fitted with end pieces, a length of plastic drainpipe can be used to carry rolls of paper or material. A golf bag is a perfect case for stands and tripods. On some airlines golf bags don't count against the baggage allowance.

Insulated Kodak bag

Fisherman's pouches

Ever ready cases

Motor drives

Releases

Cable releases are used when making long exposures with camera on tripod, eliminating camera shake caused by human contact. Double ones work two cameras.

Soft release buttons are left permanently on camera by some photographers. Release button is more accessable and the action is easier on slow shutter speeds. Air release cable is 30m long. Used for single shots and can be fitted to any make of camera.

Long releases used with motor drives: (a) plugs into trigger head can be operated from 3m away; (b) connects to motor drive. Plug can be removed and wired to transmitter or underwater housing.

Double release

Cable release

Soft release button

Air release

a

b

Pistol grip (c) with connection to motor drive, useful when shooting a subject with heavy lenses. Connection from pistol grip to ordinary body (d) for single shots. Be careful using pistol grips, especially shooting action with a fast shutter. There is a lot of play from trigger to release button.

d

c

An automatic winder transports the film and re-sets the shutter automatically. With it several frames can be exposed per second.

A motor drive is a more sophisticated piece of equipment. It can shoot more frames per second; has a fast automatic rewind, unlike the smaller units, and allows multiple exposures to be made. Onto this unit remote, radio control and data back equipment is fitted. Motor drives are used extensively for sport, news, surveillance and sequential photography.

It is a popular belief that professionals use the motor drive to shoot hundreds of frames of a subject, out of which they must be able to select one

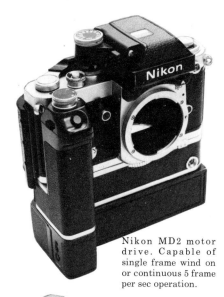

Nikon MD2 motor drive. Capable of single frame wind on or continuous 5 frame per sec operation.

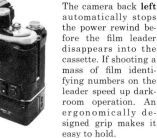

The camera back **left** automatically stops the power rewind before the film leader disappears into the cassette. If shooting a mass of film identifying numbers on the leader speed up darkroom operation. An ergonomically designed grip makes it easy to hold.

good shot. This is not the point of the equipment.

The singularly most important feature of motor drives is the automatic film transport. The eye does not have to leave the viewfinder when the camera is wound on. It can concentrate solely on the image in the finder. But remember, with fast action an image which is seen in the finder represents a missed picture. The ability to anticipate the action has to be just as keen, whether or not a motor drive is being used. Shooting indiscriminately at four frames per second is not a guarantee of getting the picture. Follow the action with the eye rather than rely on shutter speeds of 1/2000 second to capture motion.

Motorized winders make it possible to bracket exposures incredibly quickly. However, they are susceptible to damp and dust so keep them well protected and maintained.

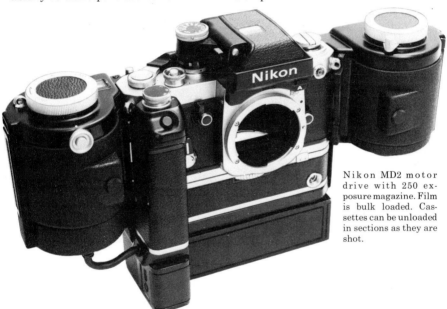

Nikon MD2 motor drive with 250 exposure magazine. Film is bulk loaded. Cassettes can be unloaded in sections as they are shot.

Modulite remote control unit **right** is a receiver mounted on the camera and triggered by a hand unit which emits an infra-red light beam. In a confined space the beam can be bounced off walls or around corners. Two cameras can be triggered using one control unit. This allows the photographer to be in three places at once.

A more sophisticated remote control is the radio transmitter/receiver set. It has a range of 0.7 km. Three cameras can be used, and it is designed to be interference free at all times. It has many uses such as wildlife, sport or news coverage. The camera can be pre-positioned hours before an event, such as a state occasion, in a location which would be inaccessible at the time of the shot.

Accessories

Rubber lens hoods are more convenient than metal ones when shooting in crowded areas where cameras get jostled. A rigid (metal) hood increases the length of the lens, thereby putting more strain on the lens mount. Rubber types are washable, they do not get hot and don't scratch—scratches can cause flare.

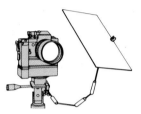

French flag is a black felt covered piece of aluminium on a multi-jointed arm. Useful with wide aperture (or wide angle) lenses as it shades the light source from the lens.

Rubber eye caps help cut out light from behind the photographer's head which interferes with the image seen in the finder. Eyelashes often create shadows in the viewfinder.

Filter holders. There are three basic types. Kodak make a cheap plastic one which fits any lens. It holds glass or gelatine filters. The Nikon type includes a built-in lens hood. Hasselblad, or the cheaper Ambico models, work on most lenses. They are bellows type and can hold filters on the front and rear of the unit. They improve performance on long lenses as they cut out unwanted flare.

Many types of **filters** are available. Cokin are French and made of solid gelatine, and their range of over 200 types includes special effects. Their screw-on holders allow filters to be partially inserted so covering only a section of the image. Wratten filters are flimsy gelatine. They come in every type for b/w and colour correction use. Can fit any holder and portable flash units. Glass filters are made by many companies. They are the best optical quality and should be chosen when a limited range is carried. Polaroids should always be glass. Cheap ones turn deep blues to greenish on E6 transparency film. Buy the best that can be afforded.

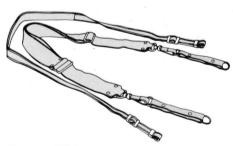

Straps. Wide straps are best as they disperse the weight of the camera. There is less strain on the shoulder when heavy motor drives or long lenses are fitted. They have long lugs with dog collar fittings. Good ones have buckles each side which do not settle on the shoulder and dig into the neck. Rolled up, they can be used to fill out corners of the camera bag. Nylon straps with non-slip padded shoulder pieces fix directly onto the camera. There are no buckles to catch in the hair. Good to use on lightweight electronic cameras. Always buy good quality straps.

Spirit levels are available which fit directly onto the hot shoe. They are vital for any application which requires a level camera.

A **compass** is well worth carrying, in order to know where the sun will be.

Panorama tripod head allows the camera to be moved in fixed stages for making up composite prints from several negatives.

Three way flash sync. Used to link three flash heads to the camera—either when the flash will not trigger it, or when main unit shorts out, and flashes continuously. When synced directly to the camera, problems of suspect wiring can be eliminated.

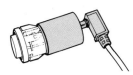

Sync trigger. A flash trigger made from a doorbell push allows the camera operator to take his own readings using the camera sync lead.

Tripod bush adaptor used when camera thread and tripod screw do not match. Check the length of tripod screws, especially if using an adaptor.

If it is too long it can damage the internal workings of the camera.

Slave unit. A photoelectric cell which is plugged into a flash unit to be fired by another flash.

Silica gel absorbs moisture. Always keep a sachet in the bag with camera or film—even indoors.

Retort stands are useful for holding reflectors or mirrors for still life set-ups.

Rosco space blanket material is available in 1.8m x 1.2m (6′ x 4′) sheets in silver/silver, silver/gold and silver/ blue combinations. Often more useful than a hand flash, they kick back so much light that they may have to be held far back from the subject. Can also be used as a background. When folded they measure only 0.07m x 0.05m (3″ x 2″).

A short **step ladder** with two or three steps is invaluable for shooting over the heads of crowds or down onto a subject. Can also be used as a make-shift tripod, either with a clamp or by resting the camera on the top step.

Household objects

Photographers who are interested in making pictures rather than just taking them should have most of these household objects close at hand. They are used frequently and sometimes a tool, spare plug or piece of tape is essential to the success of a picture. A painting might need to be hung on a wall for atmosphere in a shot, a light might have to be taped up, or a candle used to aid focusing when shooting in the dark with a hand flash.

Be as well prepared as possible for each assignment. With a comprehensive tool kit repairs and adaptations can be made. Pack the equipment into a lightweight zip top bag rather than a heavy metal tool box.

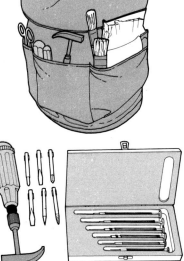

The basic tools should include ratchet and electrical screwdrivers; multi-purpose screwdriver kit, wire strippers; long nose pliers (which can be filed down for use in tight areas); insulated heavy pliers; big scissors; retractable blade knife for heavy cutting and retractable blade scalpel for fine cutting jobs; coiled nylon/terylene mountaineering strap for securing cases and adding weights to tripod.

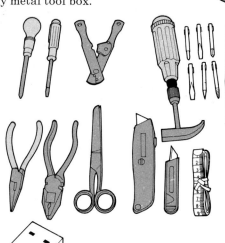

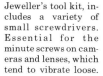

Jeweller's tool kit, includes a variety of small screwdrivers. Essential for the minute screws on cameras and lenses, which tend to vibrate loose.

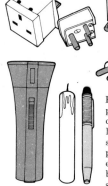

Battery flashlight, pencil light and candle. Mirror reflects light into close-up shots. Carry spare plugs. Stockings are effective filters. String bag holds rocks to steady tripod.

72

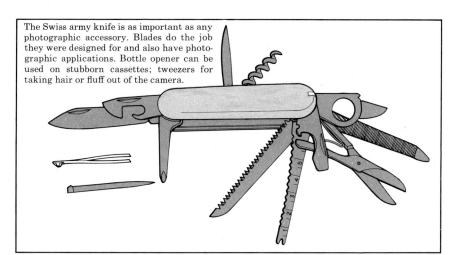

The Swiss army knife is as important as any photographic accessory. Blades do the job they were designed for and also have photographic applications. Bottle opener can be used on stubborn cassettes; tweezers for taking hair or fluff out of the camera.

The biggest variety of clips, pegs, pins and clamps should be carried. There are always things to be held in place—from paper backgrounds to ill fitting clothes. A powerful staple gun is a vital tool; string, rubber bands, drawing pins and paper clips are always handy. A selection of clamps holds heavier equipment and props. Hard and soft brushes are for cleaning equipment.

Baking foil reflector can be shaped to fit behind objects. Elasticated luggage strap for securing bags.

A variety of tapes are needed for different applications. Gaffer tape is strong and cloth backed, holds most things. Masking tape is used to stick paper. Plastic, clear adhesive and double sided have their uses.

Accessories

73

Equipment chart

It is possible to take most types of picture with one camera and one lens but as a photographer's enthusiasm grows, so will his system. This chart is a guide to the equipment discussed so far, and its application to the most popular types of photography. The most useful equipment needed to cover a photographer's specific interest is listed against the subject heading.

CAMERA TYPES

Subject	Manual	Automatic	Nikonos	Widelux	Miniature	Auto/Motor Drives	Fisheye	Ultra-wide 15-18mm
Portraits Indoors	●					●		
Portraits Outdoors		●						
Children		●						
Weddings		●				●		◉
Photojournalism	●	●			●	●		◉
Out for the day		●			●			
Still Life Indoors	●							
Still Life Industrial	●							
Close-up	●	●						
Close-up Wildlife	●	●						
Sports	●	●				●		
Landscape	●	●						◉
Aerial		●				●		
Marine			●					
Beauty	●							
Nude Studio	●	●						
Nude Location	●	●						
Glamour	●	●						
Animals		●						
On Safari		●						
Architecture	●	●						
Travel	●	●	●	●	●	●	◉	◉
Travel Hot + Humid	●		●	●	●			◉
Travel Cold	●	●	●	●	●			◉
Audio Visual	●	●		●		●	◉	◉

	LENSES						FILM							
	Normal 50mm	Macro 55-105mm	Zooms 35-70mm etc.	135-180 200-300mm	500-1200mm	Specials	Kodachrome	Ektachrome	200-400 ASA	Type B	Colour Neg	b/w 25 ASA	b/w 125-400 ASA	Special Film

Camera systems

	TRIPODS					CASES				
	Normal	Heavy	Monopod	Tabletop	Clamps Beanbags	Aluminium	Leather Shoulder	Soft Bag	Insulated Film Bag	Lens Cases
Portraits Indoors	✓									
Portraits Outdoors						✓	✓			
Children	✓									
Weddings	✓		✓							
Photojournalism	✓	✓	✓	✓	✓					
Out for the day				✓		✓	✓			
Still Life Indoors		✓								
Still Life Industrial	✓									
Close-up		✓								
Close-up Wildlife	✓									
Sports	✓							✓		
Landscape		✓								
Aerial					✓					
Marine									✓	✓
Beauty	✓									
Nude Studio	✓									
Nude Location	✓									
Glamour	✓									
Animals		✓								
On Safari	✓	✓			✓	✓		✓	✓	
Architecture	✓									
Travel			✓	✓	✓	✓	✓	✓	✓	✓
Travel Hot + Humid									✓	✓
Travel Cold	✓			✓					✓	✓
Audio Visual	✓	✓		✓	✓	✓				

Portable Flash	Strong Bulbs	Reflectors	Spot/Gossen	Flash	Weston	Polarizing	81 Series	Graduated	Soft	Special Effects	Cable Release	Compass	Steps

Camera systems

The system

Building up a camera system is difficult for someone just starting to take 35mm photography seriously. So many manufacturers promote the technological or cosmetic aspects of their equipment that photography often takes second place. These suggestions for a system are based on picture taking performance.

The body should be automatic but it is important that it should have manual override. It should be ergonomically designed and strongly built. Many manufacturers have opted for plastic construction but these cameras can get damaged easily.

When you are buying a camera the dealer will try and sell a body with a normal lens. Unless this has a wide aperture it is not much use. For a little more money, purchase a 55mm macro which has all the properties of a 'normal' lens, plus the close focusing ability.

Optically 90mm/105mm lenses are good in every range, as they are easy and cheap to manufacture. They are extremely sharp with no distortion, but have the tele-lens quality of packing-up perspective. The 90/105mm range lenses produce distinctive pictures both vertically and horizontally. When used with high quality adaptors they make good wide aperture tele-lenses.

Like the 90/105mm the 24mm is optically a fine lens. It is preferable to the 28mm lens which is a stretched

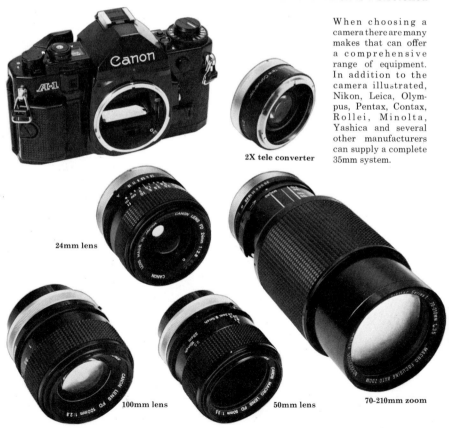

When choosing a camera there are many makes that can offer a comprehensive range of equipment. In addition to the camera illustrated, Nikon, Leica, Olympus, Pentax, Contax, Rollei, Minolta, Yashica and several other manufacturers can supply a complete 35mm system.

2X tele converter

24mm lens

100mm lens

50mm lens

70-210mm zoom

35mm design. The 24mm has all the best wide angle qualities with little distortion and is excellent for general photography.

If money is not a problem a 75-210mm zoom lens is preferable to a 100mm + 2X converter. These are expensive but offer more versatility than fixed length lenses. Avoid cheap zooms. Initially system manufacturers, with their high quality requirements, took a long time to introduce zoom lenses. Now all the major zooms are extremely good. They are sharp and do not need refocusing throughout the zoom. As they are so popular, 100 per cent quality control is just not possible—so zooms should always be tested for overall sharpness at the widest aperture both at the longest and shortest focal length.

Modern quality lenses are sharp at any aperture, whether wide open or stopped down. It used to be thought that a lens would be sharper stopped down two stops from the maximum aperture, but this no longer applies. The next two lenses to add to a system would be a 300mm tele-lens and a 35mm wide aperture depending on what type of shots the photographer specializes in.

A second camera body will be necessary to utilize the full complement of lenses, or when both colour and b/w films are being used. A manual camera with removable pentaprism would be the perfect choice, but these are not produced by all manufacturers and those that are available are the most expensive of the range.

In addition to the basic cameras and lenses the serious photographer should equip himself with a range of accessories, beginning with the necessities illustrated below.

Beginners should equip themselves with the following filters; 81 A/B/C, 85A, 80B, Polarizer, ND2, Graduated, Star and Soft.

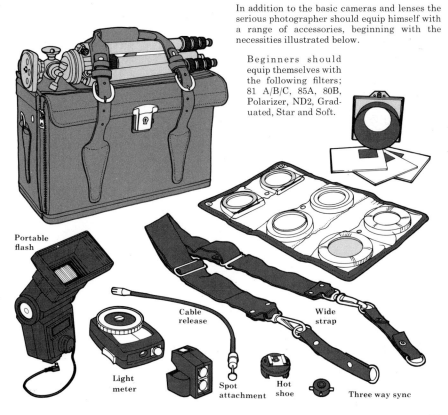

Portable flash

Light meter

Cable release

Spot attachment

Hot shoe

Wide strap

Three way sync

79

Preparation

A systematic approach to photography will depend as much on preparation and care of equipment as on the readiness and ability to make an exposure. Expensive cameras and the cheapest accessories must be kept in good order at all times if good, clean, accurate pictures are to be made. Cameras and lenses should be kept separate from darkroom equipment and they should be protected from dust, moisture and extremes of temperature.

Cleaning equipment

(1) Dust-Off compressed air. When using it always hold the can upright, otherwise the air comes out as vapour which smears the lens and takes time to clear. The small cans tend to vapourize even if held upright. Dust-Off should be used sparingly on the lens elements and around the film path. Often a chip of film will lodge behind the take-up spool. A camera is not a sealed unit. Dust-Off is just as likely to blow dust in as blow it off.

(2) WD40. Use on tripods, camera case, locks and hinges, and on certain parts of the camera. Put a small amount on a piece of soft lens cloth and wipe the camera metalwork (not the inside or the glass!) Use WD40 if going near the sea or in the rain. It slows down the eroding effect of salt and water.

(3) Aero-stat. An anti-static pistol used on the film path, take-up spool and back pressure plate. Important that it is used with motor drives which create static on fast rewind.

(4) Lens tissue **(5)** Lens cleaner **(6)** Chamois leather. Do not use the cleaning cloths which are recommended for spectacles, as these are often impregnated with a greasy cleaning agent. If rubbed on the lens grease can give a star filter effect. The best cleaner is a well washed chamois leather. Use the cleaning liquid on a cloth or tissue and wipe it gently over the lens, but only if the dust-off has failed to remove the dust, or if there are oily smears on the lens. In certain parts of the world dust can be so fine that only the fluid will remove it. Under these conditions fit a filter to the lens and keep it clean. Most smears

Top surface should be large enough to hold camera case, trimmer or light box. Fit a rim all round to stop objects rolling off.

A camera trolley is an invaluable piece of furniture when shooting in the studio or around the house. If an area of the home doubles as a make-shift studio, a trolley can be used as a mobile version of the camera and accessory cupboard. Build a workbench with cupboards, drawers and a fitted trolley which can be wheeled out next to the camera set-up, providing easy access to film, filters, tools etc., without the need to keep walking over to a bench or cupboard. After shooting the trolley rolls back into the bench and becomes the camera cupboard.

Top drawer holds household tools, staple gun, adhesive tape etc. Second drawer contains cameras, and lenses. Others hold film and miscellaneous equipment.

Drawer slides are strong so they can be left open. Construction is wood or metal with firm joints.

Trolley should be high enough to use top surface without stooping; big enough to hold gear without getting in way.

Wheels are plastic type which swivel independently.

will come off with 'huff' of breath. Never wash a filter. Always keep the rear lens elements clean.

(7) Brushes. Blow brushes are like manual versions of Dust-Off. They are good for general use and travel, but the bristles do get soiled easily. A sable paint brush (8) is useful as it can be kept clean with a gentle wash in warm water. Use it on the lenses. A stiffer brush (9) is needed for the camera body and metalwork including the outside lens housing. It is important to keep grit away from the wind-on lever and small controls.

(10) Cotton buds can be used to clean the mirror, although a dirty mirror will not affect pictures. With a dab of WD40 wipe around the lens mount and the hinged back.

Batteries. As we are now living in the 'battery age' photographers must become battery conscious to survive. Batteries have different trade names in various countries.

Batteries have a built-in clock. They always fail when the shops are shut. Always check batteries before going out on a shoot. Always carry spares with you, and always keep them warm and clean. Never touch the terminal. If corroded, scrape terminals with a knife or sandpaper. Never throw loose batteries into the camera bag as they can discharge on contact with any metal object, including other batteries. When possible buy them in plastic packs and keep them wrapped until needed. If the only ones available are not in sealed packs ask the retailer to check the voltage.

Maintenance

A major camera service centre reports that 50 per cent of camera malfunctions are due to worn-out batteries, especially with automatic cameras. Non automatic cameras with TTL metering are also dependent on batteries, which should be replaced regularly. The most common camera faults are: plastic cogs wearing out quickly; mechanisms of compact cameras (shutter, wind-on, mirror lock) getting jammed by the smallest grain of sand; nuts and bolts tending to fall out in some complex cameras.

Never oil the barrel of a lens. Oil seeps through and clogs the iris blades.

If the camera is not used for long periods do not leave it alone. Periodically run through a series of exposures—even without film.

If used frequently have it serviced once a year.

If in daily use have it checked every six months.

Actions of 1/2000 sec are only accurate for a few weeks.

If more than one camera and a selection of lenses is used, the shutter speeds and apertures can be matched to within $\frac{1}{4}$ stop by a camera mechanic.

Most faults with modern sophisticated cameras are operator malfunctions—PEOPLE DO NOT READ THEIR CAMERA MANUALS PROPERLY.

Preparation

81

Check list

Consistently good results depend largely on good habits. Most of the bitter disappointments experienced when pictures come back from the laboratory can be avoided by making this checklist an automatic process.

It can be embarrassing to find the film has not been wound on before taking a shot. Check that the lever is taut. Get into the habit of checking that film speed and shutter settings have not been altered between shots. With experience a photographer will come to recognize the sounds the

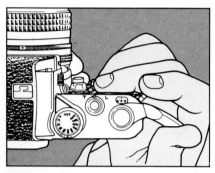

1. Check camera is not loaded. This is indicated by lack of tension on film advance lever.

2. Check that the 'gate' and the film path are clean. Particles of dust will stick to film.

3. Check that film is wound onto the take-up spool correctly before closing back.

4. Check the back is properly closed or the slightest knock will open it.

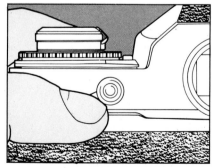

5. Check that the batteries are good and always carry enough spares.

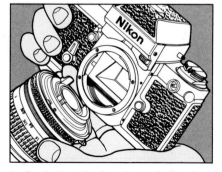

6. Check that the lens is absolutely clean, particularly the rear element.

shutter makes at different speeds.

If film is changed in mid roll always make a note of the frame number when the film is unloaded, and mark it on the cassette or can. It is better to have a blank frame than a double exposure which wastes two shots. When re-loading a partly shot roll cover the lens so as not to re-expose the film. After shooting a roll of film, wind back straight away. If planning to shoot another roll reload.

Never *assume* that everything is alright. Check it, Check it, CHECK IT.

7. Check that the lens is mounted properly and that it engages the meter, if fitted.

8. Check the ASA scale is set for the film in use, and you know if it is over or under rated.

9. Check what film is in the camera, especially if it has not been used for a while.

10. Check that there is no unwanted filter fitted to front of the lens.

11. Check that the correct shutter speed is set, particularly if flash is being used.

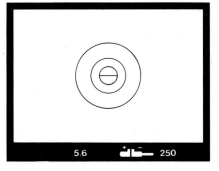

12. Check the TTL meter gives a realistic reading. Compare it with a hand meter.

Preparation

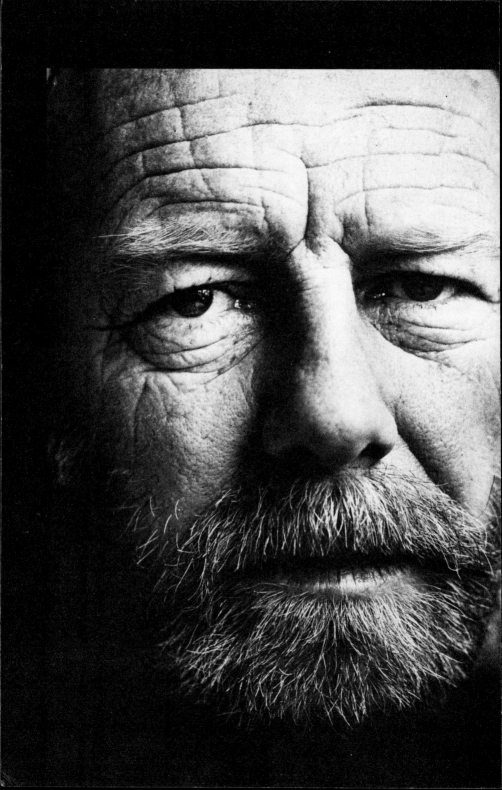

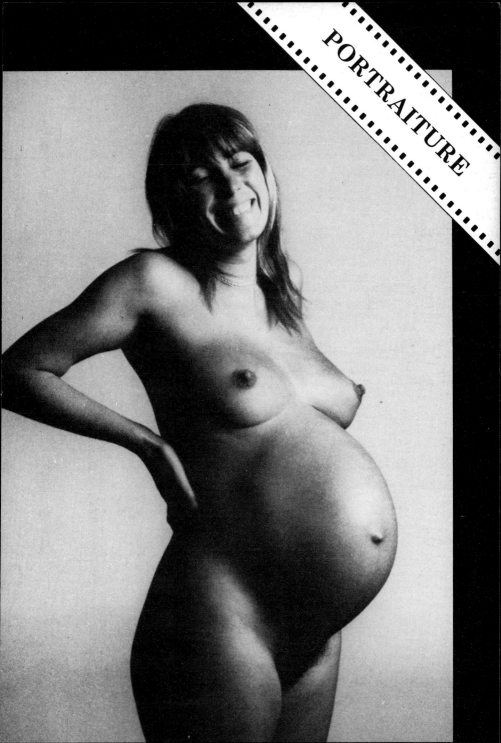

Portraiture

The 35mm camera brings its own qualities to portraiture—just as do the Hasselblad, twin lens Rolleiflex and plate camera.

The speed of operation and its small size make the 35mm the obvious choice for location work, or for the spontaneous picture when the photographer needs to be free from cumbersome equipment. The high quality fast lenses do not need a lot of light to hold sharpness throughout a shot. It is possible to use the whole range of lenses, with all their creative potential, for portraiture but the most appropriate ones are the 90/105mm range, including the macro.

A 35mm camera is much less intimidating than larger format equipment. All people (even models) are apprehensive when sitting for photographs. Many are terrified. It is, therefore, vital to make the subject feel relaxed.

Do not separate photography from the rest of your life. Most people have to relate to others in the course of their work, and have to make them feel at ease. Portraiture is little different except that over the duration of the sitting the photographer must produce a good picture.

Do not dither or flap around. You have to project an air of confidence and it helps if you know what you are doing.

The search for the true personality of the sitter makes portraiture one of the most fascinating aspects of photography. Be observant. Look at the face, hands, stature and carriage of the sitter. This is difficult to do with discretion especially if the subject is nervous.

It is generally accepted that you should 'never judge a book by the cover'. However, when referring to people, this is a dangerous attitude. Have faith in the superficial and observe it with great care.

The lines of the face of middle aged and older people are not there because of some accident of chance—they are the direct result of a life lived. Do not try to change them, but be kind when it matters.

Portraiture takes several forms. In the studio, either a good likeness or a critical view can be achieved. When taking formal portraits, most photographers attempt to make a sympathetic likeness of the subject. Use a tripod to give the sitter a constant point of reference. You can then move about and look at the sitter without inhibiting him.

The action of pushing the button is of course the critical factor. Make sure the sitter knows there will be more than one exposure—possibly several rolls will be shot. If a subject feels intimidated by the camera shoot a

Some people express themselves with their bodies, others with their faces. The bearded artist on the **preceding spread** has a face which is so expressive that it demanded a close-up view. A 105mm macro lens was used.

The pregnant woman was a friend who arrived at the studio in exuberant mood. The shot was taken immediately and reflects the enjoyment and spontaneity of the moment.

The actress Rio **far left** had a masculine hair style, although her femininity shines through. The deliberately hard lighting and black vest were chosen to accentuate the paradox. A Softar filter was used with the lens stopped down to f16 in order to keep the complexion smooth.

Sir Zafrullah Kahn **left** venerated elder statesman and theologian, was photographed with a 35mm lens so space was left around him to suggest he was a wise old man at peace. Although this was a set-up shot there is no sense of intrusion.

The snapshot portrait **below** is the type of picture carried in millions of wallets to remind people of the ones they love, especially when parted from one another due to work, war or other circumstances. This sort of picture would never be considered art, but it brings more pleasure to more people than any other type of photograph. The snapshot portrait should never be dismissed as trivial.

roll or two in a throw-away manner, but never run the camera without film. The best shot may come early on, but if the camera is not loaded the shot will be lost.

Talk to the sitter to establish eye contact and ensure the eyes are sharp even if other features are out of focus.

Environmental and reportage portraits show people in less controlled situations. However, the most universal type of portrait is the snapshot.

Snapshots are the pictures of the ones we love. They are fond memories to be carried in the wallet, and are usually humorous. At their best they represent a valid photographic form. Professional photographers find snapshots hard to take; they are too preoccupied with technique to be sufficiently involved with the situation.

Portraiture

News portrait. Billy Graham was watched through a 180mm lens while addressing a rally. The climax was anticipated; hands, eyes and mouth were all animated. Group portrait. Make sure that everybody can see the camera. Rather than have people standing shoulder to shoulder, adjust the composition to fill the frame. Have people sitting, standing and kneeling.

Kids on a San Francisco street were shot on a 35mm lens. You don't have to ask children if you can photograph them, they will usually do all the work for you. The street is a wonderful location for a photographer but be ready to capitalize on the unexpected.

The shepherd belongs to the nomadic Guja tribe of Northern India, descendants of ancient biblical Syrians. A portrait was wanted which showed him looking like a biblical character. It is a set up shot. Although they carry the lambs like this, it was placed there for the picture.

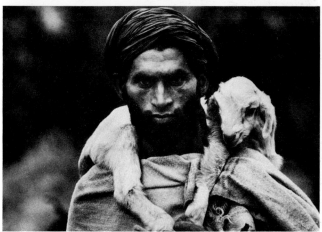

It is easy to record a likeness of a person but hard to make a visual document of somebody's personality. Photographers should have their own vision. For instance, rather than just showing an architect in front of a building he has designed, it might be more effective to photograph him holding a model or the drawings of the building.

One of the advantages of using a 35mm camera is that most people being photographed have no idea how much the lens sees of them. The wide angle lens places people in among the symbols of their life and maintains the strong relationship between the camera and subject. The long lens can either isolate the subject from the background or it can bring the background up behind them establishing another relationship.

The many special effect techniques can add visual interests to the portrait, as long as they are relevant and not just being employed as gimmicks. Study the lighting of great portrait painters. The best photographic portraits are as important visual statements as any painting.

Portraiture

There is little point in understanding the lighting techniques and philosophy of portraiture without knowing how to help subjects project themselves in the most flattering way.

When taking a portrait which is intended to flatter it is important to place the subject to his or her best advantage. Often the act of giving subjects something to do has the effect of distracting them from their natural terror.

To help subjects project the image they desire the photographer must have a sympathetic attitude towards people. With practice the eye will become more critical and faults which should be hidden will be recognised with ease.

Be aware of the graphic relationship between the subject and the environment. Patterned clothing and vibrating backgrounds can be used to good effect but often they detract from the point of interest.

Have plain black polo neck sweaters or T-shirts at hand. Most people look good in them and the face and hands stand out with no visual distraction. When shooting colour film plain colours should be chosen to complement the subject's character.

Nervous tension is often apparent in the action of the subject's hands. Some people grip their seats or clench their fists. Try to get the subject to fold the arms, clasp the hands or put them flat on a table or their knees. If this does not work keep the hands out of the frame.

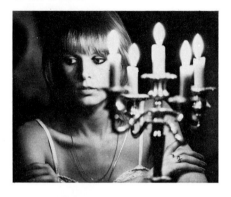

Candlelight is soft and warm in colour and is one of the most flattering and romantic of all portrait lights. The flickering, directionless light smooths out facial wrinkles. Take reflected readings off the face as the image flame will give an incorrect reading.

Be careful with neck wrinkles when shooting over the shoulder. If the head is tilted back then turned to camera the neck will wrinkle. If subject drops the head forward a little then turns to camera, lifting it up, the wrinkles will be reduced.

When being photographed, many people exhibit tension by staring at the camera. Ask them to close their eyes and drop their chin onto the chest, then slowly lift the head and eyes. The stare will be gone.

To hide baldness, light the subject from the side and shoot from below the chin line. Lighting from above and shooting from forehead level gives unwanted prominence to the hair line.

To under-emphasise a double chin, shoot from slightly above the head with the subject leaning forward, forcing him to stretch out the chin by looking up. Do not let him sit ramrod stiff with a forced smile.

 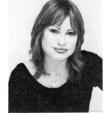 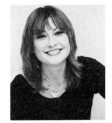

Some people show their nervousness by tension around the mouth. Ask them to fill their cheeks with air and blow it out. This relaxes the mouth and the silliness of the act produces a genuine smile.

As a general rule get the subject to lean forward into the picture. A positive attitude to the camera produces more dynamic portraits.

Use as long a focal length lens as possible when shooting people with large noses. Long lenses compress perspective, wide angles exaggerate. Position the subject square to the camera and avoid throwing a shadow from the nose.

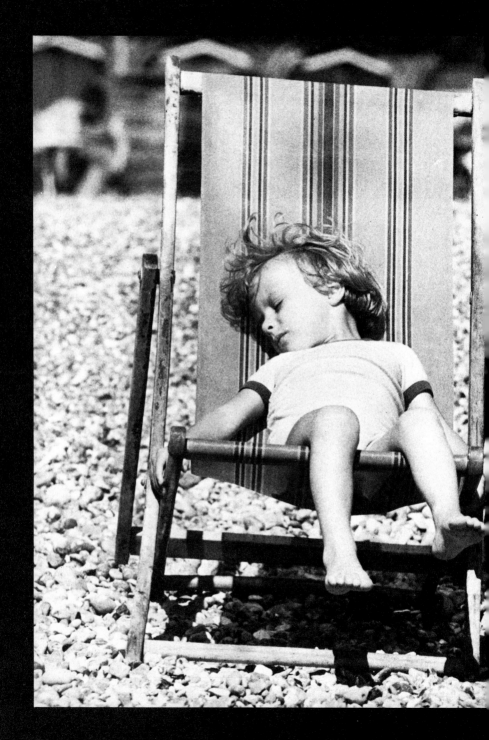

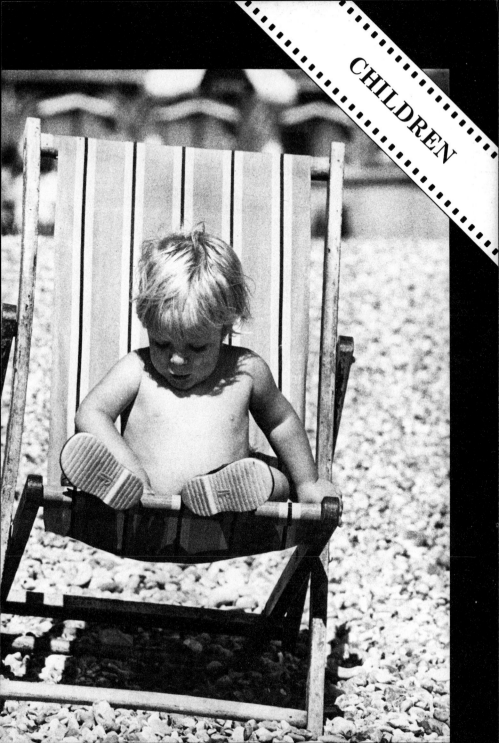

Children

Photographing children is a part of the overall enjoyment of family life. It should not be a special activity or made to seem over important. As a normal part of daily life it is great fun. If you fail today there is always tomorrow. Adopt this philosophy and many good shots will be made.

Taking pictures of children can also be a most exasperating and frustrating experience. Looking back, the parent with a camera will remember as many near misses as a fisherman. Photographing one's own child can be extremely rewarding as it involves a parent in one of the great photographic themes. The great children pictures are the ones where the photographer has recorded the 'world of the child' and not just photographed a likeness.

Children go through stages of being extrovert and shy—do not try to force children into being photographed when they are feeling shy. They will resent it and may never be comfortable in front of a camera again.

In the real world children (especially babies) have rashes, spots, mumps, measles and bad temper. Even under these conditions good pictures can be made which are fun to look back on in later years.

There is no such thing as a special children's light. Study the pictures shot in window and daylight on pp42-43. The best pictures of children have been shot in natural light. It not only looks better but the absence of lighting complications helps concentration on the actions and expressions of the child.

Not surprisingly some great children pictures have been taken by women. Natural understanding and sympathy are what it is all about. Mothers should be as confident with a camera as with the telephone, taking pictures of their children whenever the spirit moves them.

In the studio

Children are not beings from outer space—only small people—so do not insult their intelligence. Be firm, polite and precise when giving directions. Children don't have to be handled with 'kid gloves'. It is often a good idea to let the child help with setting up a studio session. This helps them to feel involved. But never start the session until absolutely ready. When setting up the lights use an available adult model; a child's concentration will not last long. When the child is there do not waste time (especially if the subject is under six years of age). Have the camera ready and loaded, with the next roll out of the packet. Take meter readings in advance.

If the child is not interested, forget it! You are wasting film and losing confidence. A photographer must give off an air of confidence (this applies to any type of portraiture). Don't panic —it's only a photographic session, not a summit meeting.

A new brother or sister **top** will interest a child. Anticipate the meeting and capture reaction. When he meets Santa **below** go to the head of the line and practise on other children first.

The first birthday **top** should not be missed. With anticipation a good shot is inevitable. For the first bath **below** pre-focus the camera and be ready for the reaction to soapy water.

Children

The biggest mistake people make when photographing children is to put the camera down too soon. Children have a talent for performing the moment the camera is put away. Stay around. If the camera is always there, the child will soon get used to it.

When shooting the 'world of the child' set up a situation in which the child is sure to respond. Then back off. Allow them to become involved, then shoot. Do not push the child, just record the action.

The fact that the environment has been set up allows shots to be anticipated. This is better than trying to record the actions of a rampant child.

Try shooting from a kneeling posi-

tion—the child's eye view. One seldom sees pictures of a child shot from his own height, like a real person.

When shooting in the studio it is a good idea to record the child's voice and play it back. Children are bewitched by the sound of their own voices.

Do not scrub all the dirt and charm off the child before taking the shot.

Apart from all the basic techniques of portraiture one of the most important factors is the ability to follow focus. On all lenses bring the left hand down as the subject comes closer, and turn clockwise when the child moves away. Children move fast and follow focus is vital. Make it automatic.

Weddings

On their wedding day the bride and groom consider it one of the most important days in their lives, so don't offer to take the photographs officially unless you are utterly confident of what you are doing—confident of the light conditions, handling the people, and in your ability to work fast.

If the formal wedding pictures are left to the local specialist who uses a larger format camera, the 35mm owner is free to record all the unguarded, informal moments during the whole day. The best pictures may be taken long after the official photographer has gone home. It is a friendly family day, with everybody excited and far more interested in talking to long-lost relatives than obeying the wishes of a photographer.

Be firm and pleasantly dictatorial to get the pictures: in years to come people will be thankful you were firm and not timid.

100

The bride's mother **preceding spread** adjusting the veil that she wore on her own wedding day. Photographed just before leaving the bride's home with a 35mm lens and fast film.

The blessing **top left** photographed on a 180mm lens with the camera mounted on a tripod. Although it does not disturb the ceremony ask the priest for permission to shoot in church.

The ring and bouquet **left** a detail shot of the couple while they waited to be photographed by the official photographer—a 80-200 zoom was used.

Signing the register **above**. Hand flash was bounced off the ceiling but on a slow shutter speed to kill the hard flash shadows.

Outside the church, choose the right position to set up. Then instruct the guests to throw the confetti at your command—use a slowish shutter speed so it is blurred.

Weddings

When photographing a wedding it is worth planning a shooting schedule in advance. List the aspects of the event to cover and try to shoot them all. Some of the obvious shots are of the bride dressing, arrival at the church, the ceremony, signing the register, family groups, cutting the cake, and leaving on the honeymoon.

Other shots could include the father pinning on his button hole flower, the presents, a posed portrait of the bride, guests arriving, close-up details in the church and reception, the priest, bridesmaids, the cake, the ring and so on.

At the reception a range of unlikely subjects present themselves. Photograph the funniest telegram, the oldest relative or father dancing.

After the event have enlarged (20″ x 16″) contacts made (colour and b/w) from which to choose the final prints. The large contacts are more readable to the layman and, in addition to provoking a reaction, they encourage people to order more prints. The contact sheet, with 36 images, is also an impressive picture to hang on a wall.

PHOTO-
JOURNALISM

Photojournalism

The photojournalist remembers fondly his good pictures, but is haunted by the great pictures that he missed.

Photojournalism is about capturing the essence of the human condition in pictures that will inform and clarify the mind of the onlooker. The great news pictures and photo stories live for a long time as they are a comment on the times in which they were taken.

The attitude of the photographer is the key. Most of this is intuitive, but there are some basic qualities which can be developed by the aspiring photojournalist.

1. Concentrate on the subject (always look for the poignant picture).

2. Be aware of what is going on around you and have the instinct to be where the picture will happen.

3. Maintain a personal response to the subject, combined with sufficient detachment to see when the right picture will occur.

4. Be ready to go to any lengths in order to get the picture.

5. Inspire faith in others to get them to help you.

6. Keep the pressure on oneself when the pictures are not happening (often the best pictures happen just when you have thought of giving up).

7. Have a sound knowledge of camera technique and confidence in the craft so that it becomes second nature.

8. Understand completely the properties of the film being used.

9. Never be put off by problem situations (e.g. mixed light sources, low light level, inaccessibility); with patience and command of the techniques a problem can be turned into a creative advantage.

10. Remember that obtaining the picture is the only objective. If you see the picture without the camera at your eye, you have probably missed it. The ability to anticipate action will come with experience.

Photojournalism requires a conscience as well as a camera. On the **preceding page** refugees wait outside Calcutta, and an anti-apartheid demonstrator is led off an English rugby field. The shot of the boy being threatened **above** accompanied stories on children and violence. Bangladeshi 'freedom fighters' taunt a prisoner **left** during the 1971 Indo-Pakistani war.

'Some of the most compelling reportage pictures have been taken by photographers working with a journalist. A good journalist has a mind like a camera—that is, he thinks not only in abstract ideas and facts but also in images—and he can suggest situations to a photographer which he has 'photographed' in his mind. A good photographer can see images through his lens which can best be described in words and these he passes to the journalist. Some of the finest reportage pictures and words stem from this rare overlapping of talents.'
John Pilger,
Chief Foreign Correspondent,
Daily Mirror, London.

'A photograph is as vital to a newspaper page as a news despatch. Like a written article, it should be informative and entertaining. It can grab a reader's attention faster than an article and almost as quickly as a headline. A good news photograph tells the news at a glance. It also can seduce the reader into examining the written word.

A reporter wants a photograph to report. A photograph should tell the reader of a place and of action and of people and their emotion. A photograph can set a scene and show the action of world events; tears, laughter, boredom, triumph and tragedy can be reported in words that take only minutes to read. A photograph can do the job in seconds—and make the impact last a lifetime. A good photograph is worth one word—impact.'
Richard H. Growald,
National Reporter, U.P.I.

Photojournalism

Essential equipment

Two bodies EL type, one with auto wind. 20mm, 35mm, 80-200mm zoom, and 300mm lenses. Small electric eye flash gun, small tripod and meter with spot attachment.

In the soft camera bag should be fast b/w and colour film, two rolls type B colour and whatever else you feel happy using.

On major assignments where there is time to set up and consider the picture, a photographer would expect to use all the equipment he can command.

Wide angle lenses allow the photographer to have physical intimacy with the subject. (Reaction to a closely positioned camera can sometimes add a vital element to a shot). Electronically governed automatic cameras make it possible to shoot quickly.

Don't drink too much; while searching out a toilet many shots can be missed. Don't carry more equipment than you can run with.

When walking around with a camera the photographer can observe the greatest show on earth—the 'theatre of life'. Capture the unexpected moments as they happen. Don't just stare.

After pointing the camera at the action re-
member the reaction, which may be just as
interesting. British right-wing politician Enoch
Powell **above** finds approval from an audience.

California hippies 1970—London punks 1978.
The camera records changing values. Pictures
often become more relevant with time, so never
throw away a negative.

Photojournalism

The photo story is the most satisfying and valid assignment for the photojournalist, giving the opportunity for vivid insights into the human condition. Photo stories used to be published, with a minimum of text, in the great illustrated magazines until television documentaries virtually wiped out the market. The versatile 35mm camera is the most appropriate equipment for capturing the definitive moments of a story—like this one illustrating a day in a teaching hospital.

Photojournalism

The services of the photojournalist are often called upon by public relations officers to record a company's industrial activities. The definitive picture that demonstrates the relationship between men and machine may take a day or more to stage manage, or it may be the result of a normal photographic assignment where pictures are taken spontaneously.

A good test of an industrial picture is to show it to the working people in the picture. If they say 'yes, that's how it is', then the photographer has gone a long way to interpreting the activity.

The oxy-acetylene cutter **left** is working on the oil pipeline in Saudi Arabia. The printer **below** is checking an early copy of the newspaper hot off the press. This planned shot was lit with three electronic flash heads.

A knowledge of the manufacturing process may not be necessary for good industrial pictures. A Widelux camera was used **above** to photograph a stage in the gold refining process. Available light was used and the camera mounted on a monopod.

A factory contains many graphic still lifes in addition to action shots. New and shiny objects are often seen in interesting compositions. The shot of the cable drum **below** was used in the manufacturing company's annual report.

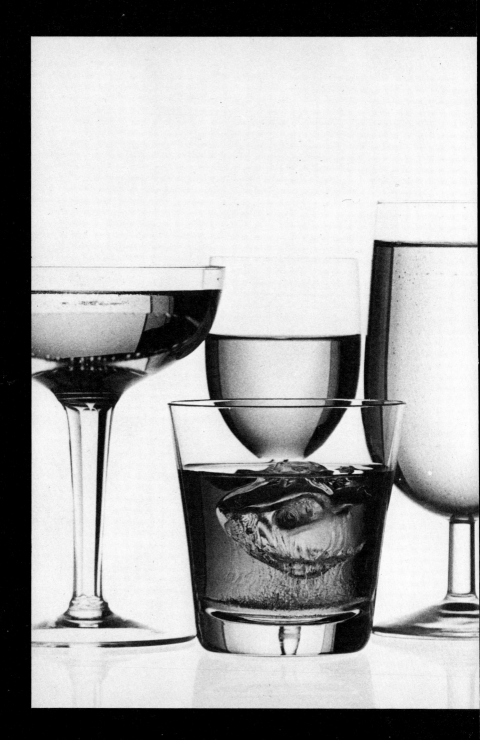

Still-life

Advertising still-life shots of products are probably the most widely seen photographs. They are not usually taken on 35mm cameras, but the basic principles of still-life photography apply, no matter what camera is used.

The still-life photographer is dealing with form, texture, the relationship of one object to another, the lighting of those objects and the overall composition within the format of the finished picture. Still-life photographers have been known to take days in the studio arranging things, striving for the simplicity of a composed, harmonious picture.

The objects, although appearing in one dimension, must have body and substance and this is created by the lighting. Although the lighting is under the total control of the photographer, nothing is original. All arti-ficial lighting effects are imitations of natural light, so study the effects of daylight on various surfaces. When recreating an effect with studio flash use the modelling lights to see where the light falls.

Large format sheet film cameras are often used in studios. They have movable fronts and backs with which the relationship of lens plane and film plane can be altered to correct perspective distortion and hold depth of field. By shooting at the smallest aperture on a 35mm camera depth of field can be achieved without the picture looking as contrived as if it was shot on a larger format camera.

First attempts at still-life photography are best tried with top back lighting and a front reflector rather than one hard side light and a softer shadow light.

The glasses on the preceding page were shot on 105mm macro lens. They were placed on a white infinity background running from the edge of the set, under the glass, down to the ground and back up in a loop. The loop area was lit by (1) set at two stops over the general reading. Extra power was needed to 'light out' the back edge of the glass. (2) lit the liquid.

A glass full of liquid will pick up reflections like a lens, so keep the area behind the camera dark and free from reflective objects.

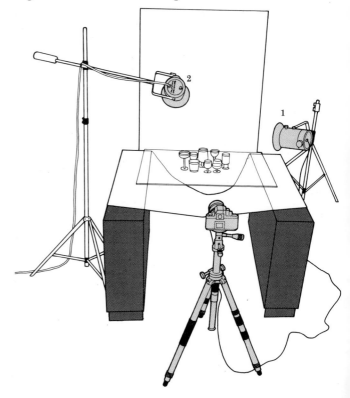

The Cartier products were placed on a piece of black slate which had been rubbed down with oil to create some reflections. The light was pushed through a double layer of colour corrected Rosco tissue paper. Not only did the light illuminate the objects but the reflecting surfaces of the objects are picked out by the large area of white paper.

The black velvet absorbed all the unwanted light on the left side of the set. A white polystyrene flat was used as a general background.

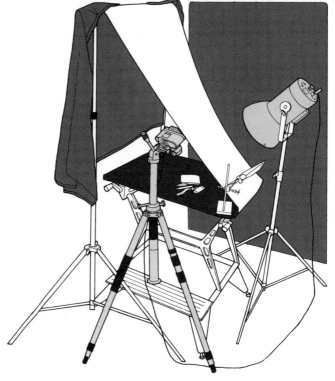

117

Still-life

Top backlighting makes objects stand out from the background, separating one from the other and giving a good 3D rim light.

Do not use raw, hard lights; diffuse the illumination.

The larger the light source the better the light. One light source with several reflectors to put the light back into the set can be used to hold natural detail in the shadows. This is generally better than lighting the dark areas with separate lights.

When shooting a bottle of red wine or port, dilute the liquid as light will not penetrate. Ice cubes used in still lifes are usually made of plastic as real ones melt too quickly. If a model's hands are being used in the shot take extra care with lighting and make up, otherwise they can look like claws or chicken legs.

A still-life photographer will require several props to use when working in the studio.

Use retort stands to hold mirrors for reflecting light into dark areas.

Black velvet and sheets of white opaque plastic are always needed for use as backgrounds.

Sheets of coloured card, especially black, white, silver and gold should be available for use as reflectors. Sheet glass on top of black velvet creates two reflected images.

Make a collection of organic objects with a variety of natural textures to give atmosphere to shots. Pieces of stone, slate, coral and gnarled lumps of wood, pebbles and sea shells are always handy. They can even be arranged to make pleasing pictures on their own. Involve the family in collecting such objects.

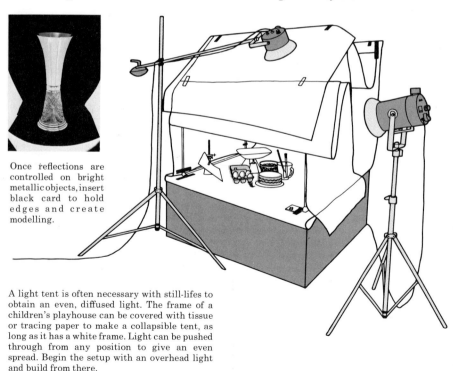

Once reflections are controlled on bright metallic objects, insert black card to hold edges and create modelling.

A light tent is often necessary with still-lifes to obtain an even, diffused light. The frame of a children's playhouse can be covered with tissue or tracing paper to make a collapsible tent, as long as it has a white frame. Light can be pushed through from any position to give an even spread. Begin the setup with an overhead light and build from there.

Great still-life shots were being taken long before the invention of electronic flash with the best of all lights—daylight. The mobility of the 35mm camera enables the photographer to take still-lifes anywhere. Compositions may come from people's arrangements of favourite objects or they may be discovered by pure chance. These pictures can either just be snapped, or shot with a tripod, which allows the photographer more deliberation, with the possibility of making minor adjustments in the relationship between objects. Still-lifes can be used to add detail information to any series of pictures, and sometimes say more about a subject than conventional shots. The greatest daylight still-lifes have a timeless quality about them.

Close-up

Close-up work is like a drug for some photographers who become totally involved in the extraordinary and un-expected sights which are not visible to the naked eye. The eye quickly becomes accustomed to this new vision and beginners' pictures usually improve rapidly—both technically and graphically.

The biggest problem for the close-up photographer is providing enough light. The closer the lens comes to the subject the narrower the depth of field becomes. This leaves two alter-natives—long exposures or flash.

The camera must be rock solid and once the subject is completely station-ary the next problem is to get light into the space between it and the lens. Mirrors, baking foil or white card can be used to bounce the light in at an oblique angle.

Tungsten light is good to use in the studio with inanimate objects because it is on constantly. With the camera locked solid the necessary long ex-posures can be made.

In the field, when shooting some-thing like a flower use either a ring flash or small hand flash. These will freeze the movement from the wind and allow the lens to be stopped right down for maximum depth of field. Take a silver reflector and a piece of white paper to use in combination with the hand flash; it will throw a shadow which will probably need to be soft-ened. The ring flash will provide a shadowless light so no reflector is needed.

It is imperative that notes are kept when shooting close-up. Keep check of exposures. As the lens is extended farther from the film plane with either a bellows or extension tubes, there is loss of light. Through the lens meter-ing is no longer correct and exposures have to be longer. Extension rings have exposure factors engraved on them. Bellows exposure is calculated by the length of extension.

When shooting close-up of a flat object such as the coin, make sure that the camera and subject are squared up. Use a spirit level on both.

Shot was taken on the 55mm macro lens after playing with reflectors to pick up a glint in the eye of the JFK half dollar.

The same lens was used with an M ring. The numbers writ-ten on rings are exposure fact-ors. Factor 2 requires one stop increase in exposure.

The M ring was replaced with K rings for this shot. The fac-tor was 4, de-manding an in-crease of two stops expos-ure.

Greatest mag-nification is achieved with bellows fitted to same lens. Exposure fac-tors still apply but always bracket for these shots.

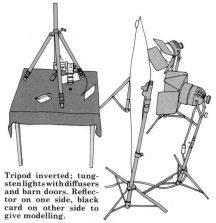

Tripod inverted; tung-sten lights with diffusers and barn doors. Reflec-tor on one side, black card on other side to give modelling.

The baby's hand was shot on an 80-200mm zoom plus an 0.5 close-up lens at f11. Flash was reflected from above by umbrella. Zoom with close-up filter is useful for tight cropping on moving subjects.

The hyacinth was shot on a 55mm Macro at f16, with a backlight from each side and fill from front.

The eye was shot with a 105mm macro lit by ring flash mounted onto the front of the lens **below right**.

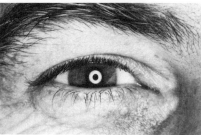

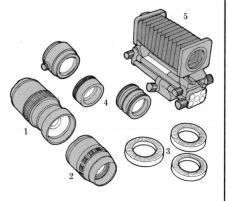

The simplest way to shoot moderate close-up is to add close-up supplementary lenses. There are no exposure adjustments necessary but there is some loss of definition, especially if the subject is backlit. When stopped down to f8-f11 they are acceptable. When fitted to long lens they can be used to exaggerate the compression of perspective.

For top quality and more extreme magnification, extension tubes or bellows must be used. Metal tubes come in fixed lengths and can be added together providing increased magnification in fixed stages. They are light and cheap.

The ultimate quality comes with the use of a bellows, which is an infinitely variable extension, vital for the serious close-up enthusiast.

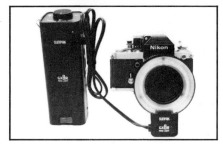

Macro lenses (**1** and **2**) can be focused closer than normal lenses. Supplementary lenses (**3**) also permit closer focusing but with loss of definition. Extension tubes or rings (**4**) can be used separately or together but with a bellows unit (**5**) there is more control.

Sport

The 35mm camera system changed sports photography in the 1950's. The portable tele-lenses and motor drives enabled the photographer to get right in with the game, showing the viewer what it was like to be a player rather than just a spectator.

Sports photography has been responsible for many innovations both in technique and camera adaptation. The professional sports photographer is constantly trying new approaches, gadgets and gimmicks in order to show sports in new and different ways.

Good pictures are much easier to achieve if the photographer knows the game and the particular style of playing of the main participants. Rather than wait for the perfect moment to click the shutter, photograph steadily with the ebb and flow of the game; this way you are in time with the game and you are much more likely to hit the button at that critical moment. With long lenses keep both eyes open: the right eye looks down the lens and the left is used for a wider view of the game.

The only area where the 35mm camera is not good for the professional is when using flash in an already lit area. The shutter is synced at 1/125 second maximum, but the existing light creates a ghost image. The shutter should really be on 1/250 or 1/500, but most SLR cameras cannot be synced at these shutter speeds.

It is always interesting for the photographer to search out and photograph that ingredient which makes a champion sportsman different from the others. Sports photography is not only concerned with freezing the moment of victory or defeat; it is also to do with capturing the spirit of endeavour and the off-court drama.

Major sports meetings like the Olympics or soccer World Cup are as difficult for professionals to photograph as they are for amateurs. The public seating and press enclosures are often a long way from the action.

Athletes are sportsmen in peak condition; the best pictures show their physical commitment. A wide open aperture will hold them off the background and isolate their effort. A person sprinting toward the camera will be travelling at about ten yards per second—it takes experience to hold them sharp on a wide aperture. Have a prefocused camera aimed at the finish tape.

Swimming is one of the most difficult sports to photograph. During a classic event the best swimmers are under the water for most of the time, so it is necessary to follow focus to keep the head and the water sharp.

Baseball in the park is a good example of a sport which can be photographed without pressure. The photographer is free to choose position, unlike at a major event.

The sports portrait **right** is of Mario Andretti on the grid at the British Grand Prix. Any top sportsman is in his own world of concentration before an event and at these times the most effective portraits can be made.

The gymnast on the **preceding spread** is working on the rings—an activity which demands the most amazing strength and control. Gymnasts go through the routines quickly, so shoot all the time.

Sport

When photographing motor sport it is best to get onto the infield where the action is happening around you. Long races with many laps give opportunities to shoot from the same position.

Pre-focus on the track. Panning shots are easiest to take on longer lenses. Shoot on slow corners if possible—the real speed is never apparent in a photograph.

Use the stop down button to check focus. Reload during the intervals; waste five frames rather than lose the picture because you ran out in mid action.

Know the game and the players.

Use the programme as a caption reference. Write the frame numbers on the programme for easy player identification.

Sit in the West stand so that the late afternoon sunlight is on the East stand rather than in the lens.

Sit ten rows back in the stand to use the height rather than in the front row at a low level.

Take pictures of people playing sport in the parks: you can get much closer and it is good practice.

As it is essential to know how much 'blur' there will be in the picture, use a variety of shutter speeds, from panning at 1/4 sec to shooting at a 1/1000 sec. It is often better to have a little movement such as a blurred foot or arm, in the picture rather than freezing it.

Never chase after the peak action, anticipate where it is going to occur. Be ready, set-up and pre-focused for the shot. It may only occur once in the day. When shooting at an area such as a goalmouth or finish line, with a fixed camera, tape down the lens so it does not get knocked out of focus.

When panning with the action, and using a motor drive, keep shooting while focusing for the shot.

The spot attachment is an essential accessory. Very often the field of play is well lit but the stands are dark. This could upset the electronic exposure meter.

Always endeavour to fill the frame with the action.

The polo and Welsh rugby players were shot from fixed camera positions with long lenses and tripod mounted camera. Follow action through the lens, keeping the other eye open.

Fast shutter speed was necessary to freeze the water on the white water canoe shot. The 300mm f2.8 lens allows fast speeds and, although heavy, it is a favourite with sports photographers.

Landscape

To photograph a dramatic landscape enhanced by a magical sunset is one of the most memorable experiences a photographer can have.

The major difficulty when using a 35mm camera to photograph a landscape is how to do justice to a huge vista on a 35mm transparency. There is a big difference between looking at a small picture on a viewer and projected on a screen.

Scale is important in landscapes. Vistas look most impressive if there is something to relate to, such as a person, house, car or camel. Panoramic shots should include foreground detail to sweep the eye into the background.

Dal Lake, Sringar, Kashmir, before sunrise on a winter morning **top left**. Shot on a 180mm lens at f4. Not a chance picture. Scene was observed in daylight, but shot in morning mist with blue tones of dawn light, and water at it's calmest. The standing stones at Callanish on the Isle of Lewis, Outer Hebrides **preceding spread** were shot on a Widelux camera.

The Great Sand Sea of Tarhit, Algeria, **left**. Shot on 400mm lens with polarizing filter. Arrived too late for the desired shot, but the camel presented itself. Picture would be nothing without camel. Camera was mounted on tripod, polarizer used to cut reflection of light and bring out modelling in sand. Sand dunes best shot in early morning or late afternoon light.

Haggar Massiff, Algeria, **above**. 300mm lens, no filter. Taken just as sun appeared to left of picture. View extends about 100 miles. Major problem was wind which shook camera, even mounted on heavy tripod, during $\frac{1}{4}$ sec exposure. Sun takes time to rise, so it is easy to run out of film early. As it was cold cable release was fired from pocket.

Landscape

Most beginners think that the wide angle is *the* landscape lens, but telephoto lenses, especially the 300mm, are effective. When focused on infinity, the landscape is compacted into the picture and is rich in shapes. From a high vantage point on a clear morning a view of 80–100 miles can easily be seen. To get all that into a picture and take it home with you is worth all the effort.

Choose your position and lens with care. Many of the great landscape painters cheated. They moved rock outcrops, even mountains, a few inches on the canvas to make the composition work. Photography may lie a little but it doesn't cheat.

Graduated filters are useful to hold detail in the sky while retaining foreground interest. The polarizing/red filters on extreme wide angle lenses also add drama to the sky. It is an interesting exercise to photograph a favourite landscape from dawn to dusk. Choose a time of year that usually has an interesting weather pattern.

It is very frustrating to be driving along in fantastic photographic weather, like pre- or post-thunderstorm light, and not have a subject to photograph. It is risky to chase sunsets because they disappear fast. Keep a good contour map in the car, so not only the roads are marked but the lie of the land and interesting features are apparent. Use a compass so you can work out where the ball of a setting sun will drop.

A keen landscape photographer will get to know the weather pattern quickly. It is not a problem in many parts of the world, where the weather acts in a predictable way, but if it is changeable, use it.

Tanzania. Shot at midday with a red filter fitted to emphasise clouds. The truck arriving at the point of converging perspective becomes focal point of picture. A 20mm lens was used. Big empty landscapes, such as this, need something in the picture for the eye to hook onto.

Scotland. Day for night effect was achieved with red-blue and polarizing filters. Shot at mid-morning in autumn. Lens used was 35mm, aperture f11. As filters increase exposure heavy tripod was necessary. Filters only marginally affect sharpness, but had shot been taken at night it would have been less sharp.

Northern Portugal. Taken during a lull in thunderstorm with a graduated filter on 35mm lens. The camera position had been selected in advance but heavy dramatic sky was needed to emphasise mood of location which was site of a decisive battle during 18th century Peninsula wars.

Many photographers prefer to use black and white film, because the print is tangible. The grain and tones in a black and white print are also in harmony with the natural textures of rock, grass, lakes, mountains, sky and clouds.

The colour landscapes in *National Geographic* magazines often include a back view of the photographer in his 'special issue' red jacket. The eye goes straight for the red then wanders around the picture, taking it all in.

Equipment

In addition to a selection of lenses and filters a heavy tripod is a necessity. A spirit level enables compositions to be made with level horizons.

A Widelux camera or panoramic tripod head enable the biggest vistas to be photographed.

Carry a compass and binoculars. Do not be lazy and shoot out of the car window. Leave the vehicle and move around, looking for the best camera angles.

Aerial

From the air the world is seen as one huge and incredible graphic design. Familiar cities and landscapes become a series of shapes made of light and shade. In composing pictures which use these shapes to their full potential a zoom lens and motor drive are useful, although the most important factor contributing to successful aerial pictures is preparation.

In a light aircraft or helicopter there will be so much noise that it will be impossible to hear if the camera is working properly. Check it thoroughly before taking off. Once on board the plane make sure that all bags and equipment are strapped to seats. When the door is open (as is usually the case when taking pictures) a fast bank will send any loose gear sliding towards the open doorway.

Always brief the pilot thoroughly before take-off. Explain the targets and the angles from which to approach. Ask him to let you know where the aircraft's shadow will be. Ask him to make rudder turns rather than flap turns which cause the plane to bank steeply. Rudder turns keep the aircraft on a more even keel. The most suitable types of aircraft from which to photograph are the high wing monoplanes such as the Cessna. The wings do not intrude into the shot and there is less turbulence around the windows.

The best time to shoot pictures from an aircraft is early morning (up to two hours after sunrise) when the light is fresh and clean, and late afternoon (two hours before sunset) when the shadows are once again getting longer and the light is full of colour.

Unless the sun is catching a bright reflective surface, such as water and glass, and throwing a strong highlight, exposures should be easy. As the light is so direct when looking down from the sky, automatic exposure cameras can be used with confidence. If it is hazy, underexpose slightly. On clear days the atmosphere tends to make colours appear cold, so 10R or 10M filters can be used. When shooting black and white film, orange filters are effective. Polarizers can be used to cut reflected light, especially in the heat of the day.

Bracket exposures to cover all possible effects of design. As the subject is a long way from the camera the sharpest possible film should be used. Kodachrome is perfect here, although it may be too slow to use all the time. Bear in mind that aircraft vibrate considerably, as do their passengers, so the fastest shutter speeds should be employed. Ideally, try to shoot at 1/500 sec, and never slower than 1/250. Use the heaviest camera available and keep it on a short strap.

When shooting through open win-

dows, avoid the use of rubber lens hoods, which distort in the wind and fold back onto the lens causing a vignette effect.

At high altitudes be aware of the sun's angle. It is brighter above the cloud layer and often bursts through into the aircraft. Ensure that it cannot hit the back of the camera and affect the exposure by entering through the view finder.

While aerial photography from light aircraft is a pursuit limited to specialists and those people lucky enough to know pilots, there is great potential

The oil rig on the preceding page was shot with a 2A filter to accentuate the colour of the sunset. A zoom lens was used to control the composition of the harvesting scene. The shot from an Airbus window was taken with a red filter fitted to darken the sky.

for picture taking when flying on scheduled aircraft.

The most common problem when shooting through the window of an airliner is the intrusion of reflections on the inside window. These can usually be eliminated by cupping the hand around the front of the lens and pressing that against the window. Use of a rubber lens hood is also an effective way of cutting out the light. If there is plenty of room throw an airline blanket over the head and shoulders to cut out all chance of reflections.

The pictures to be made from airliners include glimpses of exotic wilderness such as the North polar regions, desert and mountain ranges. The top surface of cloud layers and the moon are also impressive sights well worth photographing. On a long flight the captain of a jet may give permission for shots to be taken on the flight deck. Pick a relaxed moment to ask, and be as pleasant as possible.

Marine

The underwater environment is truly another world. Everything about it is different from dry land and, unless you know exactly what you are doing, it is a dangerous place to be.

It is not necessary to dive deep in order to enjoy the use of the Nikonos underwater camera, or the special housings which are available to take any make of 35mm camera. Exciting pictures are to be had from shooting on the surface, from half in and half out (as in the picture on the preceding page) or even from the shore or in a swimming pool.

Water is never consistent. Whether diving in the ocean, lake, stream or swimming pool, the biggest photographic problems are to do with exposure and rendition of colour.

Much light is reflected off the surface and even with specialist underwater exposure meters accurate readings are hard to achieve. Light is filtered through the water, often causing readings to be about $\frac{1}{3}$ stop underexposed. Open up between $\frac{1}{4}$ and

$\frac{1}{2}$ stop over the meter reading. Electronic flash is essential in murky conditions, but much of the light bounces off minute particles suspended in the water. The key to good pictures is to keep the distance between camera and subject to a minimum and bracket exposures.

To capture the great range of underwater colours, the use of colour correction filters is essential. Clean sea water gives a blueish green to greenish blue cast, dependent on the clarity of water, the depth, type of sea bed, and colour of the sky. Hot and cold currents also create differences in colour. Swimming pool water usually has a blue cast.

The major difficulty is to record the warm colours in the red-orange range. The use of filters is often purely experimental. Begin with a 10R working up to a 40R for the greenish blue and then try yellow filters from 10 upwards for the blueish casts. Near the surface the 30R is most useful. Seacors Sea Filter IV is also a good general pur-

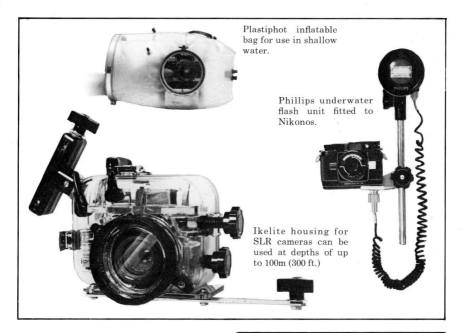

Plastiphot inflatable bag for use in shallow water.

Phillips underwater flash unit fitted to Nikonos.

Ikelite housing for SLR cameras can be used at depths of up to 100m (300 ft.)

pose colour correction filter.

Filters which are screwed directly onto the lens must be fitted underwater to allow a liquid surface to meet both elements. An air pocket will cause distortion, and the difference in pressure may also crack the filter. Lens hood filter holders are not attached directly to the lens element so this does not apply.

The lenses available for the Nikonos camera are all comparatively wide angle as refraction underwater makes images appear bigger. These lenses also necessitate working closer to the subject, which reduces diffusion of the image caused by light scatter. The extra depth of field is useful when shooting under low light levels.

It is not essential to use scuba equipment for exciting underwater shots. Swim in shallow water with a snorkel, but wear a wet suit whenever possible. Lakes and mountain streams get extremely cold and even in tropical waters the suit offers protection from sharp rocks and jellyfish stings.

Mistakes underwater can be fatal. Before diving, learn about the physical and psychological hazards. Never dive alone. Once engrossed in photography it is easy to drift away.

Protect cameras from direct sun. Apart from affecting the film and shutter mechanism, heat will dry out the grease on the waterproofing seal. After shooting wash out thoroughly and re-grease seals.

Rough water reflects light off the surface, and ripples cause readings to fluctuate. Work out an average.

Light reflected off a sandy bottom gives about one extra stop.

Shoot close to the subject. The ideal distance is 1/5th of total visibility. (50ft visibility, shoot at 10ft).

Agfa reversal films are well suited to underwater shooting. They give natural warm tones with less blue cast than Ektachrome.

Colour negative films are useful because the results can be corrected.

Beauty

Beauty photography differs from other types of portraiture in that the photographer wishes to depict women at their most glamorous and romantic. This image of womanhood is specifically aimed at women, rather than men, and must appeal to female fantasies. The photography, which must be tasteful, requires the painstakingly clinical attitude of the still-life photographer. The top beauty photographers are highly skilled technicians able to bring the right expression out of the model at the decisive moment.

To achieve the shot on the preceding page, an 80-200mm zoom was used, with a Hasselblad Softar No 1 filter, exposed at f11. A gold umbrella was covered with tissue paper and placed right on top of the lens. Background was pale green Colorama paper lit from each side to make it smooth and even.

The model was sitting at a card table, on which she could lean her elbows and affect different poses in comfort. A white card was used on the table to bounce light back in the shadows on the face.

As the representation of subtle cosmetic hues is involved, a knowledge of the application of make-up is essential to the beauty photographer. Professionals use make-up artists, but amateurs should learn as much as possible for themselves.

The basic equipment illustrated above includes

Eyebrow brush	Sponge for base
Eyelash comb	Translucent powder
Eyelash curlers	Dip stick lipstick
Eye shadow	Tube lipstick
Mascara	Lip gloss
Kohl pencil	Lip brush
Pencil sharpener	Powder blusher
Eye shadow pencil	Cream blusher
Concealer	Blusher mop
Fluid base	Rouge mop

Foundations are not masks. They make a good skin look better, a poor skin healthier.

Dry skin needs thicker foundations; greasy skin needs fluid.

Concealers are invaluable for covering dark shadows and blemishes. Anything made lighter stands out—Anything made darker will recede.

Blend all make-up well. The best effects are with brushes. It takes time and practice to achieve perfection.

Cover the skin with talc before applying quick tanning cream so that the uncovered areas are visible. **Eyes**. Apply basic cover first. If using pencils, apply on top of the base. If using powder lighten eyelid with translucent powder first so the shadow will set better.

Emphasis can be applied with eyeliner: use only a thin line and blend it into the lash roots. Highlight with pearly or white shadow on top of the brown base.

Use bounced light off reflectors or umbrellas to make the face shadowless.

A soft focus filter with the lens stopped down smoothes the skin.

Experiment with other filters. A 2A (pinkish) or 81A,B, or C plus a 5R will give the skin a warm quality.

Cut out pictures of beautiful girls from magazines and file them. Try to copy or adapt the ideas you like.

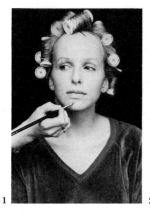 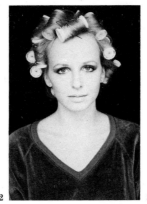 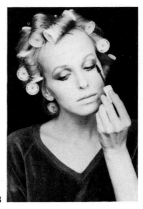

1 2 3

1. Base make-up. Use a concealer to cover dark shadows (under the eyes) and blemishes. Apply fluid make up with damp sponge and concealer with brush. Always use a base as close to natural skin tone as possible. Using a sponge gives smoothest texture. Blend away down neck and under chin to avoid a hard line.

2. Pencil on eyelid. Blend the pencil up into the brow bone with a brush to define the natural shape of the eye. Choose a colour which complements the model's hair and eyes. Natural colours such as browns and pinks are best. Stay clear of bright blues and greens which can appear as bright blobs. The eyes are usually the focal point, so effective beauty pictures depend on eye contact between photographer and model.

3. Put translucent powder over the eyelids, then apply more colour with powder shadow. This is used to define the shape of the eye and deepen the colour. Apply lots of mascara with an eyelash comb to separate the lashes. Mascara helps to open up the eyes. Make sure there are no blobs. Water soluble is best.

4. Apply translucent powder all over the face to

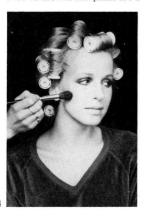

4 5 6

remove any shine. Then apply blusher on the cheekbones. This shapes the face and defines the cheekbones. Darken under cheekbones and lighten the top. Cream or powder can be used. Blend the blusher away to eliminate hard edges.

5. Lips should be outlined first with red pencil to define the shape. Fill this in with a slightly lighter lipstick using a small flat brush for best results. Use a touch of lip gloss on the bottom lip only to add highlight. Extend the line of a small mouth slightly. With a wide mouth keep inside the line and use lighter colours.

6. Final step is to uncurl the hair. Use a hair drier, blow heater or just flap a piece of card to give the hair life. Unless cutting is involved, hair should always be done after make up so it is not disturbed. It is important to use electric rollers to give hair body and sleekness (if that is the desired effect). Hair which is slightly greasy shows highlights better than dry hair. Freshly washed hair photographs badly. The wispy straw-like pieces stand out and look untidy.

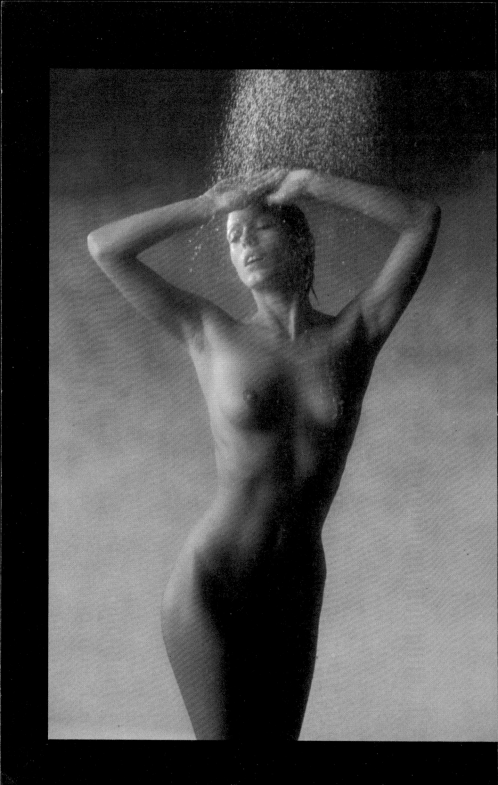

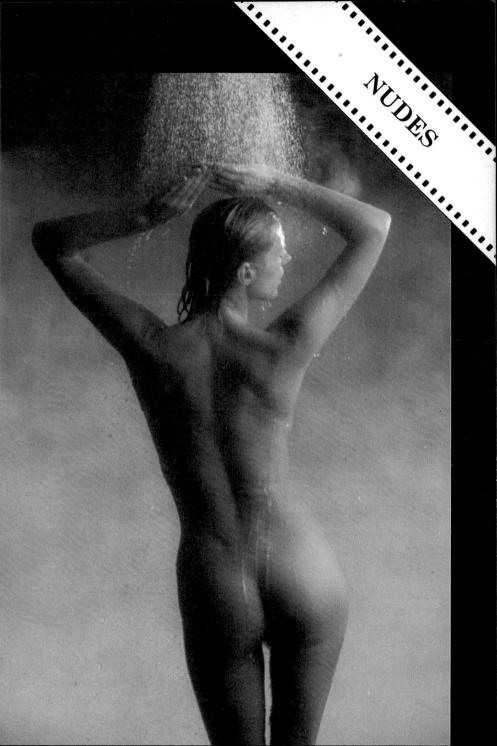

Nudes

Nudes are easy to shoot badly and probably the most difficult subject to shoot well.

The fantasy image of an extraordinarily beautiful Venus waiting in front of the camera, of whom a failed picture would be impossible, is just that—a fantasy. The plain truth is that there is no perfect body—most have blotchy skin and lumps in the wrong places. Once this has been understood nude photography becomes a pure exercise in lighting.

It must be kept in mind that a body is a collection of round shapes. Never light the body front-on as this will flatten those round shapes. Instead light from above or on one side and use reflectors where necessary. Basically the body must be lit to throw the imperfections into shadow, or away from the camera. Point the best features towards the camera.

When shooting a nude (even if the model is a friend) keep cool and create a casual, relaxed atmosphere. It is most important to keep the room or studio warm. Presuming that the photographer has his clothes on the temperature should be on the uncomfortable side for him. Cold skin does not photograph well. Blue blotches and goose pimples are not considered attractive. To make the nipples erect apply an ice pack.

Models should not wear underclothes for several hours before a session as elastic on panties, bras and socks leaves unpleasant marks. This must be insisted on tactfully. The marks take a long time to fade away, so ask models to wear loose clothes only.

Never bother to attend group photo sessions with a shared model. These are a vulgarisation of the spirit of nude photography and are hopeless for getting a beautiful picture.

The two shots on the preceding page were shot against Colorama continuous background paper which had been sprayed with paint. The nude was lit with two front/side lights bounced off umbrellas covered with tissue. The face was backlit with another lamp with snoot. The model stood in an inflatable paddle pool and an assistant on a step ladder poured warm water from a watering can with shower nozzle. The spot light at the back was used to highlight the water and steam.

The nude reclining on a mattress was lit by a single light source bounced off a gold coloured umbrella covered with tissue. The light was positioned directly above her on a boom. Softar and 81B filters were fitted. By using an 80-200mm zoom an almost abstract effect was achieved.

Whereas the female nude is shot to enhance the feminine curves, the male was photographed with a strong sculptural feeling. Baby oil was applied to his body to make the arms glow and accentuate the muscular form. A 300mm lens was used to isolate him from the background.

Pin-ups

A vital function of the glamour photographer is to make the model feel fantastic.

The fact that a pretty girl agrees to pose for pin-up pictures indicates that she wants to be extrovert and look sexy and glamorous. It is up to the photographer to draw that look out of her and release her inhibitions. That will not be achieved by being boorish and tasteless.

Try and capture on film the image which a girl would present to the mirror in her bedroom. Encourage her to pose so that she feels good, then adjust the pose to fit the shot.

Lighting should suit the model. Use strong midday sun or flash for an overtly sexy woman, a softer light for a more sensitive, feminine girl.

Choose clothes carefully to suit the model. If she has great legs show them; if great breasts show them. If she's got it, help her flaunt it!

The girl **left** was stret- ched out to flatter the body. A 180mm lens was used with a pol- arizing filter to hold the intensity of the gold swimsuit and the suntan. Such shots are best kept simple.

A 35mm lens was used **right** to slightly elon- gate the girl's figure. The background is a lace net curtain and a sheet of Rosco was used as a reflector to fill in the shadows. Backlighting is sym- pathetic to round shapes. Filtration was 81A and 5R.

Pictures of couples **left** are often consid- ered as glamour shots. They can be fun to do. The shot did not appear like this to the eye. There was plenty of detail in the people and the water. The gold shaft of light from the sunset attracted the photographer. By exposing for this light the couple were under exposed by three stops and reduced to silhou- ettes. This kind of effect can be visualised by stopping down to minimum aperture and using the preview but- ton. After reducing the shot to basic shapes, the models were care- fully positioned until seen in profile.

ANIMALS

Animals

Great wild animal shots require a lot of patience and dedication as well as a knowledge of wildlife. These shots are seldom the result of luck but are mostly taken by specialists who spend their life photographing animals. Each shot may take days of waiting. This should not put the amateur off, however. Beautiful pictures can be had by a combination of patience, concentration, luck and the right equipment.

A 200mm lens is just like a normal lens in the wide open spaces. A 300mm is the minimum length tele lens. A 500 or 1000mm is the most useful.

To make really good pictures of wildlife one must make a study of animal behaviour to have a better chance of anticipating action. A naturalist's sensitivity is as important as photographic technique.

On safari the best pictures will be shot early in the morning or late in the evening because that is when the animals tend to be most active.

Once an animal has been located (with the help of a good guide) the most important factor is total concentration. Keep the eye to the camera and constantly check focus until the animal moves into the right position for a good shot.

Be careful—even in a vehicle it can be a dangerous business. Wild animals move fast. Do not drive in where you can not get out fast. Unless there is a great deal of light use fast film so that the fastest shutter speeds can be used with the longest lenses, which do not have wide apertures and have to be used hand-held.

On an organized safari, when pictures can be taken from a car window or through a wagon roof, a bean bag is the ideal camera stand. If you do not have one made up, fill a carrier bag with small stones; balance it on the window and sit and wait in the vehicle until a shot presents itself.

The golden eagle on the **preceding spread** was photographed in a bird sanctuary on a 300mm lens fitted with a 2X converter. The converter allows the image to be held bigger —on the 300mm lens (with or without converter) the closest focusing distance is 4.0m (13ft). The 600mm lens only focuses down to 6.2m (20ft). It sometimes helps to be able to get that much closer.

The dolphinarium shot **right** was taken on a 180mm lens. Composition was the result of three previous visits to the show.

On safari in Africa. There is very little colour in the middle of the day so a polarizer should be used to cut reflected light and a warming filter to put some colour back into the picture. Both the shots **below** were taken on a 500mm mirror lens with a 15 Magenta filter. They were shot out of a car with the camera on a bean bag.

There are many safari parks around the world which are best visited on quiet days. Clean the car windows beforehand; with the lens pressed against the glass, picture quality should not be affected.

Animals

There is an incredible amount of wild-life around the average city or suburban garden which provides a great challenge to the animal photographer, often more so than African big game. Take the opportunity to shoot pictures of the local wildlife and domestic animals.

When shooting nervous creatures, as most of them are, think of the first shot as *the* shot. Make sure of it; the noise of the shutter will frighten the animal and it may never return. With close-up shots of birds electronic flash is necessary to freeze them in motion.

Portable unit flashes are of such short duration that many birds do not even notice them. Those which do see the flash often get accustomed to it quickly.

To get the best results be single minded about which variety of animal you wish to photograph, then determine the best location, season and time of day. Let the animal settle and never frighten it. Even small animals need room to escape. If cornered they may panic and you could be in danger. Never get between an animal and its food.

Choose clothes to blend in with the scenery. Do not wear silvery items like belt buckles. Cover shiny equipment with black tape. Even cover yourself with camouflage netting if necessary. Carry a selection of bait such as bread for birds and honey for insects. Binoculars are also essential for scanning the horizon when working in the country.

When shooting at a zoo or marina it pays to know the times for feeding or displays. At the marina watch the show through once while looking for the best viewpoint.

The blue-tit was photographed from the kitchen window. Birds are used to the activity in the house so are not bothered by the camera shutter. Guy the gorilla was one of London zoo's favourite attractions. The shot was overexposed by one stop to hold detail. A small hand flash was mounted on the camera to photograph the cat— again overexposed to hold detail in the fur.

To be consistently successful when photographing shy animals or birds, such as the otter **above**, one must use a hide. Birds are particularly nervous of movement.

The simplest type of hide is made with four stakes knocked into the ground and covered with canvas, leaving spaces through which to shoot. Over the years nature photographers have come to realize that a hide need only be the most simple structure. Its purpose is only to hide the photographer; it does not need to be camouflaged or made to look like a tree.

For shooting birds in their nests, the hides sometimes have to be built in a tree or at least high enough off the ground to see into the nest. Study the species thoroughly before investing the effort needed to set up a hide.

Once the hide has been set up it may take hours before the animal shows itself. Be prepared for a long wait.

Architecture

The architectural photographer's primary job is to interpret another person's art. The more the photographer knows about a building, such as the intended function, the materials used in its construction and its history, the better the picture will be.

The main consideration when photographing architecture is light. The best photographer may spend several days checking the appearance and atmosphere of a building at different times of the day and during the evening with the interior lights on. It is extraordinary the change that takes place in a building with a change in the light conditions. On a dull, cloudy day a building may be flat, grey and boring, but late in the afternoon the clouds will clear and it will be bathed in gold light—suddenly appearing beautiful and alive.

Buildings, like people have different appearances and personalities, and they should be shot to bring out this personality. A sparkling, brash new building may be best shot on a sunny day with the hard light picking out the steel and glass. With the help of a polarizer its uncompromising hard edges will stand out against a dramatically dark blue sky. On the other hand a Georgian terrace may be

at its most charming at dusk, with soft, warm, natural light and a few lamps shining in the windows, perhaps using an 81A filter to bring this warmth to the fore. At dusk, good shots can be taken of a building when the interior lights, or external floodlights, are first turned on and there is still some blue light in the sky.

A compass is a great asset for photographing architecture. Calculate where the sun will be all through the day and plan for it.

Essential accessories are a polarizing filter for colour, and orange and red filters for black and white film. Perspective correction lenses are necessary for correcting verticals—although one can often shoot from half way up a building opposite and avoid distortion.

Be wary about lighting interiors: only light for photographic necessity, without conflicting with the architect's design.

The Mosque near Karachi, **preceding spread**, is a building of great architectural significance, built by the designer of the Taj Mahal. The shot of London's Roman Catholic Westminster Cathedral was exposed for the floodlights on tungsten film which exaggerates the blue of the sky. A perspective control lens was used.

A telephoto lens was used **above** to compress the highrise buildings, giving a feeling of the modern city.

The shot of the Roman baths and Bath Abbey **right** was taken on a 20mm wide angle lens. Composition was made from the air with the photographer standing in a crane bucket.

The Central Hall at Mentmore, England **far right** had so much depth that a Widelux camera was used to contain the image. A camera position must be chosen which does not create too much distortion. The camera was used with a table top tripod pressed against a wall.

Travel

Good travel photographs come from good trips and good trips come from good planning. Don't buy a new camera or lens just before going on holiday; test and be familiar with all equipment before leaving.

Don't only look for the obvious—the panoramas, the strange clothes, all the things that are different from back home. Have an eye for the details. Remember that you will show your pictures to friends on your return, so try and give them the atmosphere and feel of the place. This is sometimes better done with three or more detail shots rather than one general picture.

The best pictures are the result of thought and effort. Even though most travellers only hope for a snapshot with which to remember the good times, it is well worth waiting until the subjects of a shot place themselves in pleasing compositions, as have the old couple **above**. Although the picture of the girl on the camel is a snapshot it took some time to get her and the camel in the right place with the right light for the picture. Do not rush travel pictures.

Shooting both colour and black and white when travelling can be a problem, as each needs a separate photographic approach. Sometimes the 'human family' type of picture works better in black and white, when colour would detract from the essence of the subject.

It is better to travel with a positive interest in something, rather than a 'today's Monday, must be Mexico' attitude. Carry a camera at all times; the miniature types are eminently portable. If you miss a shot you'll kick yourself—because you won't forget the image left on your brain.

Never put off a shot until tomorrow. The chance may not be there—and neither might the photographer. By all means return to the spot later, but take the shot anyway.

Do not photograph military installations. Even civil airports have restricted areas, so be careful. Military type clothing should not be worn in countries where there is, or may be, trouble. Nobody wants to become a POW on holiday.

Respect other people's cultures. Never intrude into places of prayer or private areas. Ask permission to take pictures but be prepared to sneak a shot if the answer is no. Be discreet and always polite—so you don't foul it up for another photographer later on.

The ability to 'lens' a picture is one of the traveller's greatest assets. Overhead electricity cables, which appear in street scenes all over the world, can be a nuisance. Shoot in low light and push the film. This minimizes the unwanted lines.

Professional photographers clean their cameras every day, immediately after returning to base. At the same time captions can be written while the memory is fresh, notes can be made and the next day's shooting planned. Do this as soon as possible. Be methodical.

Take along a Polaroid camera, if for no other reason than to give pictures away. Local children can be a nuisance if they are begging for gifts. A picture is more useful than chewing gum.

Most photographers shoot film in 36 exposure rolls, but film which is only used for specific types of shot (such as 400 ASA negative, type B colour, slow black and white) are more convenient in 20 exposure rolls. These rolls can be finished in one go without having to be rewound and the cassettes marked off.

A waist level finder is useful for shooting people if you do not want them to react to the camera. Right angle lenses, designed for shooting around corners, take so long to aim and focus that they become a liability, often making an exhibition of the photographer.

For many people travel is an experience shared with the family. When carrying assorted hand baggage, cameras are often incidentals. Photographic necessities can be carried in the adapted jacket described on p189. An automatic body should be fitted with an 80-200 zoom. In one of the pockets carry a 24mm lens wrapped in chamois leather, and fill the other pockets with a range of accessories.

Travel

Read all about a place before visiting. A knowledge of local customs, main features and interesting events is helpful and it doesn't detract from the excitement of first impressions.

Try not to travel with a group, as photography is a single minded pursuit and unsympathetic people will affect the concentration needed to take good pictures.

Do not cover too many places in one day, or overshoot on the first day in a new place. There is a tendency to do this due to the excitement. By overshooting early on it is also possible to run out of film, just when the feeling of the place has been absorbed and the film could be put to its best use.

It is often best to choose a location and wait for the action to come to you. Stand back and observe before shooting a number of frames.

1. Spetze, Greece

2. Tuareg, Tamanrasset

3. Malindi Beach, Kenya

With a 35mm lens a composition has a strong curve (1) in sympathy with the shape of the boats. A 35mm lens was used (2) to 'pull' in black background. Shot (3) was taken on a Nikonos with a 35mm lens. The hard light has turned the figure into an abstract shape. A figure in a landscape is always a good subject. People going about their daily business (4) always make interesting shots. An 180mm lens was used. A 500mm mirror lens was used to make the sun big (5), balanced to the silhouette of the mosque. Isolate pleasing pictures (6) by use of lenses. The 80-200mm zoom allows tight pictures to be composed. The contrast between figures and buildings (7) is emphasised by the 20mm lens. Muted colour is as effective as a vibrant full colour picture. Strong sunlight picks out the golden domes (8) and is not affected by

4. Kashmir Village, India 5. Istanbul Mosque, Turkey

6. The Algarve, Portugal

7. Central Park, New York

8. Kremlin Church, Moscow

9. Trooping the Colour, London

10. Shepherd, High Atlas, Morocco
11. Riviera, France

the polarizing filter which has darkened only the sky. At an event like (9) one can either shoot wide angle or look for details as here, using a 108mm lens. (10) was shot from a car on a 400mm using a bean bag for support. (11) shot at 3 p.m. was exposed for intense highlight, everything else has turned dark. Always bracket in these conditions. A 105mm lens, wide open, held (12) 'off' the background. Use of 80-200mm zoom in the shade light (13). A simple direct composition with just enough white around the hat for emphasis.

12. Kafir Kalash, Pakistan

13. Priest, Corfu

Travel

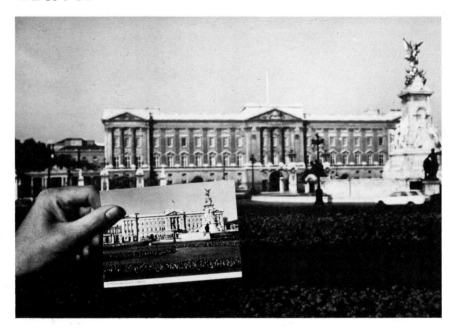

When visiting a foreign town buy post-cards of the places of interest. If the visit is short the cards will help save time: they enable the sight to be selected and, if there is a language barrier, they can be used to show cab drivers the destination. Once at the sight look for the camera angle the professional postcard photographer had chosen and try to produce a better shot. Then walk around and photograph the location from different angles with different lenses and filters.

Note the position of the sun and calculate the time when the light might be better. If necessary return to the spot for a better shot.

Do not be put off by unfavourable weather conditions; it is possible to get a unique picture of a location that has been photographed a million times before. Find out if there are any special events taking place while you are in town.

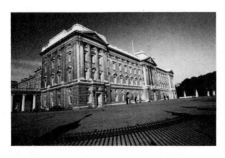

The camera was pushed through the railings. The shadows sweep the eye into the building. Shot on a 24mm lens with polarizing and ND filters.

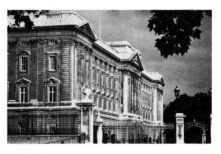

By moving away from the building a long lens could be used. Out of focus trees which fill the sky help the composition. Shot on a 200mm lens.

If an occasion draws the crowds make an effort to be in the right place. Get there early. Often one has to wait for the event to begin, so do not carry too much equipment. Photograph the people around you and their reaction to the event. These photographs of Queen Elizabeth II's

Jubilee Celebrations at Buckingham Palace were shot from the crowd. Take in the atmosphere of the event and look for detail pictures. Shoot from over the head if necessary. When the event is over wait around and see if there is anything of interest to shoot.

171

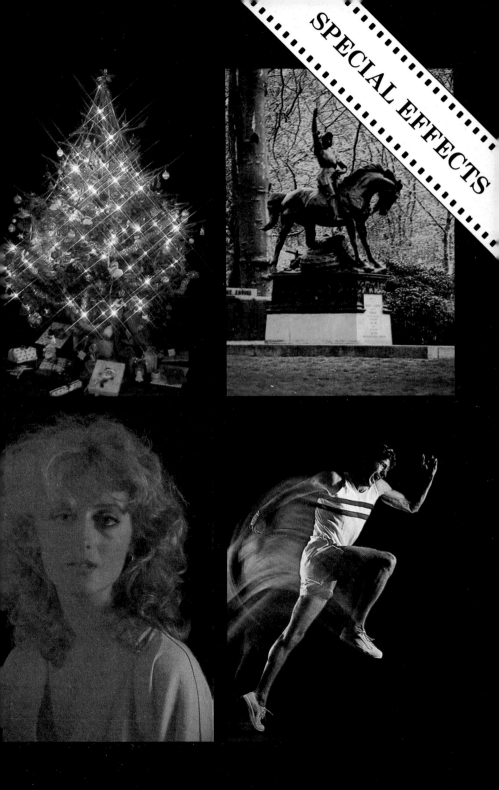

Special effects

Spectra X48 filter made by the German B+W company. This filter makes a rainbow coloured halo of any hard spot of light, in this case the sun. There are several types of Spectra filters giving either a prismatic slash of colour off a highlight or a starburst effect such as this.

Use of double exposure. First the girl was photographed against a white background which was overexposed by two stops on an 85mm lens. Then the lens was changed to a 24mm with a red filter and the wall was underexposed by two stops. Added together, the two exposures were correct.

Drawing with light. The girl was photographed with flash in a dark room standing against black velvet. The shutter was held open after the flash. The outline was drawn with a pencil flashlight, covered with red gelatine, held close to the girl, aiming at camera for about one minute.

A triangular prism filter has made one daffodil look like a bunch of five. The overlapping will depend on how close the subject is to the camera. If the prism is rotated on a long exposure the centre remains sharp, the outside becomes a swirl. Parallel prisms reproduce the image side by side.

174

Star filter. One of the most useful filters for any photographer and a logical one to use on a Christmas tree, making stars of the fairy lights. It works on any hard spot of light. The effect varies with aperture so use the preview button before shooting. Available from all filter manufacturers.

Infra red film exposed with a 60 Red filter. When using this film take incident light readings at the recommended ASA setting and bracket. In hard daylight results can be contrasty. For dramatic effect use strong filters. Experience is needed to predict the effect on colour.

Coloured gelatine over the hand flash has infinite possibilities. If the flash is set on automatic it should be the same distance from the subject as the camera is. Take care that the gelatine does not cover the electric sensor eye on the flash, as this will affect the exposure.

The camera was set on open shutter and the lens covered until the runner moved. He was lit by a tungsten spot and a reading taken for the highlights which gave a long exposure, so the movement would register. Two flash heads, in front and behind, were fired when the runner hit peak action.

Special effects/2

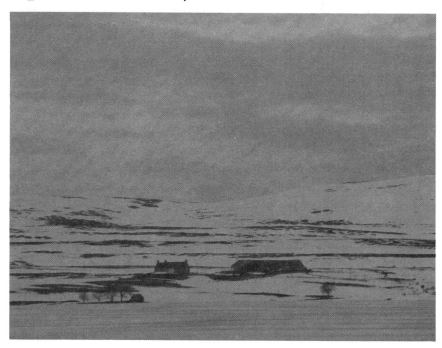

There are hundreds of filters on the market made by many different manufacturers. All of them have a special effect on a picture but sometimes the filter effect *is* the picture. If used too often, any special effect can become boring. Anything placed in front of a high quality lens is going to affect the quality of the film image, even if only marginally, so where possible buy filters made of optical glass. Cheap polarizing filters don't give the correct reading when used with a TTL metering system.

There are several filters that the photographer can make himself. Rather than put vaseline on a clear filter, put it on a 10″ x 8″ sheet of glass and hold that over the lens. This allows the photographer to control the extent of the blurred softness in the picture.

A spun glass ash tray or the bottom of a drinking glass over the lens breaks the image up interestingly.

A black silk stocking stretched over the lens is used a lot in the movie industry as a soft focus filter. The best soft focus filter on the market is the Hasselblad Softar series 1 to 3, but a step ring is needed to fit it to 35mm camera lenses.

When using graduated filters, check the picture with the preview button. If stopped down too much on a wide angle lens the join of the filter will show in the picture. Shoot as wide open as possible. Using a polarizing filter in combination with the graduated filter creates an even better image but be careful with the exposure, and bracket.

Pop filters transform the colour of a subject to the corresponding colour of the filter.

Coloured polarizer **top left** used on a snowscape, is two filters in one. By rotating one, the band of polarized light is coloured. A feeling of speed is accentuated by parallel prism 6 filter **left**. Half is clear, the other half registers visual echoes. The **keyhole filter** should, like any mask, be used with the lens stopped down for sharpness. The split field filter **right** holds sharpness on infinity and close to the camera.

177

Special effects/3

The photographer should be able to adapt the many forms of lighting to specific shots that the eye cannot see.

These pictures demonstrate a cross section of what is possible. A strong light was placed behind the girl smoking. This created a halo around her which was accentuated by the Softar filter. The lens was stopped down to f16. The soft skin tones were maintained by reflecting the light back into the face. This picture and the girl with the 'exploding hair' were both shot on an 80-200mm zoom lens. The lighting set-ups were similar; a tungsten light behind and a flash at the front were balanced. Zooming the lens during the one second exposure created the streaking hair effect.

The male pin-up was shot with flash and natural light. A meter reading was taken off the sunset sky, then the figure was given one stop more light with the flash (sky f11, figure f8). This underexposed the sky. Using this method it is possible to hold sharpness throughout the picture. Bracketing and a tripod should be used. Some hand flashes have wide or narrow beam settings. Using the narrow setting with a wide angle lens will give emphasise to a particular area of the picture.

The hammer hitting the egg was shot with the Nikon Speedlight synced with the motor drive, set on multiple exposure. This makes it possible to take a series of frozen actions on one picture. A different technique was employed for the girl walking upstairs. The camera was set on open shutter, in a dim studio. The flash was manually triggered as she moved.

By using complementary filters on the flash and camera, it is possible to colour the background without affecting the foreground.

With an orange filter over the lens the whole image becomes orange but by putting a complementary blue filter over the flash head the two filters will cancel each other. What is lit by flash will now be normal but this has a localised effect and the background will still be orange. It sounds straightforward but some experimentation is necessary to be able to predict the results confidently.

Special effects/4

Zoom lenses can be used to create several types of special effect shot. Exposures have to be long, so mount the camera on a tripod. Most of the pictures on this page were taken with an 80-200mm zoom lens.

In the shot of the tennis player the ball was stuck to the racket. The first exposure was made with the lens set on 80mm for about 1/3 second, then another exposure was made while zooming slowly to the 200mm setting. The player had to remain still throughout. It is hard to gauge the exact exposure and the amount of zoom so bracket with various combinations. When trying to record a highlight streak, shoot against a dark background.

The night time traffic and signs were exposed for about three seconds; one second with the lens on 200mm, then two seconds as it zoomed back to 80mm. Bracket to get the correct

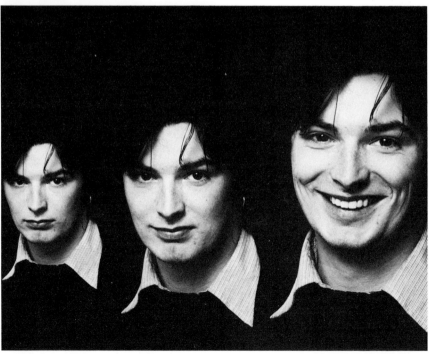

combination of zoom and exposure.

To expose three heads on one frame, mark off the viewing screen in three sections. Stand the subject against a black background and light with flash. Make three exposures with the lens set at different focal lengths.

The photograph of a bridge which appears to be melting was taken on a perspective control lens which was moved during the 2 second exposure. This movement creates the streaks.

An experimental kaleidoscope lens can be made easily by taping together some small hand mirrors. The shot illustrated used four such mirrors which were placed over a 20mm lens. The centre remains unaffected but the rest of the picture comprises broken segments of the overall view.

Other effects can be made with lenses. One of the most simple involves changing lenses half way through a double exposure. Use two lenses with markedly different focal lengths and halve each exposure.

Special effects/5

Many special effects can be created in the camera or darkroom without resorting to filters, special lenses or lighting tricks.

Movement can be introduced into a still picture by mounting the camera on a tripod and making a long exposure. The shot of the girl who appears to have moved was created by moving the camera. Two thirds of the exposure was made as normal and the final third was shot while the camera was moved. Use the tripod column to achieve vertical movement and the pan and tilt head for horizontal movement.

There are several ways to use a projected image. The most commonly used are front projection or back projection. Back projection can be used to create an exotic location in the studio. A special screen is needed which allows the image to come through. Make sure that the beam of light does not travel down the path of the lens or it will be visible.

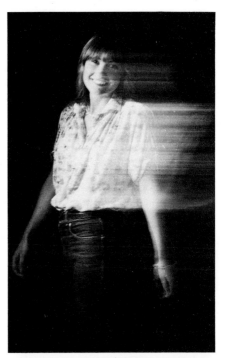

Excessive grain **left** can be achieved with any film by over rating and over processing, or by using special developer.

Colour films put through the wrong developer give heavy grain and interesting colour changes. Infra-red colour film produces unusual results but only experienced photographers can predict them.

Black and white infra-red film gives a unique semi-negative effect **below**. Exposure is difficult to calculate without experience. Infra-red film also creates problems with focusing. The emulsion is thicker than normal so the film plane is in a different place. Use the I.R. scale on the lens.

The photograph showing an artist's impression of a black hole behind a professor of science involves front projection. An image is projected from the same side of the screen as the camera, fitting two images of different size into one picture. Be careful of shadows on the screen. To obtain a soft pastel colour project a slide onto a matt white card and re-photograph it.

Photographing the reflected image in a convex truck mirror gives a simulated fisheye effect. When working in confined spaces it can be used instead of an ultra-wide lens. Place the mirror at a strategic angle. Do not focus on the mirror but on the image, which will usually be close to the infinity end of the scale. Look out for backwards writing. Another way of obtaining a distorted image is to shoot through a fresnel magnifying lens of the type used on the rear windows of vans and buses.

Travel with the camera

Before embarking on a trip, make sure that camera equipment and film are insured for their replacement value. Many household policies do not cover camera equipment abroad, nor if it is left in the boot of a car.

In case hotel security is suspect, carry a cycle lock with which to fix the handle of the camera case to the plumbing. It is also worth considering that an obvious camera case might attract the attention of thieves. Some globetrotting photographers conceal their camera cases inside less conspicuous luggage. In some countries, particularly behind the Iron Curtain, airline security for internal flights disallows the carriage of cameras as hand baggage.

It is wise to carry several lists with the serial numbers of the cameras and lenses—but only put the value on one. Some countries will permit the temporary import of camera equipment up to a certain value for personal use so declare the equipment to that value. The Customs' main concern is that goods are not re-sold in their country. Having a list ready saves the Customs officers' time and looks efficient. It will be stamped and attached to your passport. Do not lose the list; surrender it on your departure.

Some countries subscribe to the carnet system whereby equipment of value may be imported for a limited period without attracting payment of duty. Another way to safeguard against paying duty is to arrange with a home bank to lodge a bond in the main bank of the country being visited covering the amount of duty on the cameras. The traveller with one camera and two or three lenses will seldom have difficulties at Customs but some professionals have spent weeks trying to retrieve cameras which have been impounded. Avoid such problems by carrying the right papers.

How many cameras and lenses and how much film can be imported varies from country to country, so check with a travel agency or with the embassy of the country concerned.

Good pictures come from good preparation—which starts with packing. Empty the camera bag and start from scratch. You will now know exactly what there is and where it is. Check that items such as tripod screws, flash

Serious photographers should establish a method of captioning their pictures. There is no perfect way, although having a photographic memory helps.

Tape onto the back of the camera a piece of paper folded lengthwise into four, giving one side per film for eight films. Write a brief description of the shot and exposure details next to the frame numbers. Later, transcribe the information to a master caption book containing other background information. This method is good if there are a lot of difficult names to spell or if several cameras are being used.

The caption book is styled on those used by *National Geographic* magazine. They are made up of carbonized top paper, giving two copies. Again, use the frame counter as the initial guide but if there is doubt add a brief visual description of the picture. This makes the identification of processed film much easier.

leads, spare batteries and filters have been included.

Pack the cameras with the shutters uncocked so that there is no strain on the shutter spring. The lenses should be set on the widest aperture so there is no strain on the iris. Also, make sure that batteries do not come in contact with metal objects and that nothing is pressing down on a lever.

Wrong

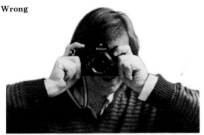

Hold the camera in the palm of the right hand with index finger on the trigger. Left hand supports and maintains focus. Use the right eye; this leaves room to wind on without moving the camera. Use the camera as if shooting a rifle. Make yourself stable, keep elbows in, feet apart. Squeeze the trigger; do not jerk it.

Right

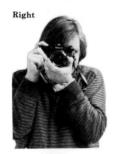

Wrong **Right**

The cameras are going to be subjected to bumps, knocks and vibration, none of which does a precision instrument any good. So make sure the corners of the camera case are sufficiently well padded.

Remove film from the camera if crossing politically sensitive borders; an official may open the camera regardless of whether there is film in there or not. Don't pack the Swiss army knife in your carry-on baggage as it is considered to be a possible hijack weapon; put it with the checked luggage.

If you run out of film abroad, check that the film you buy is in date. It is obviously better to buy it from a shop that has a large turnover. It is possible to have 'process paid' film processed in a country other than the one it was purchased in—as long as there is a plant there. But don't take the risk of expecting the processor to mail the film back to the home country. Don't post Kodachrome home in the yellow envelopes: it has been known to get stolen and then re-sold as fresh film. Mail the film in plain envelopes enclosing the yellow envelopes as a sign that process costs have been paid.

The cost of film varies from country to country. In some countries it is so valuable that photographers have used it as currency. It is always much safer to buy it at home, or from a respectable dealer or duty free shop.

All quality cameras are sold with world-wide guarantees so it does not matter where a camera is bought. As long as the necessary paperwork is returned it can be repaired under that agreement at home. If equipment is bought abroad keep all the paperwork. Carry photostats of all the receipts for everything in the camera bag to show the Customs officer on your return, even if the equipment was bought at home. The Customs know by the serial number on the camera whether that batch was officially imported.

185

Adverse conditions

Cameras need constant loving care and daily attention when they are being used in adverse conditions.

Extreme cold. If a camera is to be used in conditions below −32°C (−25°F) the oil should be changed for one of a much finer grade. The normal camera oil congeals at sub-zero temperatures, rendering the camera useless. Once a camera has been winterized, do not use it in normal temperatures as this will cause excessive wear. It is advisable to test the camera thoroughly in polar conditions (such as a cold store) before use.

Carry camera equipment in a hermetically sealed metal case. Leather, canvas and rubber lose their natural properties when they freeze. Cold canvas will snap like a piece of thin wood. Take plenty of gaffer tape to keep things sealed against fine snow and to cover metal parts which may come into contact with skin. Fingers, eyebrows and cheeks will stick to frozen metal. Torn skin is painful and takes a long time to heal.

Try to keep cameras at a constant temperature—bringing them into a warm room from the cold causes condensation to form inside the camera body. The moisture will then freeze on contact with the outside air. Put cameras in airtight plastic bags containing packets of silica gell before bringing them indoors. The condensation will then form on the outside of the bag and not in the camera.

Cameras are protected from the weather if worn under a parka anorak. However, if you start perspiring, the moisture will soon freeze on the camera. Snow landing on a camera which is warmer than the outside temperature will melt and immediately freeze. Wind-blown snow can be as fine as talcum powder, so make sure all hinges, cracks and joins are sealed.

Keep film as cool as the camera. Do not subject it to great changes in temperature as this can upset the colour balance. It is advisable, in adverse conditions, to use amateur E6 colour film rather than professional stock, as this has been manufactured for a longer shelf life and is more stable. Extreme cold 'freeze dries' film making it brittle, so do not wind on too quickly as the sprocket holes will rip. Be careful handling the film when it is cold as it can be razor sharp.

The light in polar regions can cause several exposure problems. For many weeks there is no direct light and in the summer it is bright and clean. Exposures in cold regions can vary from 1/500 sec at f8 with 25ASA film on one day to 1/125 sec at f4 with 400ASA film on the next. It is best to take a stock of every speed of film. In mountainous regions the light can be so bright it almost goes off the meter scale. Use polarizing and graduated filters to put some form and shape back into areas of snow which are reflecting the light. Battery powered meters are unreliable in these conditions so take a Weston Master or other selenium meter.

Tropics. The major problem in tropical conditions is high humidity. Fungus grows on film, leather and stitching rot and rubber splits. Sometimes creatures even take up residence in cameras. If there is not an electric dehumidifier available, keep the camera and film in sealed plastic bags with several packets of silica gel and keep these in a hermetically sealed camera case. Do not open rolls of film until they are required, and seal exposed rolls in plastic containers, also with a bag of silica gel. The gel can be dried out periodically by putting it into a domestic oven for a few minutes. Keep wiping the camera with chamois leather and use a UV or 1A filter to protect the lens.

Desert. Ground temperatures in the desert can be up to 50°C—if the cameras are left unprotected in this heat they become untouchable. Direct

sun on a camera is likely to melt the cement and glue holding the lens elements in place, causing them to shift if the camera is jolted. As the lens cools down the materials contract at different rates—this can also cause permanent damage.

Keep cameras in silver coloured cases to reflect the sun or make a foil covering for a soft bag. Avoid placing any case on the ground or on a car roof—allow the air to circulate around it.

Clean and maintain equipment at night when it is cool. Film should be stored in a metal case with a thick polystyrene inner case which is only opened at night. It will remain relatively cool all day. A camera wrapped in chamois leather at night will stay cool well into the day.

Air conditioning will cause condensation to form on equipment which is brought in from the heat.

Dust is a major problem. It is advisable to use a sealed Nikonos camera during sand storms. An ordinary camera is not a sealed unit but added protection can be given to it by applying vaseline or Nikonos 'O' ring grease around the joints of the meter head, lens mount, hinges and the grooves at the back. Apply it with care, using a cotton bud. The dust will be trapped in the grease. Tape over all exterior parts which are not in use such as the flash sync, motor drive terminals, battery check button, and levers.

Sea water and even salty sea air can cause permanent and rapid damage by corrosion to the metal work of a camera. The best protection for sea water is to insure the camera—if it falls in, claim for a new one as nothing much can be done to repair it.

Cameras which are exposed to spray should have the metal work wiped periodically with a swab of lint lightly soaked in WD40. Keep it off the lens and apply sparingly.

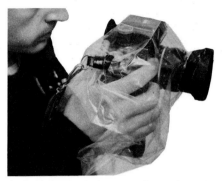

A plastic bag protects camera from rain, snow or dust. Cut a hole for the lens and secure it with tape. Keep right hand in the bag, left one outside.

A handwarmer strapped to the back of the camera stops the film going brittle in cold weather. It also keeps the face off cold metalwork.

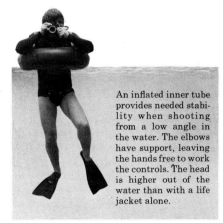

An inflated inner tube provides needed stability when shooting from a low angle in the water. The elbows have support, leaving the hands free to work the controls. The head is higher out of the water than with a life jacket alone.

Clothing

The lightweight combat jacket **right** is claimed by the U.S. Army to be insect proof. Extra pockets, taken off another jacket, were added on the inside and on the sleeves. Non-slip shoulder pads, made from corduroy have been added to stop the cameras and the bag slipping off. It is annoying to be constantly putting the camera back on the shoulders.

The jacket is really an overgarment. A standard safari or bush jacket is as good but will be more expensive and may be too tailored. Avoid man-made fibres and make sure it is loose fitting. All pockets should be secure. Velcro tabs are fine: they are quick to use and are noisy—which will hopefully discourage pickpockets. The sleeve may sound an unlikely place to have a pocket but with cameras round the neck, and the elbow bent when loading and reloading film, the sleeve pockets are accessible and the bulk doesn't get in the way.

The inside pockets should be deep. Carry a handkerchief and the chamois leather in the pocket to stop small things bouncing out.

Keep all official passes handy. If called upon to show a pass it is more impressive to find it first time rather than scramble around for ages. Some people have pockets on the thighs of their trousers for documentation and maps.

Jeans are fine, unless they are going to get wet and cold; then they are uncomfortable. Trousers should be strong, as time may well be spent grovelling, kneeling and lying on wet or rocky ground. The knees always seem to go first.

In politically sensitive countries avoid military style clothing. To some people cameras are closely associated with spies, so look like a tourist. Officials, armed or unarmed, are the same the world over: they are suspicious of photographers. So if you really want an official to be on your side and to do a favour for you, don't be outrageously dressed. First impressions count for a lot—and remember it is the picture that matters.

Wear cotton shirts with high collars, so the cameras don't cut into the neck; and with good breast pockets for money, passport and other important documents. A money belt could be worn if you really feel threatened. It is better to have things in separate pockets than everything in one. Really long hair gets tangled up in camera straps, but more annoying and painful is getting the front of one's hair caught up in the motor drive rewind. Photographers are on their feet for most of the time so make sure that footwear is sound. Don't break in a pair of boots on a job. Wear wool socks in most climates and cotton in the heat. Nylon socks can cause blisters and aching feet.

A fisherman's waistcoat has a lot of pockets. It is ideal for hot climates, where a jacket would be too warm. The fisherman's waistcoat is loose fitting and has a net shoulder area for extra coolness. There is ample room in all the nine pockets for the items on the opposite page. But there is also an added pocket on the back, for carrying a lightweight anorak in case of rain.

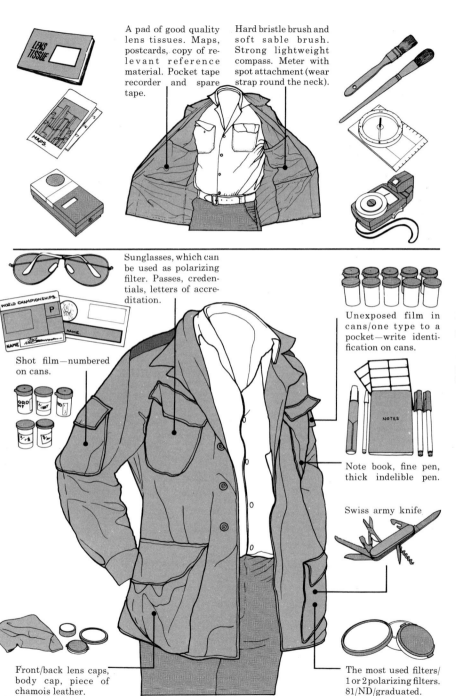

A pad of good quality lens tissues. Maps, postcards, copy of relevant reference material. Pocket tape recorder and spare tape.

Hard bristle brush and soft sable brush. Strong lightweight compass. Meter with spot attachment (wear strap round the neck).

Sunglasses, which can be used as polarizing filter. Passes, credentials, letters of accreditation.

Shot film—numbered on cans.

Unexposed film in cans/one type to a pocket—write identification on cans.

Note book, fine pen, thick indelible pen.

Swiss army knife

Front/back lens caps, body cap, piece of chamois leather.

The most used filters/ 1 or 2 polarizing filters. 81/ND/graduated.

Clothing/2

A photographer should never try to take pictures in the cold and wet unless he is warm and comfortable. When dressing for the cold bear in mind that long periods will be spent waiting for the right moment. Respect nature because it has the upper hand and be prepared.

A parka is a good all weather garment but always carry a windproof 3/4 length jacket (or *cagoule*). A cold wind can be lethal. When the chill factor is taken into account the temperature may be more than ten degrees lower than indicated.

Keep the cameras warm and dry, zipped up inside the jacket. Keep the batteries warm. With some cameras it is possible to keep the motor drive battery pack in a pocket with a short cable connecting it to the camera.

Never carry too much equipment. Energy is needed to keep warm. In soaking wet, dew, hill fog or condensation, keep the camera parts in plastic bags, and off the gound.

Jeans offer no protection at all in wet or cold. Genuine Harris Tweed trousers are good, because the wind dries the material quickly and they are always warm. A good investment is a cashmere wool roll-neck pullover, which is as effective as two normal sweaters. Keep waterproof footwear and a golf type umbrella in the car at all times.

A fisherman's **sou'-wester** worn back to front affords good protection in the rain when using short lenses.

You have to be sure footed when carrying equipment. Wear **training shoes** with non-slip soles on mobile assignments.

bumbag

A useful item of clothing to carry is a lightweight **showerproof anorak** to protect the camera in a shower.

An extra anorak can be used to cover a tripod mounted camera. It is so small it can be packed up and worn on the belt of a ski **'bumbag'**. The folded anorak makes a good ground sheet.

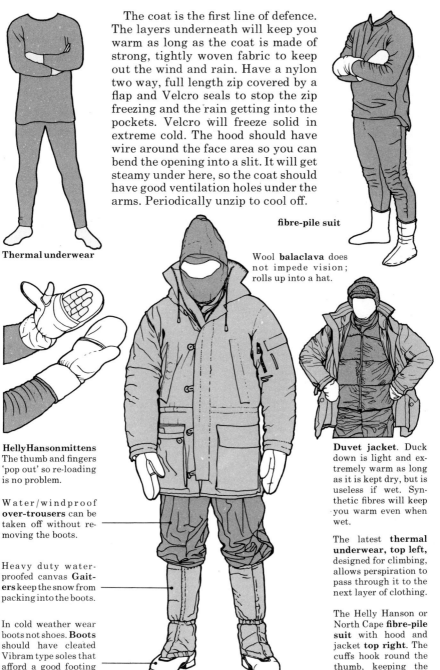

The coat is the first line of defence. The layers underneath will keep you warm as long as the coat is made of strong, tightly woven fabric to keep out the wind and rain. Have a nylon two way, full length zip covered by a flap and Velcro seals to stop the zip freezing and the rain getting into the pockets. Velcro will freeze solid in extreme cold. The hood should have wire around the face area so you can bend the opening into a slit. It will get steamy under here, so the coat should have good ventilation holes under the arms. Periodically unzip to cool off.

fibre-pile suit

Thermal underwear

Wool **balaclava** does not impede vision; rolls up into a hat.

Helly Hanson mittens The thumb and fingers 'pop out' so re-loading is no problem.

Water/windproof **over-trousers** can be taken off without removing the boots.

Heavy duty waterproofed canvas **Gaiters** keep the snow from packing into the boots.

In cold weather wear boots not shoes. **Boots** should have cleated Vibram type soles that afford a good footing on most surfaces.

Duvet jacket. Duck down is light and extremely warm as long as it is kept dry, but is useless if wet. Synthetic fibres will keep you warm even when wet.

The latest **thermal underwear, top left**, designed for climbing, allows perspiration to pass through it to the next layer of clothing.

The Helly Hanson or North Cape **fibre-pile suit** with hood and jacket **top right**. The cuffs hook round the thumb, keeping the wrist warm.

Travel/Medical

Eye strain is one physical complaint which is likely to afflict photographers, particularly those who alternate between a bright studio and the darkroom. It might also occur after spending hours over the harsh light of a transparency light box.

Many people worry about overworking their eyes but, if the eyesight is good, eyes will not be harmed by use, although deficiencies may become more noticeable.

Most people know not to look directly at the sun. If the sun is part of a composition, frame the picture with the lens stopped down. Also avoid looking directly at electronic flash lights; they can cause temporary loss of vision and after-images.

First aid box should include: eye ointment, eye wash, eye drops, bandage, antibiotics, water purifying tablets, glucose and salt, aspirin, travel sickness pills, antihistamines, sticking plaster, insect repellent, needle, iodine, alcohol and scissors.

Before setting out for an exotic location make sure that adequate sickness insurance has been arranged. Take precautions against the following diseases whether or not vaccination is a condition of entry to a country.

Tetanus. Caused by contamination of wounds. It is preventable. A course of three injections is spread over a period of at least twelve weeks.

Yellow fever. Transmitted by mosquito bite. An International Certificate of Vaccination is required by many countries.

Smallpox. Eradicated by the W.H.O. but probably still endemic in Somalia and Ethiopia. International Certificate necessary during epidemics.

Rubella (German Measles). Causes severe defects in unborn children if caught by pregnant women. Women should be immunized unless they have already had the disease.

Hepatitis. Viral liver infection. Have gamma globulin injections, which reduce severity of any subsequent infection, if travelling to Third World countries or Southern Europe.

Malaria. Can usually be prevented by taking anti-malarial pills for as long as the instructions state—before departure, while in a malarial zone and, most importantly after returning home. Insect repellent, mosquito nets and protective clothing help prevent mosquito bites which transmit the disease.

Amoebic dysentery. Causes diarrhoea and can lead to complications. Treated by tablets of Flagyl.

Photographers who often have to spend long periods standing around waiting should be aware of the following complaints.

Heat stroke. In hot climates the body quickly loses heat and needs a greatly increased intake of water. As salt is lost in the sweat, prolonged sweating can lead to salt depletion and cramps. In extreme heat with high humidity, body temperature can rise; and above 40°C (105°F) collapse can occur. Drink lots of water with a teaspoonful of salt per pint. If you begin to feel the effects of the heat, rest in the shade and sponge the body down every ten minutes.

Frostbite. This usually affects the extremities such as toes, nose, ears and fingertips. Touching extremely cold metal such as cameras can be dangerous. Wear protective clothing and keep moving. The onset of frostbite can be insidious and almost painless. If the circulation is cut off for too long gangrene sets in and fingers and toes can be lost. To treat, massage and warm the affected parts slowly.

Travel/Legal

In Iceland a permit is required to photograph nesting birds. In South Africa it is prohibited to photograph roads and bridges. In Jamaica the authorities disapprove of people who photograph beggars. In some Third World countries the main civil airports are also military bases where the strictest security regulations apply. Offenders who are ignorant of these local laws may lose the film in their camera and sometimes their freedom. Ask the advice of the embassy before visiting a sensitive country.

In most Western countries there are no restrictions on taking pictures in public places. There are laws on invasion of privacy but these generally apply to photographers only if their pictures are to be used for advertising purposes. In France a householder's privacy is invaded if a picture of the house is used without permission. If a photograph is used which suggests that a person endorses a product he or she may have grounds to file suit against the photographer.

A model release form signed by the subject will be the photographer's protection. This should be written to cover any eventuality, such as re-touching the finished print or incorporating it into a collage.

The more comprehensive the release form the less chance the model will have to sue the photographer. Whenever a paid model is used a contract should be drawn up which includes a section whereby they waive all rights to the picture and the use of their image.

Pictures of people in public places can be used for most artistic or editorial purposes, no matter how indiscreet the subject may have been. Events which are newsworthy are generally considered to be public property, as are the images of celebrities such as film stars who normally court publicity.

Pictures shot in private places like theatres, sports arenas and private houses are a different matter. Under local bylaws or conditions of entry a person taking photographs may be guilty of trespass and in some places equipment can be confiscated. In most British art galleries it is not permitted to take pictures, while some European and American galleries do allow photography for personal use.

The procedure for purchasing and publishing photographs varies from company to company. Some contracts involve signing away all rights to a picture, which then becomes the property of the buyer. Think carefully before selling photographs this way. Professionals never do it, unless perhaps a great deal of money is involved.

Other publishers have more reasonable agreements by which they purchase the rights to use a picture. If there is a repeat use in another context or country the photographer can expect to receive a further fee.

Clients who commission photographers often buy every shot taken on that job. In these cases, any personal shots should be taken on separate rolls.

In general the photographer retains copyright on his pictures, unless he has signed it away. Read contracts carefully. The copyright laws are confusing and in many countries they are being revised in favour of the photographer.

Work should never be submitted to an agency or publisher without a delivery note with terms clearly stated. Draft contracts are available from the national unions which represent photographers. Fees for use and penalties for loss, damage or delayed return should be stated. Without the client's signature the photographer will have no grounds for making any claims. Identify all submitted pictures clearly with name and caption.

Medical/Legal

193

Faults on film

Sometimes a roll of film which comes back from processing includes pictures which do not look at all like the ones you remember taking. The faults discussed here are common to all cameras and all types of colour and black and white film. Even the most seasoned professionals make mistakes occasionally but with a careful and methodical approach these faults can be avoided. The photographer must be familiar with his equipment but not to the point of contempt. The shots which are ruined are too often the ones you have been waiting to see.

Hair can get into the back of the camera where it lodges in the track in which the shutter runs. A similar, less sharp image appears if a hair is caught on the back of the lens. Check both areas when reloading film.

Unsynchronized flash occurs when too fast a shutter speed is used—usually over 1/125 sec. Check that shutter speed dial is not accidentally moved during use. Most modern SLR cameras sync at 1/90 sec or slower with all types of flash.

Shutter bounce is caused by a slack spring on the shutter. The trailing curtain bounces back instead of closing the shutter opening, allowing a fraction more light onto the film. An easy fault for a dealer to repair.

Fogging is what happens to the film if the back of the camera is opened. Wind film back after exposure. Usually five or six frames will be lost if the back is opened. If it is likely to pop open, tape the back shut.

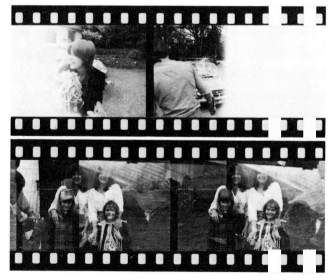

Double exposure. Even with several bodies it is necessary to change films in mid roll. To avoid double exposures write the number of shot frames on the leader of partly exposed film.

Motor drive fault 1. After loading a motor drive camera and winding on, it is usual to re-set the film counter. This shot is a result of not setting the dial correctly and winding on too much to begin with. The motor fired twice.

Motor drive fault 2. The motor drive dial was set on 1/60 sec but the actual shutter speed required and set on the camera was 1/4 sec. The result is that the film is transported during the exposure making highlights streak.

Rain drops on a lens act like small lenses and distort the picture. They are most noticeable on wide angles as individual drops, but on longer lenses they are just blurs. Use UV or 1A filters and a big lens hood in the rain.

Vignette is a rounding of the frame corners caused by the wrong lens hood or too many filters being fitted. Bellows can also cause vignetting if they are racked out too far. Check with the preview button, looking at a light area.

Flare. A hard light shining directly into the lens can either project the shape of the aperture opening **above** or create rings of light and loss of colour by overexposure. Wide aperture telephoto lenses are most susceptible and may need a French flag to mask the light.

Wind on. A camera is a precision instrument which can wear out. In this shot **above right** the wind-on is faulty. The shutter was cocked and ready to fire after the lever had only transported the film half way, resulting in overlap. This is another simple repair for a mechanic.

X-ray machines at many airports carry signs which claim they do not damage film. However, if the machine is at full power, there is a great risk to film although the effects may not be immediately recognizable. Colour reversal and b/w film take on a hazy milky quality. Older machines will ruin film—so be safe; carry the film through the body scanner.

Processing and printing

Unless a photographer is deeply involved in photographic chemistry there is little point in trying to develop colour reversal film. The best way to get consistently good results is to build up a friendly relationship with a local laboratory. Most small towns have a D&P (developing and processing) lab, but if there is not one in your area get to know the local wedding or portrait photographer. Such professionals usually do their own processing and they may put customers' film through with their own. A fee will be charged, of course, but these people often prefer to use their processor regularly as consistent quality is dependent on a consistent volume of film going through.

People who live in large cities will have a choice of laboratories; if in doubt as to which one to choose ask a professional where he gets his processing done.

Become familiar with the terminology to avoid being talked down to by laboratory assistants. Find a good small laboratory which will take time to discuss the results. An amateur can get some of his best advice from a laboratory worker.

All films which use the E6 process have the advantage that their effective film speed can be altered by changing the time in the first development bath. To double the film's speed (known as pushing one stop) the first developing process is run for an extra two minutes. Film can be pushed by stages of one half stop, or even by a third of a stop, in labs which give a personal service.

It is also possible to 'pull' films by cutting the development time by two minutes per stop. This effectively reduces the film speed.

The more a film is pushed the greater its contrast and the coarser the grain will be. Conversely, pulling the film

Pushing E6 films warms the colour. Cutting by more than one and a half stops makes whites go blueish. Some laboratories produce warmer results than others.

Take a clip test (two or three frames off the front of the roll) and calculate the amount of push or cut required to balance the colour. Send the remaining film back immediately. Colour balance of chemicals may alter overnight and especially over a weekend when the laboratories are not in action.

Black and white processing is simple. It requires very little equipment but lots of care. The effective speed of all black and white films can be altered by changing the development time. The contrast is also affected by development time, temperature of developer and the amount of agitation in the developer. But whether processing your

own film or using a lab, there is no point pushing up the speed of a slow film (and the grain and contrast) if a faster film can be used.

There are many different developers on the market; some of the most useful ones are: Ilford Hyfen for the sharpest results and fine grain on slow films; Agfa Rodinal for high quality at any speed, (this is a one shot developer thrown away after use); Aculux for the best possible grainy effect; Acu-special for best results with high speed film.

Processing colour negative film is not a complicated procedure; it just requires greater attention to time and temperature control than black and white film. Half the fun of negative film is that the user can do his or her own processing and printing and so exercise greater control over the results.

will reduce contrast and flatten the image. In a laboratory an under-exposed transparency is called 'thick' and an overexposed one 'thin'.

Hand processing is often preferable to machine work as the agitation is given greater consideration. Constant agitation of the chemicals gives brighter, cleaner colour.

High speed Ektachrome films can easily be pushed two or even three stops, if searching for grainy effect of if the exposure has been made under low light conditions.

Kodachrome films cannot be pushed or pulled and must be processed by Kodak or one of their agents. These are excellent films to use where processing cannot be done for a long time after exposure.

Anyone with a darkroom equipped to handle black and white, and an enlarger with a filter slide can make Cibachrome colour prints from transparencies. The process is simple and the quality excellent, and the printer has absolute control. The Cibachrome image is permanent and as it is printed onto plastic paper it is tough. Cibachrome is also remarkably cheap.

It makes more sense to print from a transparency which can be seen rather than use a negative which demands that the print be matched to a memory of the colour. The photographer can control the colour balance on the camera and produce the desired result. This is then the perfect guide for the print. If necessary the colour balance can be corrected. If the print is being made at a laboratory they will be able to refer to the transparency when they make the print.

By shooting colour negative and making your own prints it is possible to achieve effects that would otherwise involve far too difficult a brief for a laboratory.

As with shooting, colour printing is based on the principle of adding and subtracting complementary filters.

> **Kodachrome** is mounted by machine. An electric eye uses the black line between the frames as a guide to cut the film. If a picture has a strong overall black background with an off-centred image, there is a possibility that the machine will centre the image in the wrong place. Farther into the roll, pictures may be mounted with the frame line running down the middle. To avoid this happening, cut the right hand corner by the address panel on the yellow prepaid envelope and the film will be returned in one long roll.

Total familiarity with this principle and the practices involved is essential.

Printing houses can provide good cheap machine-made prints from average quality negatives or transparencies, but they must be thoroughly briefed. If the print is to be made from a difficult original it is best to order one larger than 10″ x 8″ as this format is too large for the machines and the printer has to control the process personally.

R types are taken directly from the original without an internegative. They are cheap but can also be of high quality. In the USA large good quality R types are obtainable from many private laboratories.

The Kodak C type system of internegatives is one of the best for quality. A negative is made from the transparency, then printed as normal.

An interesting modern development is the colour Xerox process. Cheap prints can be made from a transparency or print in a few moments. The quality is not photographic—the prints have the appearance of a printed page. Although Xerox prints do not have the contrast or strength of colour of Ciba or Kodak prints, they are well worth experimenting with, especially for sales presentations.

197

Retouching

The necessity of keeping developing and print work spotlessly clean becomes apparent as soon as the first prints reveal spots, water marks, hairs or scratches.

These blemishes are almost always on the film (whether negative or transparency) and when seen on the final print they are greatly magnified. The size of a 35mm frame limits the amount of retouch work that can be done on the film, so most often the blemishes are treated on the print.

There is also a creative aspect to retouching which elevates the craft to the level of an art form. Most of the dynamic photographic advertisements in magazines and on billboards have been heavily retouched, either to add emphasis to certain features or to eliminate less desirable characteristics. Many of these shots are actually composite pictures which have had the joins skilfully blended in by the retoucher.

Another aspect of the retoucher's work has been seen from time to time in news pictures from totalitarian countries. Once prominent figures have mysteriously disappeared from photographs at the hand of the censor's retoucher. No photographer should condone this practice.

Although artistic expertise is vital to the photographic retoucher, the process of 'spotting' a print is comparatively simple. Careful attention to detail and a firm hand are all that are needed. Black spots on white areas of a print are usually from pin holes in the negative. These are best removed by gentle scraping with a scalpel blade or by bleaching. White spots are the result of dust or dirt on the negative and these need to be painted out with a matching tone of photo dye.

Sometimes the overall effect of a picture can be enhanced by cleaning up unnecessary detail which detracts from the composition.

1 White out background to give prominence to subject. Mask with low-tack transparent masking film. Cut the film on the print—it takes practice to get the right pressure without cutting the print. Bleach with dilute potassium ferricyanide applied with a cotton swab.

2 Soften edges to avoid a hard outline to the head. Use permanent white gouache mixed with sepia water colour to warm the tone, (sepia gouache is not available). Apply with a fine brush.

3 Hair and fluff in the enlarger leave white marks. 'Spot' them out with photo dye suitably diluted. Use a small brush.

4 Black marks are from scratches on negative. Remove with a scalpel blade. Use gently—only scrape off the top layer of paper. Experience is needed to judge the required pressure. If you scratch too far the white paper can be toned with photo dye.

5 Remove chemical stains with sepia/white/lamp-black mix. Apply with air brush to get even, continuous coverage.

Brushes Palette Photo dye Gouache paint

Swab stick

Scalpel

An even tone is achieved with an air-brush. These are expensive pieces of equipment, run off compressors. To save on initial outlay, a foot pump or aerosol pressure pack can be used. Alternatively, a large inflated inner tube will hold enough air for all but prolonged usage.

① ────────────

② ────────────

③ ────────────

④ ────────────

⑤ ────────────

Reproduction

Seeing photographs appear in print is a great thrill for any photographer. Professionals should know what printing process is involved and what type of photograph is required for a particular job. Less experienced photographers who submit work to community newspapers, company house journals and club calendars are often disappointed at the quality of the picture on the printed page.

With modern processes there are some general rules which apply to black and white and colour reproduction. As it is only possible to transfer an even, continuous tone of ink from a printing press the effect of differing tones is created by breaking the image down into a series of dots of differing sizes. This is achieved by photographing the original image through a photo-mechanical screen which takes the form of a grid structure. It is the differing amounts of light transmitted from the original which determines the resultant dot size.

In photogravure printing the spaces between the dots hold the ink, while in letterpress the ink sits on top of the dots. One of the most commonly used printing processes is that of offset lithography. The screened image is exposed to a light source while in contact with the metal printing plate which is coated with a photo sensitive layer. The areas between the dot structure are exposed and on developing are washed out leaving a dot image which is receptive to ink. This image is transferred via a rubber blanket cylinder onto paper.

Before supplying black and white prints for reproduction, find out what size screen the printer is using. Newspapers use a screen of about 85 dots per square inch. The absorbent paper soaks up ink and finer dots would run into each other.

Newspapers are, therefore, unable to reproduce mid tones accurately.

Photographic prints should be hard and bright with four to five main tones in distinct areas. Have a dark tone meet a light tonal area wherever possible. A graduation from light to dark across the picture will cause the mid tones to block together like mud. If there is no dark tone next to it, a light tone will disappear into the white of the paper.

Many company reports and house journals are printed with a fine screen on good quality paper. Offset litho screens have up to 200 dots per square inch and give good reproduction of the tonal range. Gravure printing has long been considered the best process for reproducing photographs but many lithographic printers would claim that their process is as good. A magnifying glass will reveal the difference in quality between printed images.

For black and white reproduction it is best to supply printers with bromide prints—not the new glossy plastic paper which will flare under the lights of the process camera. The prints should be supplied larger than the finished result. All flaws and retouching will be condensed. All prints should be in proportion to the finished size, for instance one and a half times the final result. This saves the printer time and the customer money.

The use of 35mm transparencies for reproduction purposes has increased substantially since the introduction of electronic scanning techniques. The quality of the reproduced picture is as good as from a larger format original. Duping up to 5″ x 4″ or larger does not help—printers prefer to work from the originals and they also like all pictures to be the same format.

However, as the image size of a 35mm original is small, any blemishes on the transparency are enlarged, as is the grain structure. To the naked eye a transparency may appear in

Graphic arts photography is a process about which most photographers know little. This image was originally shot on colour reversal film, duped onto b/w negative and then printed in the second colour **above**. Another version **below** was made on orthochromatic (line) film.

The combination prints were made by laying rub-down line screens over the black image and printing onto a solid of the second colour. By utilizing a variety of screens and percentages of tone, a range of effects can be achieved with monochrome photographs.

perfect condition, but under the scanner's eye scratches show up.

Printers prefer to have underexposed rather than overexposed transparencies. If the colour is there they can bring it out, but if it is not they can only add so much before it looks unnatural—as is often the case with the blue sky and yellow sand in holiday brochures.

A series of colour transparencies supplied to a printer should be the same density throughout: getting an even match first makes the finished pictures better. Correcting an odd one in the series may alter the colour of several others.

Printers prefer to work from colour transparencies because the finished printed image is brighter. If they are supplied with a colour print it is re-

photographed on transparency film— but the finished print is flat and not as sharp as if it had been originally shot on transparency

Grainy and strongly textured pictures can look odd if the plates are slightly out of register. The subject matter of the picture can take on a completely different colour from the original.

The choice of paper is important in order to get faithful reproduction of a picture. Generally speaking, glossy art papers give a lift to a picture much nearer to the feel of the transparency; cartridge papers soak up the ink giving a flat matt finish to a picture. Both can add feeling to a picture, but always try to make sure that the proofs are printed on the paper that is finally going to be used.

Filing and viewing

Devise a filing system for negatives and transparencies before you have too many to handle. Feed the pictures into the system as soon as they are processed.

Start with a numbering system on the negative bags, keeping each film in a separate bag, and enter the number in a notebook with a brief description of the shots.

Write as much information as you have on the bag and make a contact sheet of each film. Write the film number on the back of the paper before processing. A 36-exposure roll fits onto 10" x 8" paper if the film is cut into strips of five or six frames. File the negatives away consecutively in boxes or a file and keep the contacts separately in another file. The contacts are then available for easy reference. Do not allow the master file out of the house or studio.

There are many designs of negative bag on the market. One of the best is a clear acetate divided sheet which takes a complete film in strips and has a caption panel at the top. The film can be contacted while still in the sleeve and filed on a hanger in a filing cabinet. These sleeves are frequently used in the darkrooms of magazine publishers where speed and efficiency are essential.

This system is particularly useful if space is limited but it is still advisable to keep the contacts in a separate file for two reasons.

First, it takes an experienced picture editor or darkroom printer to read negatives; second, as any professional photographer will attest, periodic surveys of old contact sheets will lead to the discovery of good shots which had been overlooked. A picture taken years ago which seemed insig-

A plastic moulded seed tray is a good box for storing edited slides.

When storing negatives keep them dry. Do not pack drawers too tightly. The negative diary should contain all the details written on the neg bag.

Several types of contact viewers are available. The flexible arm model is useful when retouching.

nificant at the time may be extremely valuable in years to come.

The best files for transparencies are the plastic sheets with pockets for each individual slide. There are two basic types. One holds 20 slides and has punch holes for filing in a ring binder. The other holds 24 slides, has a large protective flap covering the front and can be hung directly in a filing cabinet on metal hangers. Such sleeves allow easy viewing of slides in series and provide quick access to the best shots. Keep the rejects in boxes and, as with the contacts, return to them occasionally. There will usually be one or two which should be rescued from obscurity.

A light box is essential for viewing transparencies. There are many excellent makes on the market, at a range of prices, but it is possible to construct a simple one with opaque glass or white acrylic sheet and a cool fluorescent light source. A cheap light box, however, does not give an accurate light for colour judgement. Transparencies for reproduction should only be viewed on a printer's light box which provides controlled illumination. The light tubes are monitored and replaced after a fixed period.

An eyeglass lens is needed to view transparencies on the light box, although ready mounted slides can be viewed on hand viewers, either battery or electric powered. One of the best of these viewers is the Agfascop 100. The best lens for viewing transparencies is the Schneider magnifier. This high quality lens allows the full 35mm frame to be viewed. There are many other types on the market but most of them let top light through onto the transparency, which diffuses the image.

When the transparencies are returned put them all the right way up and draw diagonal lines across the top as a guide to restacking them in the correct order.

The transparency light box should have colour corrected fluorescent tubes fitted. These give an even overall light, but do not overheat. The Schneider 4X wide angle loupe covers the whole 35mm frame. The Agfascop viewer is an essential aid to selecting slides. Put the selected slides into acetate covers, then file them in plastic holders and hang in a cabinet.

Consecutive numbering stamps are useful for giving each slide the same number as the one in the notebook. Another stamp can be used to identify the slides with the photographer's name.

Viewing

Projectors

The best way to see pictures is when they are reproduced well and large in a high-quality magazine or book. The next best way is to see them well projected on a large screen in a darkened room.

Often a transparency looks insignificant on a light box, but when projected it becomes a picture in its own right. Detail and close-up shots usually look more dramatic when projected. Remember this when shooting for projection.

A slide has to be projected many times before it begins to discolour. Do not project favourite pictures for too long in a projector without a built-in cooling system: they might melt before your eyes— an interesting but painful experience.

Black and white prints copied onto Kodachrome take on a slight blue cast which adds to the quality of the projected image.

The best sort of screen to project on is one that gives an even reflection all over, not just on the light path where a hot spot will be created. Modern super white emulsion paints have a reflective ingredient in them, so paint an interior wall to use as a screen. The dark border which is used on a conventional screen can be painted onto the wall to help contain the projected image.

The basic design of the **Kodak Carousel** has not altered for many years. This projector is the one most used for audio visual programmes, some of which run continuously for many days. It is also used for large studio back projections, with a cooling unit attached to prevent the slides from melting. Most major magazines, advertising agencies, conference centres, schools and institutions use Carousels. The projector is supplied

The Carousel magazine can only be changed while the machine is switched on. Turn the counter to 0 before attempting to remove it. Make sure the spring clip is in place.

Suitcase back projection unit

with a remote control unit which controls the focus and picture change— both forward and backward. There is a range of lenses to choose from. Carousels are available world wide to run off all types of electricity supply.

The Carousel tray holds 80 or 140 slides. To empty the tray of pictures turn it upside down, allowing the slides to fall into the lid. With a slight twist open the tray and run a finger around the tray, stacking the slides into blocks. This is much easier than taking all the slides out individually.

The **Kodak stack loader** is a projection unit similar to the Carousel, but it has automatic focus. It will take the circular Carousel tray as well as the stack loading magazine. The slides are put into the loader as a block, making it useful for editing material straight from the laboratory. This model is only made to run off 110V electricity.

The design of the **Leitz Pradovit** projector is similar to that used by Rollei, Agfa and several other manufacturers. They use trays which hold either 36 or 50 transparencies. The trays are cheap and are good to use for storing slides when not in use.

Back projection units are loaded with the slides the right way up and the emulsion facing the screen—the opposite way to a conventional projector. As with the Leitz, the transparencies are fed into the projector in straight trays. The suitcase units are excellent to use for table top presentations as the viewing room does not have to be blacked out. As with all back projection units the texture of the fresnel screen is visible when viewed from an angle.

Size of lens and distance between projector and screen needed to achieve approximate width of screen image

Width of screen image:	1.02m	1.27m	1.52m	1.83m	2.44m	3.05m	3.66m
	40 ins	50 ins	60 ins	72 ins	96 ins	120 ins	144 ins

Focal length of lens:	Distance between screen and projector to give above screen sizes						
	m. ft.	m. ft.	m. ft.	m. ft.	m. ft.	m. ft.	m. ft.
60mm	1.83 (6)	2.13 (7)	2.9 (9½)	3.2 (10½)	4.27 (14)	5.33 (17½)	6.4 (21)
85mm	2.59 (8½)	3.2 (10½)	3.96 (13)	4.57 (15)	6.1 (20)	7.62 (25)	9.14 (30)
100mm	3.05 (10)	3.8 (12½)	4.57 (15)	5.49 (18)	7.16 (23½)	9.14 (30)	10.67 (35)
150mm	4.57 (15)	5.8 (19)	6.86 (22½)	8.23 (27)	10.67 (35)	13.72 (45)	16.15 (53)
180mm	5.49 (18)	7.01 (23)	8.23 (27)	9.75 (32)	12.8 (42)	16.15 (53)	19.51 (64)
250mm	7.63 (25)	9.75 (32)	11.28 (37)	13.72 (45)	17.98 (59)	22.86 (75)	26.82 (88)

Kodak stack loader

Leitz Pradovit

Mounts

Process paid film is returned to the customer cut and mounted. Kodachrome comes in cardboard mounts while Agfa use plastic. Film processed by a commercial laboratory usually comes back unmounted in strips.

Professionals who shoot many rolls of film on an assignment will cut out the best frames from a strip and mount them. A mounted transparency is easier to handle than a loose frame and it can be stamped with identifying marks. Many makes of cardboard mount are available at low cost. Card mounts can be used in projectors although, as they wear, the corners become ragged, causing the slides to stick in the projector mechanism.

If the slides are primarily for projection, plastic mounts should be used. There are also many types of plastic mount but the best ones for long term use are those with glass windows. These protect the film from dirt and scratches and if the slides stick in the projector they are less likely to burn. Choose ones with the special glass which does not produce Newton's rings—annoying bubble images which often appear with normal glass. Plastic slides are also heavier than card, which makes them preferable for use in gravity feed projectors.

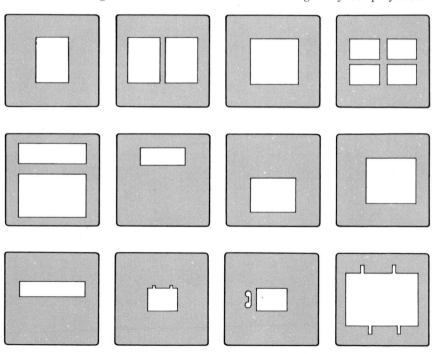

Store cardboard mounts in hermetically sealed plastic bags to stop the self-adhesive glue from hardening. Keep selected transparencies in specially marked mounts with a colour sticker on one corner.

Always use the mounts the same way round, so the emulsion side is on the same side of the mount. The emulsion side of Ektachrome film is shiny. Kodachrome emulsion is matt with a minute bas-relief appearance.

Many of the mounts illustrated here are designed for use in programmed shows where more than one projector is in use. They can also be used to mask off sections of a slide.

The bottom three shapes were made by hand. With a scalpel blade, cut out the required shape, like the voice bubble, from a piece of black film and lay that into a conventional 35mm mount. Then place the picture in the right position on the frame and sandwich the two together.

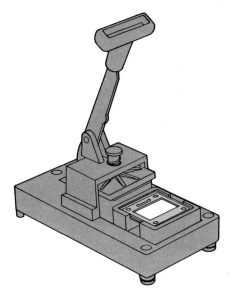

The Gepe hand mounting press makes slide mounting easier—especially if large numbers are to be done. The base is illuminated. Special tweezers pick the film up by the sprocket holes.

Duplicating

There are ways of duplicating transparencies which can give results as good as, or even better than, the original pictures. Commercial laboratories duplicate transparencies cheaply or they can be made at home on a bellows attachment or electronic machine. Professionals usually make duplicates so they can send pictures across the world without risking the loss of irreplaceable originals. But duping also has creative possibilities and is used by many of the new wave photographers to enormous effect.

Duplicating is often considered to be a rescue process. It can be used to save transparencies which are up to one and a half stops underexposed.

Begin by duping correctly exposed transparencies with normal filtration and normal development. Having established a norm, experiment with exposure times and filtration.

Kodak now make an excellent duplicate film which is available in 30.5m (100 ft) rolls to be loaded into cassettes. Ektachrome 64 or 50 (tungsten) is effective if overexposed one stop with the processing *cut* to correspond. The greatest difficulty when duplicating transparencies is the build up of contrast—which can be reduced by under-development. If more contrast is desired use Kodachrome 25.

There is no end to the creative potential of duplicating. Try double exposing two transparencies onto one picture. Dreamlike effects can be achieved with figures and skyscapes. Images can be enlarged. It is even possible to enlarge one image and leave the other same size.

On the Nikon F or F2 and Canon F1 cameras the head can be removed and the image on the ground glass can be traced for reference. With other SLRs a grid focusing screen should be used to help calculate the position of the image. Alternatively, project the images onto a screen; draw off their outlines and compose the shot to fit.

When exposing two images the exposure time for each must be halved or the result will be overexposed. Using that principle, each exposure can be altered to give the desired emphasis. Any number of images can be duped together, but keep them simple as multiple images can become confusing.

Once a photographer becomes involved in duplicating slides, images will suggest themselves to be shot specifically for superimposition. A stock of sunset pictures can be put to good use. Fascinating effects are possible by duping colour negatives and slides together, or duping onto infrared colour film; superimposing b/w

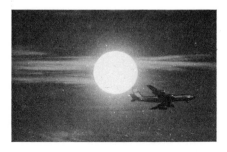

negatives onto colour—even enlarging frames from home movie films.

One of the most important factors in the process is the note book. Keep a duping diary of every exposure so that successes can be repeated. Transparencies which have an interesting content but a boring colour may make better black and whites. If so, shoot b/w negative off the transparencies. Give plenty of exposure and develop in fine grain developer. Black and white transparencies are also possible with Agfa Dia-Direct film.

Place filters between the light source and transparency rather than on the lens where they can cause loss of sharpness.

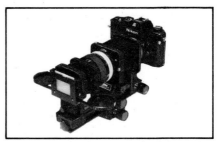

Most system manufacturers make slide copying attachments **above** which fit onto the end of the bellows. Using a sheet of glass and hand flash **below** can be effective. Attach slides to camera side of glass and mask all round. Strongly diffuse the flash head.

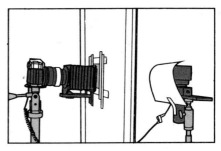

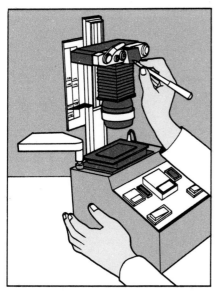

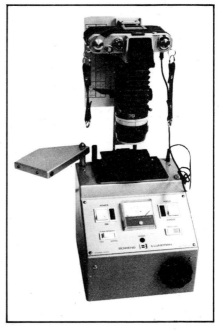

One advantage of having a removable pentaprism is that images can be outlined on the ground glass. When making a composite picture **left** the originals must be matched, or the slightest misplacement will ruin the result.

With the electronic duplicating machine **right** transparencies can be copied easily and quickly. The built in electronic flash is synced with the camera shutter. Several types of duping machines have a pre-fogging attachment. This overcomes one of the main problems—that of increased contrast in the duplicated picture.

Copying

Copying

Photographing flat artwork, such as a painting or photograph, is a precise business which requires care and concentration.

The first step is to use a spirit level to ensure that the flat art and the camera are perfectly square. Then mount the camera directly over the centre of the original.

Position lights on each side of the camera, at the same height and at 45° to the painting. If the lights are too close to the artwork they will create reflections off the surface. The lights must be balanced to give exactly the same exposure from each side. A good way to check the position of the lights when setting up is to place a matchbox or pencil in the middle of the artwork and move the lights until the shadow is exactly the same on each side. The soundest method of achieving correct exposure is to take the reading off a grey card.

The colour balance of a painting is, of course, absolutely critical. Shots taken on colour negative film can be corrected at the print stage. At one side of the artwork place a colour scale and a grey scale; these can be bought at photographic shops. The printer can then match these scales to his own to achieve correct balance. Colour and grey scales can also be used with transparency film to help achieve the correct balance on the re-shoot.

The technique of copying flat artwork is a most important one to master as it can be used so often—for titles and captions to audio visual and holiday slide shows; making copies of old family portraits, or photographs for which the negatives have been lost; and even making reproductions

Bowen's copy stand. The camera screws onto an extension arm which brings it directly over the centre of the artwork. It can also move up and down the column. Even lighting is ensured by the four adjustable lights. The complete unit can be made secure by screwing the bracket at the top of the column to a wall. This eliminates camera shake on long exposures.

Artwork can be copied straight off a wall, as long as the camera is parallel with it. Use a pencil or matchbox **right** to judge the light level. Make sure the density of shadow is the same both sides.

of oil paintings or drawings.

If the object being copied has a reflective surface, hold a large piece of black card or cloth around the front of the camera making a hide for the lens, or use a polarizing filter. If there are still reflections place sheets of polarizing material over the lights.

Many families have albums or collections of old pictures which have been handed down over the generations. Most of these are in a state of deterioration.

Restoring these old photographs with a copy set up is not difficult. Yellowish stains disappear if a yellow filter is used with black and white film. Faded images can often be revived with yellow (which increases contrast by lightening light areas and darkening the darks) or a blue filter which also increases contrast. The yellow filter will work better on sepia-toned

prints and the blue on more black and white pictures. Faded edges can be corrected in the darkroom by giving them more exposure than the rest of the print.

Holes and spots can be retouched on the copy print. If the original sepia quality is to be reproduced tone the finished copy print with a sepia kit. Any retouching will have to be done in brown tones rather than greys.

Use slow film such as Pan F or Panatomic X, which are high in contrast when processed normally. If a softer result is required overexpose one stop and underdevelop.

Frames

The variety of picture frames commercially available is infinite. They range from plastic cubes through light metal to old world traditional. It is most important to marry the right photograph to the right frame.

There are also ways of presenting pictures about the house without using frames at all. Try mounting pictures on chipboard, trim them flush and paint the edges.

A spectacular display can be made by plastering a window with duplicated transparencies. Butt them together perfectly to achieve the effect of a stained glass window. Use a variety of images; copies of graphics from books or stills of film stars can add impact to a personal selection. Place diffusing plastic (the backing of transparency sleeves) between the window and the dupes so that the backlight is spread evenly, then cover the other side with clear acetate.

A similar effect can be achieved by sticking black and white or colour prints to a wall. Exciting murals can be made with prints of different sizes. Mix in news pictures or copied shots with personal pictures of the family. Try hand colouring b/w prints and using sepia toning. Copy news headlines to include as captions.

A wall size mural can be made which costs no more than expensive wallpaper, but which is more interesting. Close-up pictures, for instance, look stunning when blown up to wall size. One giant print or a collage of smaller prints can be used.

A more orthodox way to cover a wall is with individually mounted or framed prints. These can look effective when hung close together, either with a theme or simply as a collection of the best photographs. Don't just hang them square but arrange frames in shapes. Make sure the lighting is good. Don't hang glass mounted pictures opposite a window, unless non-reflective glass is fitted to the frame.

Metallic finish photographic paper,

which is available in gold, silver and a range of colours, is perfect for making individual posters. Use negatives which are graphically simple. Home posters can be made from shots of the family car, the girlfriend or boyfriend. Again, they are more fun if they are personal.

An unusual way to present a print is to fit it to a venetian blind. Make a print the size of the blind and cut it into strips to fit the slats. Stick these down with double sided tape or adhesive. The photograph is only visible when the blind is closed.

Shots can be laid out like a magazine spread by having several negatives printed onto one sheet. Use plastic paper for ease. They can then be mounted back to back and spiral bound into a book. Titles can be added with rub down lettering and a cover made from thick card. Books such as this make fine presents for people on anniversaries, or as reminders of friends and family who are far away.

Another good way of putting photographs to use is to send them as postcards. Just make prints card size, or use ready cut postcard printing paper.

Framed pictures often look best when hung together. A collection can either be hung in rectangular blocks or in looser arrangements. Stand up frames for smaller size prints come in every conceivable shape and material and they also look better when grouped together.

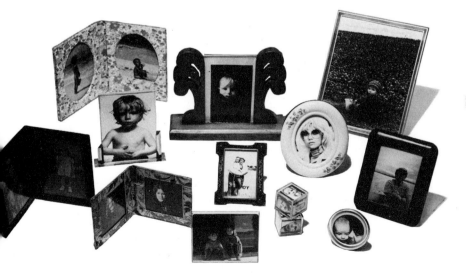

Presentation

213

Presentation

The potential of photography is only realized when finished pictures are presented for others to see—in an album or on a wall as a print or projection. It is pointless taking great pictures which are stored out of sight or hung haphazardly. Make a conscious effort to communicate through pictures and think of this as the show business aspect of photography.

Before planning a slide show, exhibition or album, however, the photographs must be edited. The selection of pictures requires a different attitude to that required when taking the photographs. Do not think about how difficult it was to get the shot, or how pleasant the holiday was. Cut the emotional attachment to the pictures and try to select them on their merits.

There is a great difference between choosing one picture to do a specific job and selecting a set to be shown together. Much of the dramatic impact of a selection of shots depends on the juxtaposition of one picture with another. The effect of two sympathetic images added together will be greater than the sum of the two separate pictures. Deliberately jarring images can be placed together to worry or unsettle the viewer. Experiment with the choice of images to make displays representative of personal taste.

Link the photographs together with a theme. If a shot does not fit in with the central idea it does not belong—no matter how beautiful it is—and it must be rejected. Rejected pictures,

however, can often be used again in another context.

The same disciplines apply whether the photographs are intended to create a mood of anger, joy, nostalgia, eroticism or fantasy; or just tell a simple story about a holiday, wedding or sales conference.

Professionals carry the best pictures in portfolios to show clients examples of their work.

The portfolio will usually contain laminated copies of book and magazine pages with transparencies mounted in cards.

Laminations are made commercially by sandwiching a print between two pieces of clear plastic and applying heat. The lamination protects the

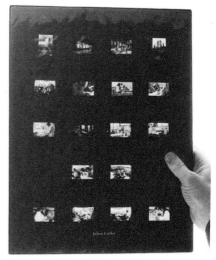

print from damage and also brightens the colours under a gloss finish. It is a good method to use when a print is to be handled a lot—at a sales meeting for example.

Transparency cards are black sheets of card with holes cut to accept slide mounts. Protective plastic sheeting covers the top. The cards can be bought or easily made.

Keeping a portfolio of current work is a good way of tracing improvements in technique, it gives an end product to the effort as well as keeping the best work available.

In the folder all the images should be the same way around.

Keep it simple with not too much to look at.

Include samples of work which have been published, samples of work that are relevant to the client, and samples of work that are just your own personal favourites.

Mount everything cleanly, with one image per page unless the images are related, i.e. a sequence set.

A presentation pack should be not too big. Remember, a space on a desk has to be found and cleared to lay the presentation on.

Viewing of transparencies must be kept simple. If the art director can get an overall view of transparencies, he will pick those that interest him and study them closer. He doesn't want to have to look at every transparency individually.

A variety of portfolio cases is available, from soft plastic types to the more expensive model shown here. It is worth buying the best that can be afforded but it should be a manageable size. Do not buy one which is too big to carry or which will take up a great deal of desk space. Insert prints so they can be viewed from one angle, without having to turn the case around. Spiral bound prints **left** can look impressive. Transparencies should be mounted in cards.

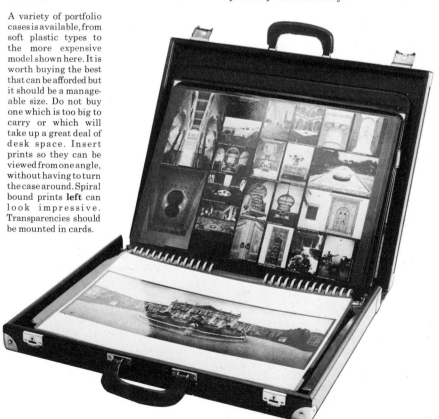

AUDIO VISUAL

Audio visual

As the name implies, audio visual is a combination of sound and pictures. It is not a poor man's film but a valid form of communication in its own right.

For a photographer it is an opportunity to incorporate all his photographic technique into a cohesive, entertaining show. Shows are made from a number of slides. Using a minimum of two linked projectors, the slides can be projected continuously so there is never a blank screen. It is usual to project either all horizontal or vertical slides, but ways of combining both are described over the page.

Pictures viewed simultaneously or sequentially combine to form a new image with its own meaning. Consider the verbal equivalent of the principle. A description of the Christmas holidays—alcoholidays—is a combination of alcohol and holidays. When joined together the words take on a new and specific meaning. The montage technique of adding images was used to great effect by the early film makers.

There are two approaches to making an audio visual programme. The first is to make one up from existing material. Open with a good beginning which leads the audience into the message and don't just end the show abruptly, leaving them waiting for another picture. Try to include several humorous shots and ensure that there is a thread of continuity running through the show. Select transparencies of equal density so the quality is consistent. Use the same type face for lettering and the same colour background throughout to create a cohesive unit.

The second way is to take all the pictures specifically for the show. Shooting for a big audio visual presentation, the photographer will be able to use all the equipment available to him to take a whole range of pictures—but it may be just as valid to produce a show using one lens and available light.

From the basic script the photographer knows the purpose of the audio visual, how many pictures are required, the order in which they appear and the relationship between pictures. He now has to think like a film director. A rough drawing should

be done of each picture required. By thinking out each shot in this way it is easier to understand the juxtaposition of pictures, and when a change of emphasis or style of photography may be necessary. However, do not become too confined by the script. Always allow for the unexpected picture.

The show will be seen on a large screen, much bigger than most printed images, so the quality of the picture is critical. The original pictures are not usually projected; duplicate copies are made. For ideal finished picture quality, the originals should be shot on Kodachrome and duplicated on to either Ektachrome or Kodachrome. The slight build up of contrast does not show when projected.

As the finished pictures have been

arrived at after several processes, the mounts will have cut into the picture area, so it is best not to compose too close to the edge of the frame. TV format focusing screens are available for most cameras, which aid the composition. When composing for special shaped screens, one can draw on the camera focusing screen. A lot can be done in the post production stage, especially if a rostrum camera is used to make the duplicates.

Don't compose the picture so that the emphasis is always in the middle. The eyes of the audience will wander — so use the whole screen. The photographer should be able to control this flow from one picture to another if the composition of the whole multiple image has been considered.

This permanent audio visual display shows how the daily television news is put together. It is presented two or three times a day at the Television Museum in London. Twenty four Kodak Carousel projectors are linked behind the 12 screens. Picture changes and the speed of dissolves are triggered by a series of electronic pulses on the sound tape which also carries music, vocal and effects tracks. The programme lasts for 12 minutes and uses 313 transparencies.

An automatic single screen projection unit.

Audio visual

The Carousel projectors can be programmed to do 'snap' changes—about two frames every three seconds—or slow dissolves from one frame to another.

Post-production work is done on rostrum cameras. These are expensive, sophisticated copying cameras that can zoom into a detail of a frame, track along a slide, change the background and superimpose one picture onto an area of another. All these duping stages create grain so work off good quality duplicates.

Titles, credits and captions are photographed on a rostrum camera. First copy the picture, then the words. Make a dupe composite of both.

A zoom effect can be achieved with the use of several lenses. Soft dissolves make images appear to move. Shoot the originals to fit rather than reshoot on the rostrum camera.

Use head shots to emphasise the words on the sound track. Make the subject look authoritative.

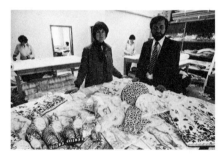

Pictures should be interesting or complex if they are to remain on screen for 20 seconds or more.

Use half frames when the audience is being briefed about a series of subjects. While the speaker remains in place the other images change.

Use a selection of mounts to add visual interest to the show. Double mounts allow more pictures to be included in the programme.

220

Graphic images should be strong. This one shows 2,500 miniature bottles on a reflective backing.

Details from printed matter look effective blown up large. This was sepia toned and recopied.

Juxtaposition of images can say more than one picture. The shot of the glass and barrels is

followed by the detail of the bottle. Rely on visuals when the script is weak.

Use of the dissolve to go from an idea to the realization. A shot of the original plan dissolves

into a photograph of the finished product with the designer standing alongside.

To place a subject against a particular background, shoot the person against a white background (on transparency film) then take another shot of the chosen background. Make a separate *negative* print of the subject against white. Then use a rostrum camera to superimpose the images of the background and the negative image of the subject. Re-expose with the positive image of the subject in place against the space in the background.

221

Audio visual

Illustrated on these pages are the conception stages, and nine finished pictures, from an audio visual programme commissioned by a major whisky company. A hundred and sixty slides and two projectors were used for the single screen show. The commentary was translated into seven languages and the company presented the show world-wide. It was also put onto 8mm film. The original script was edited to fit with the 160 picture changes. To get an idea of what the picture requirements would be, the images were roughly drawn up on a TV storyboard pad before the photographer had been to any of the locations. The drawings are only an indication of what is needed—not a rigid brief. But they do allow the photographer to have an immediate grasp of what he has to do; how to approach the job and what visual tricks he can employ

Shot no: 1. Opening sequence. Slow dissolve from wide to close-up. 4 pictures.

Voice over; presenter plus sound effects.
'Now here is the forecast for the north of Scotland. Snowfalls will persist throughout the night in most areas. . . .

Shot no: 22. Glass of whisky on location.

Voice over; presenter.
'But if the heart of Scotch whisky lies only in the mountains of the north, the skills that bring it to triumphant. . . .

Shot no: 58. Close-up whisky in glass.

Voice over; presenter.
'There are 114 malt distilleries in Scotland and each produces a whisky with a truly distinctive flavour and character. . . .

Shot no: 61. Portrait of manager face to camera.

Voice over; presenter/Sandy Robertson.
'Sandy Robertson has it in his charge/''Twenty five years ago.

Shot no: 88. Spirit safe and man.

Voice over; presenter.
'And so with the aid of his hydrometer the stillman tests the spirit with his eyes. He *knows* when the real spirit. . . .

Shot no: 90. Mr. Livie in warehouse.

Voice over; Livie.
'We store the whisky in casks which must be oak. And a certain proportion is matured in selected sherry casks that. . . .

Shot no: 147. Closing sequence. Skiers on slope slow dissolve.

Voice over; presenter plus sound effects.
'Tomintoul-Glenlivet. Light, quick and smooth as the touch of skis on crisp shimmering snow. . . .

Shot no: 148. Après-ski with whisky bottle.

Voice over
'. . . Good humoured and alive. . . .

Shot no: 149. Studio pack shot hold 4 secs.

Voice over; presenter plus sound effects.
'. . . Tomintoul-Glenlivet. . .'

Audio visual

223

Audio visual

The family holiday provides a great opportunity to shoot a mass of pictures. On your return home the subsequent slide show can tell the whole story—the funny moments, the excitement, the great meals and the atmospheric details. Keep the end product in mind when shooting. Back up the key images with sequence shots of the less spectacular events. Record local music to play as a background track and make your own tape of sounds in cafés and city streets, laughter of children on the beach, the sound of waves or animal noises. Use any sounds which adds atmosphere.

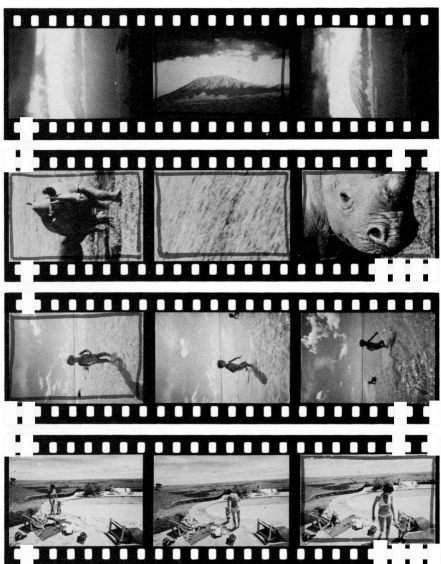

Edit the transparencies on the light box as soon as they are processed. Get all the pictures into chronological order and select the key shots. Then choose the link pictures which tie the story together. If you have verticals and horizontals of the same subject, select one of each to see which is the most effective. (It may be good to use both together.) Running several different shots of the same subject can give a more complete picture and add to the pace of the show. If the projector is being manually operated it can be speeded up to bring the sequence even more to life.

1. A shot of a passport stamp or map can be used as a title to identify the location. 2. 'The Snows of Kilimanjaro' at sunrise. This is one of East Africa's greatest landmarks. 3. The Garrett family at the pool of the Mara Serena Lodge overlooking the plains of the Massai Mara.

4. A rhino about to charge our safari wagon. 5. In a moment of terror the photographer loses the rhino from the camera viewfinder. 6. Having pulled himself together, the photographer takes a shot of the snorting beast as it pulls up alongside the wagon.

7. A detail from a memorable fish lunch on Robinson Island after a long hard journey. 8. Our son Nicholas enjoying the pleasures of the ocean outside the holiday house in Malinda. 9. My wife Michelle and self snapped by a friend in our favourite bar.

Application

Most of the billions of photographs taken every year are shot on vacation; processing houses report that their best business is done in the summer months and just after Christmas. It's a pity that so much equipment, and so much enthusiasm, isn't applied during the rest of the year. Photography can add to the enjoyment of hobbies and the success of business or merely be used to record a full life which is lived every day.

The technical expertise necessary to make daily photography satisfying is easily mastered—with this book and practice. The taking of fine photographs is far more dependent on the understanding of what is being photographed. People absorbed in their hobbies, their jobs, their children, using cameras for the sole purpose of recording information and results, can finish up with unique collections of pictures. Their *primary* interests are the crucial factor.

Most of the great bird portfolios have been shot by ornithologists and the significant studies of primitive people by anthropologists—for the obvious reason that they have the knowledge and the personal commitment to a subject and, in the case of the anthropologists, the ability to make contact and be received sympathetically.

If in doubt about what to photograph ask yourself 'What am I interested in? What excites me? What is beautiful? What makes me angry? What makes me laugh?' The answers to questions like those will provide enough material to last a lifetime. If the camera records your interests good pictures will follow.

Almost every hobby or business has its own specialist magazines, and they usually welcome pictures which are of interest to fellow enthusiasts. Send pictures in. If the magazine uses them they may want to see more. No editor or picture editor will ignore good relevant pictures. The publication may only be a small trade paper with a limited budget, but the thrill which accompanies the first published photograph can be most satisfying.

Many large companies publish house magazines which depend on contributions from employees. These can provide a good outlet for the keen

photographer who takes news or reportage type shots. More personal pictures with artistic or humorous qualities will also be welcomed by editors of house journals who often have trouble filling their pages.

People who have to travel during the course of their business can find a camera an invaluable note book, especially if used in conjunction with a pocket cassette recorder.

The number of professions, trades or vacations to which photography can be applied are endless. People in creative areas, such as architects or designers, should be well aware of the potential of the camera but executives could also take photographs to embellish the company reports.

Estate agents often rely on inadequate snapshots of property to interest buyers. A good photograph of a building will attract more attention from customers than a poor, unsharp snapshot. Those who manage large estates frequently make aerial surveys of the land. With the aid of a camera such trips can be recorded.

Teachers and lecturers can add interest to their classes with relevant photographs, possibly made up into audio visual programmes.

At the risk of putting professional photographers out of work, it should be stated that many of their smaller commissions for lectures, sales conferences, internal house magazine articles, reference or promotion can often be shot just as well by an employee.

In such cases knowledge of the business and the purpose of the final print may be worth all the technical expertise of the professional. Use the camera as a communications tool, like a tape recorder or television.

Also worth considering is the fact that equipment and travel expenses can be written off against tax, as long as they relate to your regular employment. This concession can cut the cost of photography considerably.

Experiences/1

One Sunday, while taking a walk with my eighteen-month old son Nicholas, I was carrying a Nikkormat EL fitted with a 80-200mm zoom lens loaded with HP5 film.

We had stopped while Nicholas played with some other children. At one point I turned round to see if Nicholas was alright, only to see a bigger boy holding a toy gun to his head. I took a picture of the scene almost instinctively. The camera was on automatic, so I simply had to focus and shoot.

The picture that resulted was first published in the book *The Family of Children* and has since been used by the German magazine *Die Stern;* the Italian *Oggi;* the French *Parents*, and *Look* magazine in the USA.

The obvious moral of the story is to carry your camera about with you at all times and to become so familiar with your equipment that you can shoot automatically.

I was on assignment for Time-Life publications in Istanbul. One day I was concentrating on the life in and around the Galata Bridge. Underneath the bridge there was a café where the old men gather to smoke bubble pipes and drink *chai* (tea), play some backgammon and chat.

I wanted to get a group portrait complete with pipes, but if I had dared to try that on the first day, I would have been thrown out. They were naturally shy of cameras.

I continued to go to the café for several days and eventually we became good friends, I was accepted. One of the old men had taken to buying me *chai* and sharing his pipe.

My sixth day there was a Saturday and when I went on my usual visit they were all there. They had got used to the idea of my being a photographer as I had always taken along my gear, so when I finally 'condescended' to set up my tripod, they

Paris Match

Die Stern

were all delighted and ready to pose.

The point here is that it is sometimes impossible to get a good picture —or a picture at all for that matter— without the ready co-operation of the subject. By taking your time to get to know them just a little, they will not feel as if they are being exploited.

I was sitting in a café in the Grand Bazaar in Istanbul completely fascinated by an old lady who was sitting silently by her husband as he downed four bottles of beer. Her face was a study of tragic resignation which I found very moving. She was to me a classic symbol of the unliberated woman of that part of the world. As there was little light, I put the 180mm f2.8 lens on my camera and sat it on top of the soft bag leaving it pointing,

almost accidentally, toward them, while trying to appear to be taking no interest. Eventually, I composed and took two shots. By the time I took the second, the lady had noticed me, and the second shot was less effective.

Real life shots sometimes require almost infinite patience, but they can reward you a million times over as they say so much more than glossy superficial shots.

Security surrounding a major rock concert is tight, and photographers need numerous passes to gain access to all parts of the arena.

At a concert on a recent Rolling Stones tour absolutely nobody was being allowed backstage — photographers were restricted to the front of the stage area.

I was on assignment for *Paris Match* and felt that they needed something just a little out of the ordinary. Fortunately, I had been chatting to Bianca Jagger at a party the night before, so when I saw her heading backstage from the VIP box I told her my problem. She grasped me firmly by the arm and pulled me through the security guards into the off-limits backstage area. I was the only photographer there.

When Mick Jagger staggered off the stage I took three shots of him with flash before his bodyguards had time to step in and stop me.

The moral here is not to run with the herd, and not to be afraid to use connections and ask favours. You never know—the answer may be 'yes'.

John Garrett.

Experiences/2

In 1977 the contents of one of England's greatest country houses, Mentmore, were put up for public auction. Dealers and private collectors from all over the world came to bid for some of the finest treasures to come on the market for many years. I covered the five day event for *National Geographic Magazine*, although the story never appeared. I wanted to get a shot of the sale in progress, with the auctioneer pointing to a successful bidder, and also include Lord Rosebery, the owner, and his family who were sitting on the left of the rostrum. There was a wall two feet behind the auctioneer, leaving no room to stand. In order to get the shot, a motor driven camera, plus 20mm lens, was clamped upside down and hidden behind the curtains at the back. I sat out in the front at the left, waiting for the auctioneer's finger to point, and fired the camera by means of a 60 foot remote lead. I travel with a bag full of gadgets that are mostly never used, but when a unique picture possibility presents itself you need to have the right gear to hand to take the shot.

This also points up the fact that photographers go to great lengths to take shots that might never be used, but this should not be allowed to affect your attitude, you should always try to get the best picture possible; conversely, such effort is not reason enough to have the picture published.

The shot of men at prayer, which was subsequently published in *GEO*, was taken while on assignment in Pakistan and India for the *Telegraph Sunday Magazine*. I covered the annual pilgrimage of the Ahmadiyya Muslims, a sect who believe Christ was buried in Kashmir.

Every year about a hundred thousand believers gather in Rabwah for a week of prayer. I was there for the entire week, and so had ample opportunity to cover the event from most angles.

The Illustrated London News

British Airports Authority

I was taking a picture from some distance away with a 50mm lens to try to get a wide angle shot of all hundred thousand men at prayer, but having taken that, I used the 500mm rather as one would a pair of binoculars to look for interesting details. This is the picture that resulted. Long lenses allow you to get a view of things that you might never see with the unaided eye. Use them to advantage, never just take the picture you set out to take; patient closer examination may bear fruit.

A client may sometimes ask a working photographer for a very specific shot presenting him with many technical problems. This cover for a British Airports Authority annual report was shot in a studio using a 35mm camera.

230

Mentmore

GEO

Islam is the world's fastest-growing religion, with 500 million believers and thousands of new members every day. This crowd of faithful at prayer is part of a convention of the Ahmadiyya, a small missionary sect, in Pakistan. The Sunnis, who have no official clergy, are the largest Moslem denomination. The Shi'ites have a clergy that can become a political-religious cadre, as the mullahs and ayatollahs did in Iran.

Since the background was a picture back projected on to a 14 foot square screen, the flash light could not be allowed to spill off the subject on to the screen. A small flash was placed in the umbrella to give it lift. The man and barrow had to be lit by flash, but to show the movement he was also lit by a tungsten spot as he moved across the picture for two seconds.

The biggest problem was to maintain a depth of field sharpness in the 25 feet region. With the light available from the back projector, the flash and the tungsten spot, it was possible to hold it all sharp at f8 on Kodachrome 64. To have done this with a large format camera would have necessitated the use of a great deal more light, a much longer exposure and a much smaller aperture.

One of the most common types of photographic assignment is the editorial portrait. Usually, these have to be shot at short notice so there is no time to find out much about the subject. The photographer has to sum up the situation in the first five minutes. Often people say 'Oh I don't photograph very well', but in my experience everybody does. The photographer must put people at ease—by being polite, comical, sympathetic or just standing back. This portrait of the aeronautical designer Sir Barnes Wallis was taken as soon as I entered the room, before he had noticed the camera. Although I shot several rolls the first shot was the one selected for publication in *The Illustrated London News*.

Julian Calder

231

Recommended books

Photographers are often described as having a 'great eye'. This is simply the ability to see and isolate great pictures—whether it is by capturing magical action moments or juxtaposing objects against a studio background. The top photographers have the uncommon in common—a personal vision.

It is an enormous help to study the work of leading photographers when educating the eye. Do not just sit back and applaud them, however. Try to understand why a particular shot was taken, where the light was coming from, the lensing and type of film used. Question every aspect of the picture and study the composition.

This list of books is not intended to be definitive but it is a helpful guide. They are the books that we have found most stimulating and helpful. They are not all collections of photographs —*Norman Rockwell's America*, for instance, is of interest for the lighting effects in his illustrations. Build up a library slowly and get to know the books by reading and studying them— there is plenty to be learned.

GENERAL

Adams, Ansel *Images 1923–1974*
(US) New York Graphic Society.
Brandt, Bill *The Shadow of Light*
(UK) Gordon Fraser
(US) Da Capo Press
Eisenstaedt, Alfred *Eisenstaedt's Album*
(UK) Thames & Hudson
(US) Viking Press
Feininger, Andreas *The Complete Colour Photographer*
(UK) Thames & Hudson
(US) Prentice-Hall
Fusco, Paul & McBride, Will *The Photo Essay: How to Communicate with Pictures*
(UK) Thames & Hudson
(US) Alskog
Gerster, Georg *The Grand Design, Flights of Discovery*
(UK)/(US) Paddington Press
Hass, Ernst *In America*
(UK) Thames & Hudson
(US) Viking Press
Kane, Art *The Persuasive Image*
(UK) Thames & Hudson
(US) Alskog
Kertesz, André *Sixty Years of Photography*
(UK) Thames & Hudson
(US) Viking Press
Lartigue, Henri *Diary of a Century*
(UK) Penguin Books
(US) Viking Books
Michaels, Duane *The Photographic Illusion*
(UK) Thames & Hudson
(US) Alskog
Peen, Irving *Moments Preserved*
(US) Simon & Schuster
Ricciardi, Mirella *Vanishing Africa*
(UK) Collins
(US) Holt, Rinehart & Winston
Rockwell, Norman *Norman Rockwell's America*
(US) Abrams
Seton, Marie *Biography of Sergei Eisenstein*
(US) Evergreen
Sontag, Susan *On Photography*
(UK) Penguin Books
(US) Farrar, Straus & Giroux
Taylor, Herb *Underwater with Nikonos and Nikon Systems*
(US) Amphoto
The Life Library of Photography
Time-Life Books
The Cities of the World
Time-Life Books
The Best of Life
Time-Life Books
Weston, Edward *50 Years*
(UK) McGraw Hill Books
(US) Aperture

PHOTOJOURNALISM/ REPORTAGE

Brassai *The Secret of the 30s*
(UK) Thames & Hudson
(US) Random House
Cartier-Bresson, Henri *The World of*

Cartier-Bresson
(UK) Gordon Fraser
(US) Viking Books
Erwitt, Elliott *Photographs and Anti-Photographs*
(UK) Thames & Hudson
(US) Viking Books
Evans, Harold *Pictures on a Page*
(UK) William Heinemann
(US) Holt, Rinehart & Winston
Frank, Robert *The Americans*
(US) Aperture
Lange, Dorothea *Dorothea Lange*
(US) Museum of Modern Art
Mark, Mary Ellen & Leibovitz, Annie *Photojournalism: The Woman's Perspective*
(UK) Thames & Hudson
(US) Alskog
Great Photographic Essays from Life
(UK) Life Books
(US) New York Graphics Society

PORTRAITS
Avedon, Richard *Avedon Photographs 1974–1977*
(UK) Thames & Hudson
(US) Farrar, Straus & Giroux
Avedon, Richard *Nothing Personal*
(UK) Penguin Books
(US) Atheneum
Avedon, Richard *Observations*
(UK) Weidenfeld & Nicolson
Davidson, Bruce *East 100th Street*
(US) Havard University Press
Kobal, John *Hollywood Glamour Portraits*
(US) Dover

WAR
Burrows, Larry *Compassionate Photographer*
(US) Time-Life Books
Capa, Robert *Images of War*
(UK) Paul Hamyln
(US) Grossman
Duncan, David Douglas *War Without Heroes*
(US) Harper & Row

ANIMALS
Beard, Peter H. *The End of the Game*
(UK) Collins
(US) Viking Press
Erwitt, Elliot *Son of Bitch*
(UK) Thames & Hudson
(US) Grossman
Riefenstahl, Leni *Coral Gardens*
(UK) Collins
(US) Harper & Row
Van Lawick, Hugo *Savage Paradise — Victims of the Serengeti*
(UK) Collins
(US) William Morrow

NUDE
Newton, Helmut *White Women*
(UK) Quartet Books
(US) Stonehill
Weston, Edward *Nudes*
(UK) Gordon Fraser
(US) Aperture
Hamilton, David *The Best of David Hamilton*
(UK) Collins
(US) William Morrow

SPORT
Leifer, Neil *Sport*
(US) Abrams
Zimmerman & Kaufmann *Photographing Sports*
(UK) Thames & Hudson
(US) Alskog

TRAVEL
Singh, Raghubir *The Ganges*
(US) Perennial Press
Riefenstahl, Leni *The Last of the Nuba*
(UK) Collins
(US) Harper & Row
Riefenstahl, Leni *People of Kau*
(UK) Collins
(US) Harper & Row

CHILDREN
Mason, Jerry *The Family of Children*
(UK) Cape
(US) Ridge Press

Index

Pictures in this book were either commissioned by or subsequently used by the following:
Time Magazine
Time-Life Books
Smithsonian Magazine
National Geographic Magazine
Look
Stern
Paris Match
GEO
Davidson Pearce Berry & Spottiswood
Malcolm Lauder (ARCA)
Art + Craft Editions Limited
The Illustrated London News
Sports Illustrated
Whyte & Mackay Distillers
David Donald Associates
Independent Broadcasting Authority (London)
Independent Television News
S. B. Modules
Scottish Development Agency
Sunday Telegraph Magazine
Playboy
Scottish Universal Investments
King's College Hospital, London
Nova
Oggi
Ali Razza Corp
Business Week
Cosmopolitan
Parents
Daily Mirror
The Times

The publishers and authors would like to thank the following for their assistance in preparing this book:

Neville Maude of the British Journal of Photography for details on film.
David Smith, Technical Manager of Nikon UK, for technical information.
John Pilger of the Daily Mirror, London and
Richard H. Growald, National Reporter UPI for their views on photojournalism.
Dr. George Hadfield for his advice.
Graham Wainwright and David Holliday of Leeds Camera Centre, London, for providing equipment.
Downtown Darkroom for the black and white printing.
Sendeans for information on camera maintenance.
Tony Bown for photographic assistance.
Michelle Garrett for picture selection.
Graeme Harris for photographic advice.
Jenny Allsopp, Lavinia Scott-Elliot and Alison Tomlinson for research and general assistance.
Models: Rosemary Clarke, Nikki Howath (Petal) Nancy Howard, Una Crawford, Madeline Vale (Askew) Kim Greist (Models One) Jane Howard, Make-up, Julia Hunt. Barbara Sylvester, Hair stylist, Fenwick.

Main picture credits

Garrett
36, 84–85, 86, 88, 92–97, 102 (top), 103 (top left), 104–107, 108, 109 (top, bottom right), 112 (centre), 113 (bottom), 119, 120–121, 122–123, 134, 136–137, 138–139 (top right), 140–141, 144–153, 156, 157 (bottom), 158 (bottom right), 159 (bottom), 168–169 (3,5, 6,7,11,13), 170, 173 (top left, bottom right), 178 (centre), 179 (top), 180 (top left), 181 (bottom right), 182 (top), 183 (top left, bottom right), 224–225.

Calder
37, 87, 89, 98–101, 102 (bottom), 103 (top right, centre, bottom), 109 (bottom left), 110–111, 112 (bottom), 113 (top), 114–115, 117, 118, 124–129, 130–131, 132–133, 135, 138–139 (centre), 154–155, 157 (top right), 158 (bottom left), 159 (top), 161–163, 164–165, 168–169 (1, 2,4,8,9,10,12), 172, 173 (top right, bottom left), 176–177, 178 (bottom), 179 (bottom), 181 (top), 182 bottom), 183 (top right), 216–223.

Grey card (18 per cent tone)
Measure light reflected off this tone to
obtain average exposure (see p.25).